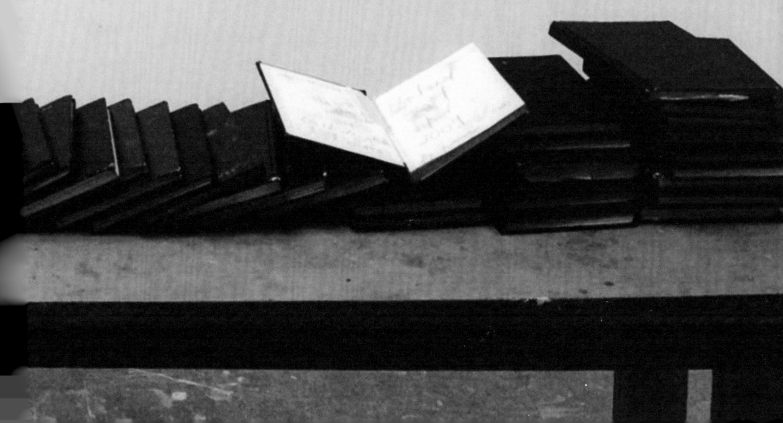

day one

day two

day three

day

day

day

da

da

da

how
to
reach
every
corner

looking

for

balance

the day the sky
was touched (reached)

–

the day we
reached the sky

–

reaching the sky

holding the sky is ok

It's OK – I'll lift the sky
don't worry –

lifting the sky

holding the sky

the day we lifted
the sky

(just another)

puberty

sound

of

panting

out of
out of
out of
out of
out of
out of

Looking
into
the

sun

don't

do

it....

se etter lys

many small
lights,
spots

many small
one large

black light

black light

back light

back door

back stage

I wrote this in the dark

I wrote this in the dark

can

woman

think

ja - så lenge
jeg ken

ja ja ja ja ja åh ja

2012

I am
thinking
of it
everyday

Farringdon Branch
08453002000
opp. the branch

25 år Lære 1804-87
28 år ??? Anno 1829-33
31 år Dresden
40 år Dresden
41 år Paris 1845

Februarrevolusjonen

Pergolesi Stabat Mater

Simon Grant

a something becomes nothing
— while everything becomes
 something relative
to space and destination

Vertical

on

my

own

46356005

man 2011

seeing
with eyes
closed

september 2013

this

is

a

political

painting

please

re n

DOLVEN

BY GABY HARTEL

ART/BOOKS

First published in the United Kingdom in 2015 by Art Books Publishing Ltd
to coincide with the exhibition 'A K Dolven: please return' at Ikon Gallery, Birmingham, 4 February–19 April 2015

Art Books Publishing Ltd
77 Oriel Road
London E9 5SG
Tel: +44 (0)20 8533 5835
info@artbookspublishing.co.uk
www.artbookspublishing.co.uk

British Library Cataloguing-in-Publication Data
A catalogue record for this book is available from the British Library

ISBN 978-1-908970-19-0

Designed by A K Dolven, Herman Lelie and Stefania Bonelli
Production by fandg.co.uk
Printed and bound in Italy by EBS

Distributed outside North America by
Thames & Hudson
181a High Holborn
London WC1V 7QX
United Kingdom
Tel: +44 (0)20 7845 5000
Fax: +44 (0)20 7845 5055
sales@thameshudson.co.uk

Available in North America through
ARTBOOK | D.A.P.
155 Sixth Avenue, 2nd Floor
New York, N.Y. 10013
www.artbook.com

IKON KULTURRÅDET Arts Council Norway FRITT ORD WILKINSON OSL contemporary galerie anhava GALLERI BO BJERGGAARD bodø KOMMUNE PRO

content

a conversation on the way:
some thoughts on a k dolven's art
Gaby Hartel

It is to accept the necessity of the simple
direct going into a field of vision as you would
cross an empty beach to look at the ocean.
Agnes Martin

In a small longish room adjacent to A K Dolven's main London studio, a space where
things are being thought through and which serves as her office and archive, something
unusual catches my eye. Placed on a narrow, long table, next to the shelves stacked
with tins of film rolls, DVDs and catalogues, I see an ensemble of about seventy objects
– black, flat, rectangular, the width of two fingers and the size a bit bigger than A5.
The objects look functional, their surface is smudged with colour and traces of wear
and tear. They are arranged in such a way that they form an extraordinary chance
installation, a lively, black, sculptural line, whose component elements have a striking
semblance to vertebrae in the human spine. And, just as the spine, they are at the
same time solid and flexible, robust and fragile. At second glance, my eye identifies
the said sculpture as an arrangement of the artist's sketchbooks of the past thirty
years, and as such, the mind fills in, as productive time turned into matter and
material. I pick up a book here and there, open it and feel at once drawn into a vast
thinking space spreading onto those white or yellowish A5 pages. I see how traces of
pencil develop and envelop ideas, bringing them into being, making them real by
turning them round and round. It is fascinating to witness how thoughts and themes
first surface in, say, 1990, then resurface in 1999 and again in 2012. I am thus involved
in a process of discovery that feels as if I were finding rare specimens pressed for
years between forgotten pages.

the inside and outside are one / the inside
and outside are one / the inside and outside
IS one
A K Dolven, sketchbooks

Leafing through those sketchbooks, I can sense Dolven's thoughts circling in on what
she sees and feels, on her prevalent topics, her memories and interests, while her

creative mind is preparing to seize that rare moment of breakthrough, when in a paradoxical state of expectant passiveness it suddenly perceives a chance to turn the routinized flow of ordinary perceptions into something solid and contained. Into a specific form. Into an art work. In a happy turn of phrase, Michel de Certeau identifies such moments of heightened vision as 'time insert[ing] itself into space'; when memory, 'that silent encyclopaedia of singular acts', becomes manifest as material – if only for an instant'.[1] In his poem *The Prelude*, William Wordsworth famously referred to those instance as 'spots of time', acting as a precursor to a series of modernist writers and artists – amongst them Virginia Woolf, James Joyce, the Surrealists – who valued 'the diffuse and messy particularities of that life' (the real)[2] and drew their audiences' attention to the productive potential of such moments of recognition hidden in everyday experience. I see Dolven's creative practice in this tradition of inspired discovery, which, according to de Certeau works like this: '[The] occasion is taken advantage of, not created. It is furnished by the conjecture, that is, by *external* circumstances in which a sharp eye can see the new and favourable ensemble they will constitute, given one more detail. A supplementary stroke and it will be 'right'.[3]

I'm interested in traces of humans in contemporary life – both in abstract thinking (painting / sound) and film, video / age and agenda / age and agenda
A K Dolven, sketchbooks

In December 2012, when Dolven opened her sketchbooks for the first time since she had started keeping them, it turned out that not only did this line of assembled books look like a spine, it literally formed the backbone of her art. Those notebooks / sketchbooks contain the themes, observations and passions that have been the undercurrent of her artistic energy for over three decades now. And as I randomly flick through the pages, I come to understand that Dolven places the human being (figure and mind) at the centre of her work; that nature is a constant; that abstractions of human understanding, and emotions, and motivations are being assessed and tried out – both in words and in drawings.

a something becomes nothing / where an everything becomes something / light darkness
A K Dolven, sketchbooks

I also see the artist's productive obsession with the line made by the hand and pencil, her focus on the human body – the ear and the eye – as a perceptive apparatus. I discover her concern for the ordinary and the social sphere that surrounds us and in which – by acting and interacting – we endlessly construct ourselves and one another. Finally, those thousands of sketchbook pages convey the artist's performative approach, which runs through every genre in which she works.

Here I see how themes are interrelated in my work, be they sound, video or film works or painting.
A K Dolven in conversation with Gaby Hartel

Most artistic creation is the result of a falling back on a palimpsest of thoughts and practices – one's own and those of others. In de Certeau's phrasing: 'In spite of a persistent fiction, we never write on a blank page, but always on one that has been written on.'[4] I read the sketchbooks along those lines, as physical manifestations of the red threads that run through Dolven's work, irrespective of the media she uses: her way of commenting on our existence in time, by arresting life for a brief moment in which it balances on the meaningful, to then dissolve into the flow of time again, while waiting for the occasion to create the next brief moment of equilibrium.

sound of balance / sound of painting / sound of me / sound of future / sound of balance
A K Dolven, sketchbooks

When Dolven was an art student in Paris, she took lessons in a circus school. Here, she soon came to develop a skill that has since become the foundational concept of her take on life and art alike: 'When you perform with other acrobats', she explains, 'it's not physical strength that counts, but your ability to keep your balance'. Interestingly, de Certeau points out that Immanuel Kant, in his *Critique of Pure Reason*, employs an intriguing analogy between the act of 'keeping balance' and artistic creation. In de Certeau's words, Kant states that 'the transformation of a given equilibrium into another one characterizes art'. And he goes on to say that 'dancing on a tightrope requires that one maintain an equilibrium from one moment to the next by recreating it at every step by means of new adjustments; it requires one to maintain a balance that is never permanently acquired; constant readjustments renew the balance while giving the "impression" of keeping it.'[5]

something in between breathing in and breathing out / somewhere in between / somewhere in between / I really long for something or somewhere in between / really looking for somewhere in between
A K Dolven, sketchbooks

A K Dolven's sketchbooks are in themselves an act of balance, poised as they are in a stylistic 'in between' space, where they pivot on the generic boundary between day-to-day record, statement of artistic / biographical process, and literary expression. Here, we find a dense richness of writing styles and genres, which range from prose poem and inspired note to lyrical lists, meditation, song, inner monologue, and – not to be neglected – shopping lists, budget calculations and recipes for beetroot juice or fish sauce.

'I wish he could hear you sing … imagine hearing your great-granddaughter sing … if we could hear you now.' I was having a conversation with my sketchbook there, before starting the work; a conversation on the way.
A K Dolven in conversation with Gaby Hartel

I like to think of the sketchbooks as multilingual and polyvocal records, as murmured statements that the artist first uttered to herself, then left trailing in the air, to be picked up again hours, days, years or decades later. The impression of hearing her voice resounding through time, or of reading a musical score, might come from the artist's statement that her books were spaces for her to withdraw into, for personal conversations with herself. Varied as the sketchbooks are in style, they display a formal unity in their respective beginning. No matter what they ultimately contain, the first page always opens on a sentence and a date. 'There is this sentence, always', Dolven explains, 'which marks the beginning of a work. And this sentence – or word – then becomes my dialogue partner.'

I'm not interested in material, the only interesting material is our mind
A K Dolven, sketchbooks

'It is a short way from the hand to the pencil', says A K Dolven. And indeed, new findings in neurology and anthropology back up what the artist knows from experience: that the interconnectedness of mind, hand and the writing / drawing tool plays an important role in the process of human understanding and creativity.[6] Much along the line of Dolven's creative practice, Austrian novelist Peter Handke states his preference for the pencil, claiming that it – like no other writing tool – allows for the necessary immediacy of representation, thereby enabling him to 'tell a story [...] *with* things', rather than 'tell *of* and *about* things'.[7]

The notion of telling a story *with the thing* and thereby respecting what simply *is* makes me think of a similar concept in Paul Klee's *Pedagogical Sketchbooks.* Here the artist speaks of the drawn line as a 'point on a walk' (*Punkt in Bewegung*), the 'point' being an extension of the artist's tip of crayon or pencil, which will then serve as a link between his thought, the art work and the beholder. Such a drawn line first catches the viewer's eye,

and then guides it through a drawing or a painting along the lines of the artist's vision.[8] Here, as in Dolven and Handke, it is the beholder's sensory apparatus in productive conjunction with a mark left on a hitherto spotlessly empty space by the artist that gives the work its urgency.

I come across a page in one of Dolven's sketchbooks of 2013 that is marked by a single red fingerprint, under which is written in the artist's energetic rounded longhand: 'this is a political painting'. And indeed, here she states the most minimal act of self-assertion possible, the instant when the subject, 'I', leaves a trace, and claims her place in the world by making one single poignant gesture of *being there*.

I use my surroundings in a conceptual way. There is this idea that is larger than what I happen to see just now. And perhaps this spot inside the painting is like this spot of snow or it is I myself who am a spot in this world. And, of course, I am the spot that I am because I mirror the surroundings.
A K Dolven in conversation with Gaby Hartel

In art, as in social history, the political has often been understood as something that is acted out by many. Dolven's discreet political practice, though, echoes such independent artist-thinkers as Agnes Martin, who identified the self as the stem cell of all sociopolitical action. 'Changes of social living', she writes in her essay 'What we do not see if we do not see', 'are the result of changes that take place in individuals. First some truth must be recognized by an individual (that is what we call inspiration), and then it must be expressed concretely and responded to by others.'[9]

A K Dolven's strong interest in the power of the human hand becomes evident in her most recent paintings, which disclose dynamic raw black lines on a white 125 × 500 cm rectangular surface, traces of a performance that she has acted out by energetically moving her hands across it: in *teenagers lifting the sky* (2014) and, similarly, *just another puberty* (2014). The few index-finger marks of the sketchbook page have been developed into a larger painting with several rows of irregular lines made by red fingerprints: *this is a political painting* (2013). The dots seem to wander along the surface of the painting, an effect that gives a playful lightness to this work, and that links it to Paul Klee's 'dots on a walk', which were in turn inspired by Hogarth's reflections on the use of serpentine and winding lines as the basis of an inspiring art perception.[10] All those preformative representations of physical presence and action remind me of social scientist Saskia Sassen's passionate appeal to claim alternative public spaces by *making* things in them. She urges us to leave traces and marks as statements in the *terrains vagues* of big cities, rather than let ourselves

be reduced to passive city dwellers who consent and conform and consume.[11] As locations for these interventions, Sassen prefers the street to the designed piazza: in the productive randomness of the street, she says, anything can happen. It could be precisely this concept of reclaiming public space by *making*, by giving shape to something by moving artfully within its confines, that makes Dolven's performative video work *bring me back* (2007), set in the streets of Brussels, so effective.

seeing / thinking
A K Dolven, sketchbooks

Not the hand alone, other parts of the body, too, act as agents in Dolven's art; the eye, for instance. When there's an image, those works seem to ask, then where are we? Right *here*, in front of it, the Realist will say. Oh no, *inside* it, claims the Idealist. That and *behind* it! the Romantic suggests. These are just three of many valid ways of seeing that A K Dolven explores. *change my way of seeing I* and *change my way of seeing II* might serve as an example. Here, the artist includes her viewers in her psycho-aesthetic quest. From the moment of entering the installation, their gaze is attracted to a vague image, which moves in spasms on a large screen. In trying to identify the rhythmic something, the beholder is lured into the screen surrounding it: into the silent foil of indefinite whiteness, which echoes the snowy expanse the artist often uses in her work – perhaps because the bareness of the snow heightens one's sense of vision and physical alertness? Or because 'beauty at low temperatures *is* beauty', as Joseph Brodsky argues in *Watermark*, his essay on Venice in winter.

you want to return / enough time and space to prepare / to prepare for what? / to prepare for what's ahead of you
A K Dolven, sketchbooks

However that may be, what the viewer discerns on this vast plane of grainy whiteness goes beyond a purely sensory experience and leads her to another specific feature of A K Dolven's art: her envolement with art and media history. The theme of *change my way of seeing I* is also a classic situation in experimental films of high modernism: the playful choreography of exchanging glances between the human eye and the camera eye. But, where Dziga Vertov's seminal film *Man With a Movie Camera* (1929) celebrated the camera as an omnipotent extension of the physical eye – thereby endowing both with a preconditioned objectivity – Dolven stresses the productive fragility of the artist's camera / eye. In allowing the viewer to feel the physical strain of her experiment – which involved forcing her eye to confront the brightness of the sun for three long minutes – A K Dolven shares her discovery of the strength of a manifold vision: the potential of diversity. Here, too, she engaged with a concept that is deeply rooted in art history: the notion that an art work can look back at its beholder as if to hold a silent conversation.

sound of painting
A K Dolven, sketchbooks

Having entered the space where the film is installed, the viewer notices sounds from outside that seep into the empty interior, thereby structuring the time spent inside the gallery and giving oneself a firm sense of the here-and-now. Two straightforward speakers, black and rectangular, play back scenes of everyday life picked up from the immediate vicinity, thus inviting the outside to merge with the intimate inner space. By incorporating the colourful and random acoustic traces of the outside, the work transfers John Cage's concept that true silence consists of ambient sound to Dolven's art space. So what, the visitor might ask, was it, that Dolven's eye saw while it was being blinded by the sun? It is tempting to imagine the answer being given in the second part of *change my way of seeing*: the 140 small-format oil paintings might, indeed, be a reflection of the artist's field of vision during those three minutes' blinking into the blaze. This is, of course, a mere assumption, but an appealing one to me, as all the paintings seem to resonate with the sunlight transmitted through the painter's eye onto the sensitive plate of the work itself. It is a hazy, misty, lively light, caught here in one hundred and forty different angles. Just as the mood of the day, or that of the viewer herself, is in a constant state of change. Dolven transfers this knowledge to the vividly tactile surface of her paintings, preparing the ground for the visitor's groping eye, so that they might, while looking, have the sensation of being 'a mobile subject before an evanescent object' (Samuel Beckett). Like film stills, the rows of oil paintings float in parallel rows along the white wall, and as if conditioned by the artistic medium of part I, the viewer can see the paintings as small screens that show her different aspects of one single moment. *change my way of seeing II* seemed at first glance to be a silent installation, as no technically redirected ambient sounds were to be heard. But on spending time with the individual works arranged on the wall like a musical score, one feels that they have a music of their own, an internal rhythm, softly humming to itself.

painting with eyes closed
A K Dolven, sketchbooks

In Dolven's recent series of black oil paintings of varying formats, *A4 black* (2014), *seeing with eyes closed* (2014) and *just another sound* (2014), she immerses her viewers into a matte, shimmering, multilayered darkness, specked with the odd dot or flash of light, here and there. Here, too, she makes use of the tactile capacity of the eye, by invoking a strong physical sensation of unbalance, which is at the same time linked to a kind of haptic memory. Light spots are also made by random specks of dust that happened to land on the not yet dry surface during the production process, thereby allowing a Wordsworthian 'spot of time' an active part in the creation of the work. Those paintings can be seen as something both immense and minute, as the artist's (and our) angle of vision seems to be in a constant process of zooming in or zooming out. As in most of her work, Dolven's black paintings investigate the tension that this interplay of intimacy and immensity acts

out on her viewers' perceptual and emotional apparatus. Individually or together, these works breathe and move, and seem to stare back at the viewer. Their atmosphere is evanescent, and it changes slightly from one day to the next, subtly echoing the mood of that particular day, of its ever-changing light, and, of course, of the never-stable state of the viewer's mind.

This sound, the bell, was like a voice, which will stay longer than all of us.
A K Dolven in conversation with Gaby Hartel

There is a link between Dolven's paintings and her sound pieces. Compare, for instance, the traces people leave on an Oslo square – like the energies left behind by them but still perceptible in the pattern they have made, being at the same time ephemeral and solid. These drawings made by numerous feet have vanished, but Dolven saw them, and at their intersection she installed a huge single bell that had been removed from the Oslo Town Hall belfry for being out of tune. In this respect, the hitherto unwanted, 'not-in-tune' sonic capacity of the untuned bell is not a background noise to a visual experience, but rather a dynamic auditory input in itself, which weaves into a dense emotional texture of individual memories, shared reverberations, and a feeling for the importance of public space. As such, Dolven's bell works are multisensory investigations into the social, aesthetic, emotional and cultural-historical effects and connotations of bells in open public spaces. At the same time, they are playing with symbolic implications of tuning separate bells into a collective harmonic instrument.

In Dolven's recent work, voices have taken over the role of bells: In *bodøvoices 2014* and *boulder of tales* (2014), she combines the non-materiality of the human voice with the solidity of a huge copper lamppost structure and found granite boulders. Here, the artist softens the sad undertone, which her reference to the passage of time (and individual lives) might evoke by combining the fleeting with the permanent. A thought by Mladen Dollar comes to mind: 'Indeed, voice and the stone [...] both have a close relationship to time, but in the opposite sense: voice epitomizes time as fleeting, it is the ephemeral moment which escapes the moment it arises, and the passing of the voice, its instant evaporation is the metaphor of the passing of time. The stone is time as endurance, permanence, durability, it is the materiality that, of all things, comes closest to eternity. Their relation to life is again at the maximum distance: the stone is non-life par excellence [...] whereas the voice not only stands for life itself [...], it epitomizes life at its purest.'[12]

Yes, I can see this now: these two voices are like two lines, like two shadows moving in immaterial space.
A K Dolven in conversation with Gaby Hartel

Another sound piece, *JA as long as I can* (2012), brings me back to Dolven's practice of arresting the moment by keeping a sketchbook / diary: 'It was my diary entry for today, New York, 18 October 2012', the artist says to me, 'that moment. It was a found thing there and then. And I'm sure if we'd done it after, or today or tomorrow, that would have been another page in the diary, really.' But *JA* is also a transatlantic dialogue, a duet, with A K Dolven and John Giorno featuring as performers. Both utter and vary the word '*ja*' for as long as their energy takes them, thus tinting the word with different shades of colour, energy and meaning. The work is an exploration into the quality of sound as a potent signifier of many things at once: of physical and temporal presence, of emotional as well as informational meaning, of the acute experience of spatial presence and absence, of harmony or dissent among human beings, as well as of the passage of time. While listening to this interplay of two voices, I suddenly think of one of Dolven's films, *vertical on my own* (2011), in which two long shadow lines mingle and separate on a snowy field.

But there are many other ways, in which this work brings together themes that A K Dolven has been developing for as long as she has kept her sketchbooks: the formal, material, perceptual and emotional effects of artistic expression that borders on the immaterial, the unseen. Here, 'soft' forms of expression are applied, such as bright and soft light, hazy whites, shadows, ambient sound, the sound of the human voice, movement, atmosphere, as well as the energies triggered by the interaction of humans with each other – be it in conversation, movement or, generally, in the manifestations of friendship.

where do I meet reality
A K Dolven, sketchbooks

In *Rhythmanalysis: Space, Time and Everyday Life*, the major study of his later years, Henri Lefebvre claims that all things become apparent through rhythm, that all representations are recognized by their curves, phases, periods and recurrences.[13] It is, indeed, through rhythmic moves, that Dolven draws her viewers and listeners into her work, as with the (unheard) Shostakovich score underlying the image editing of *amazon* (2006), the catching spin in *the day the sky became my ground* (2009), the breathing shadowline/s in *vertical on my own* (2011), or the slow opening and closing moves of the indistinct shapes in *when I discovered the end I wanted to live really long* (2013). In all these instances, it is the moving image that keeps time, both musically and existentially. In Dolven's art, time acts as both destroyer and preserver, and never does she flinch from depicting its admittedly disastrous effects on our lives, to which the works *tilts only (his shirts)* (2006), *3 february 2006 delhi* (2006), *when I leave the world behind* (2006) and many more bear witness.

But as I see it, A K Dolven seems to have found an antidote to the destructive side of time: in their generic semblance to diaries, I read the sketchbooks as an effective storage space; just as, by merging the practical, the philosophical, and the artistic, those marks on paper manage to turn time into something solid. While thinking about their specific genre, it also strikes me that those A5 objects might serve as logbooks that keep trace of Dolven's artistic journey, while at the same time pointing to the lineage of her seafaring grandfather. He was a storytelling man, a man who introduced his granddaughter to the miracles of human imagination. He also was the man who built the leather chair on which I sit while marvelling at A K Dolven's sketchbooks.

London, January 2015

1

Michel de Certeau, *The Practice of Everyday Life* (Berkeley, Calif.: University of California Press, 1988), p. 86.

2

Liesl Olson, *Modernism and the Ordinary* (Oxford: Oxford University Press, 2009), p. 5.

3

Michel de Certeau, *The Practice of Everyday Life*, p. 86.

4

Ibid., p. 43.

5

Ibid., p. 73.

6

See André Leroi Gourhan, 'Hand und Denken', in Christoph Wulf and Dieter Kamper (eds), *Logik und Leiden-schaft: Erträge Historischer Anthropologie* (Berlin: Reimer Verlag, 2002), p. 122; Gunter Gebauer, 'Hand und Gewißheit', ibid., p. 127.

7

See Peter Handke, *History of the Pencil*, quoted in Carsten Rohde, *Träumen und Gehen: Handkes geopoetische Prosa seit 'Langsame Heimkehr'* (Hannover: Wehrhahn, 2007), p. 13 (trans. Uta Kornmeier), italics mine.

8

See Paul Klee, *Pädagogisches Skizzenbuch* (Dessau: Bauhaus-Bücher, 1925), translation mine.

9

In Agnes Martin, *Writings: Schriften*, ed. Dieter Schwarz (Ostfildern-Ruit: Hatje Cantz, 1991), p. 114.

10

Compare William Hogarth, *The Analysis of Beauty Written With a View of Fixing the Fluctuating Ideas of Taste* (London: J. Reeves, 1753).

11

Saskia Sassen in conversation with Richard Sennett and others at the Akademie der Künste Berlin, 25 May 2013; Saskia Sassen, *Making Public Interventions In Today's Massive Cities*, London Consortium, 2006 http://static.londonconsortium.com/issue04/sassen_publicinterventions.html.

12

Mladen Dollar, 'The Vocal Stone', in Maren Butte and Sabina Brandt (eds) *Bild und Stimme* (Munich: Wilhelm Fink, 2011), p. 33.

13

Henri Lefebvre, *Rhythmanalysis: Space, Time and Everyday Life* (London and New York: Bloomsbury, 2004), p. 22.

looking for balance

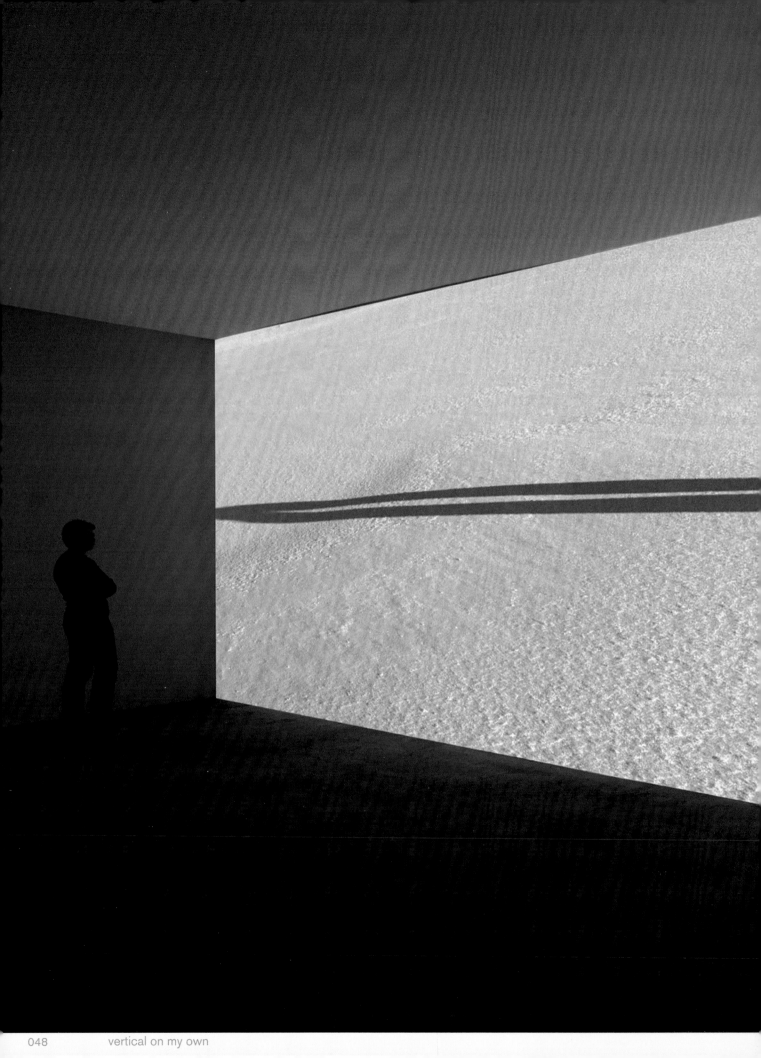

vertical on my own

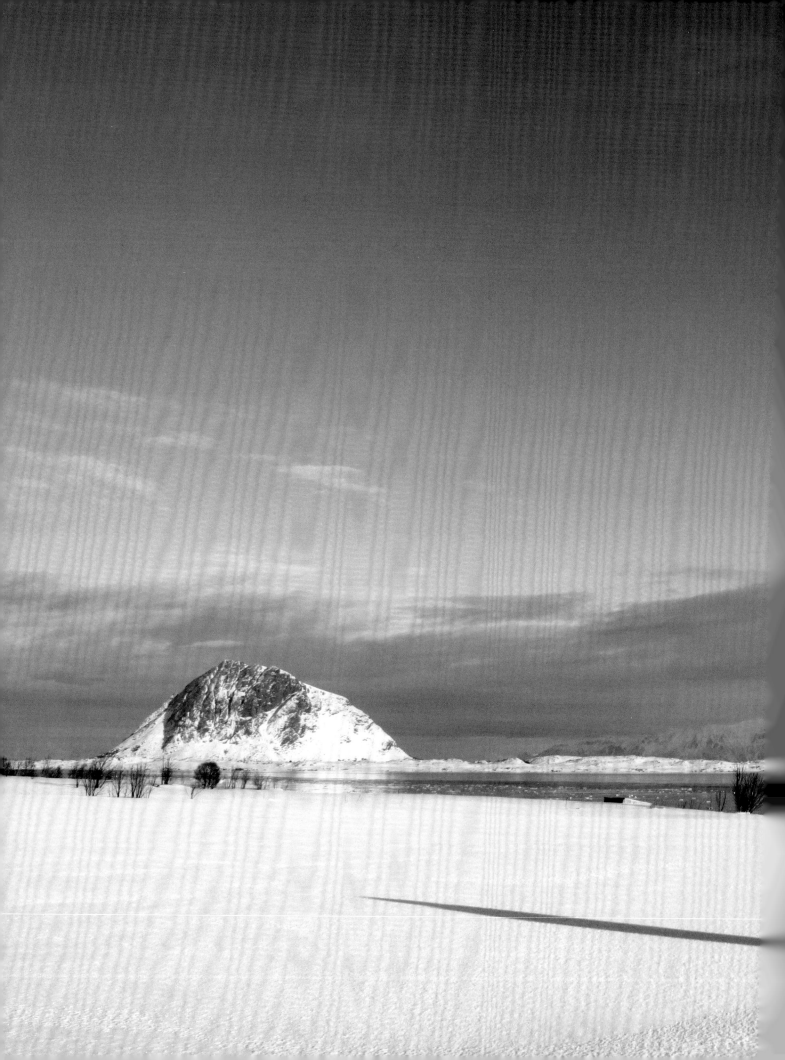

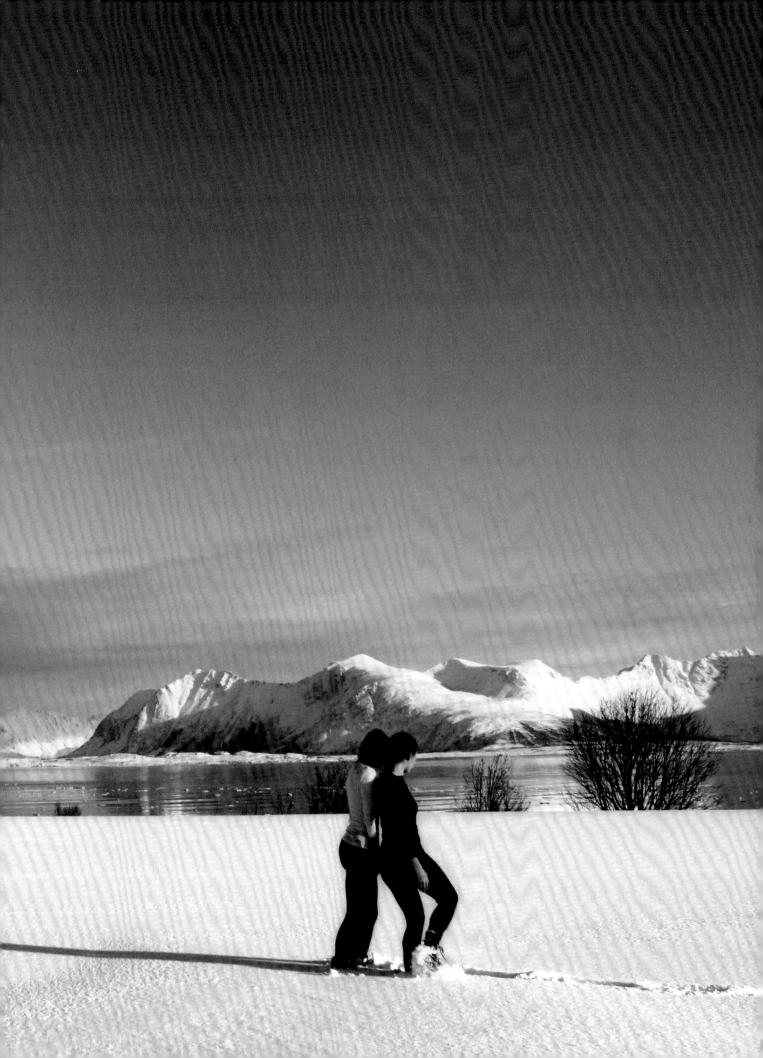

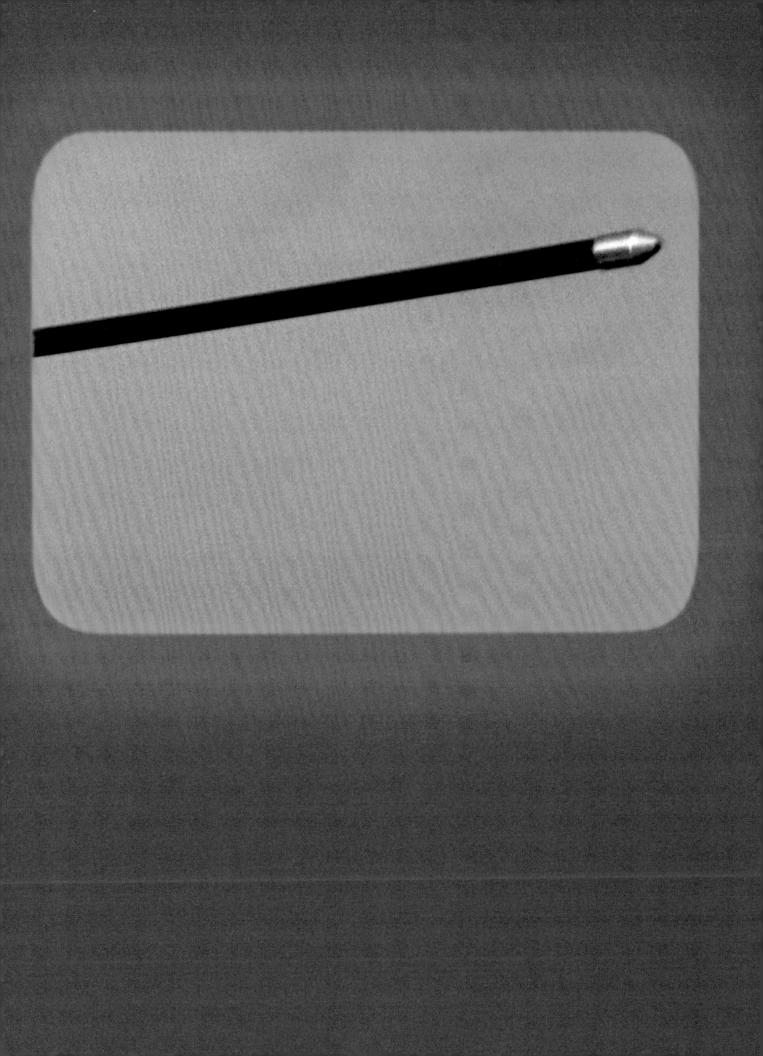

ШОСТАКОВИЧ
SHOSTAKOVICH

КВАРТЕТ № 8
ДЛЯ ДВУХ СКРИПОК,
АЛЬТА И ВИОЛОНЧЕЛИ

Партитура

QUARTET No 8
FOR TWO VIOLINS,
VIOLA AND VIOLONCELLO

Score

Памяти жертв фашизма и войны

In Memory of the Victims of Fascism and the War

КВАРТЕТ № 8

QUARTET No 8

Д. ШОСТАКОВИЧ. Соч. 110

Dmitri SHOSTAKOVICH. Op. 110

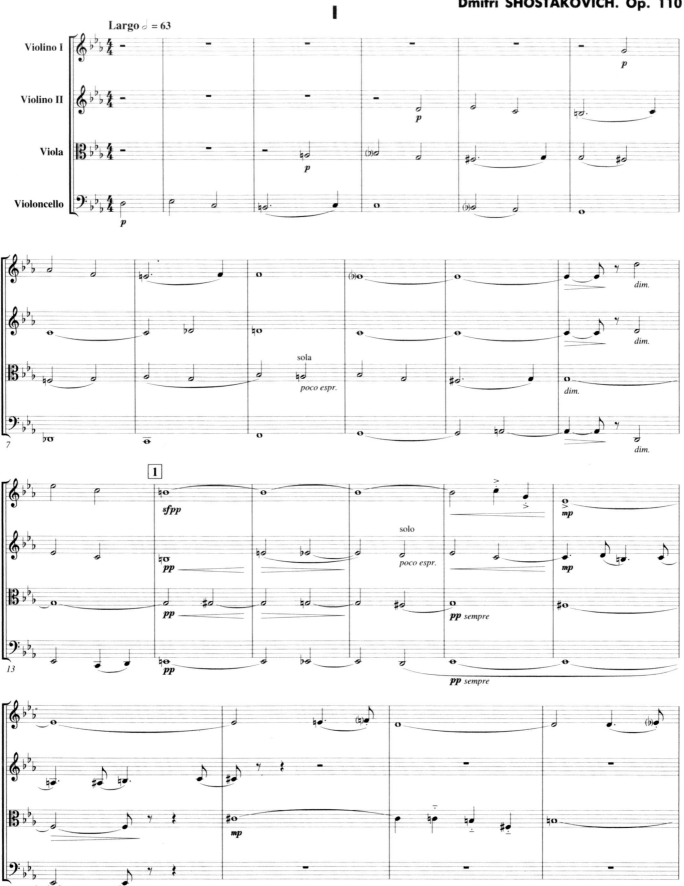

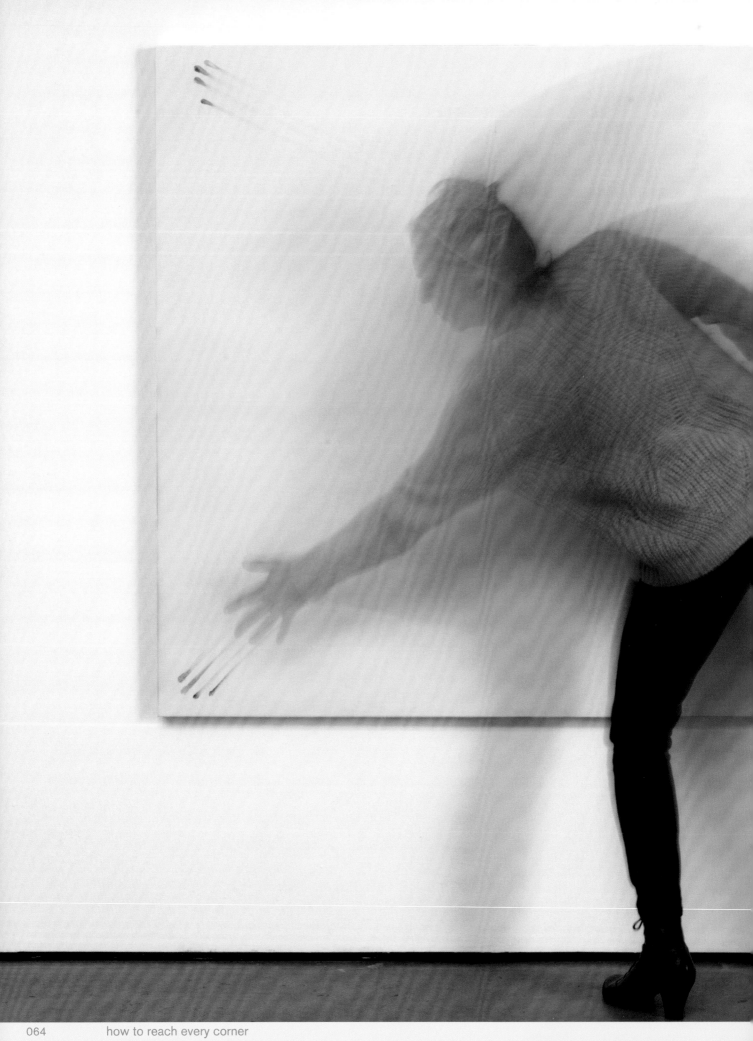

how to reach every corner

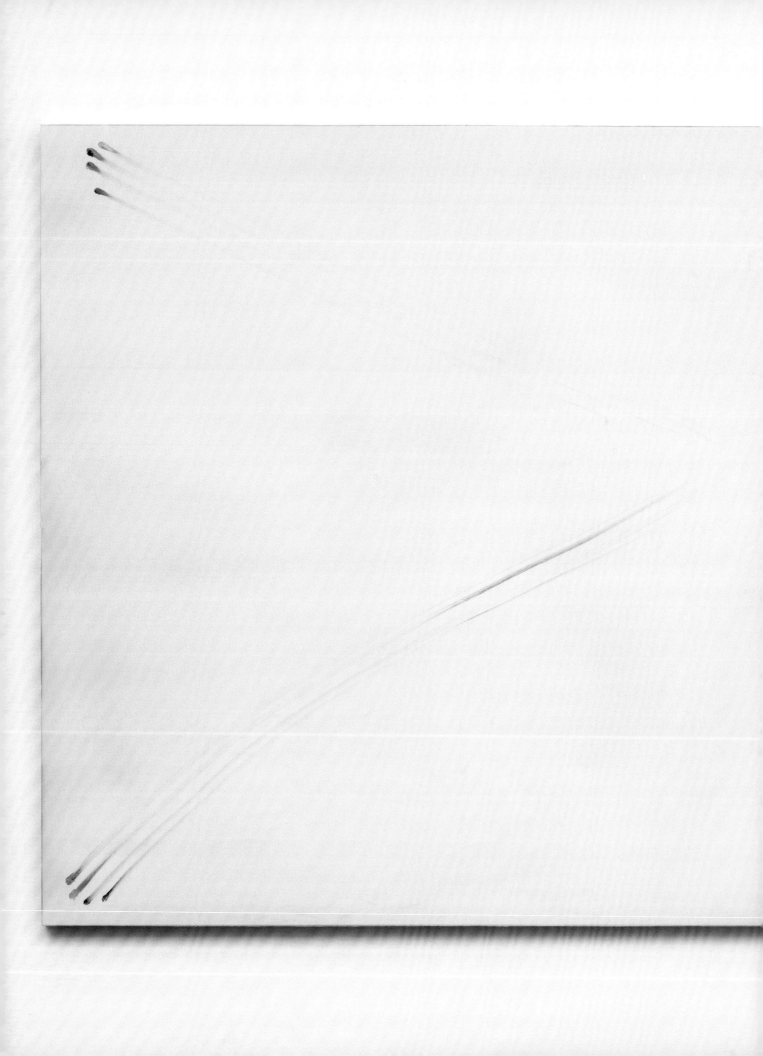

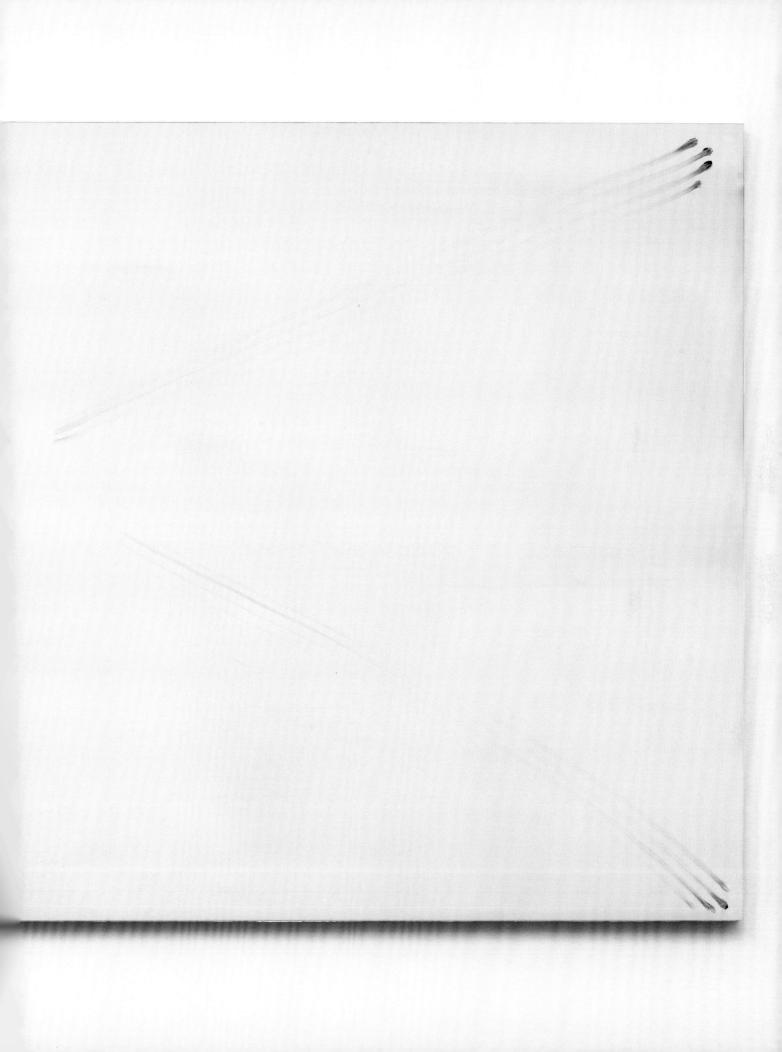

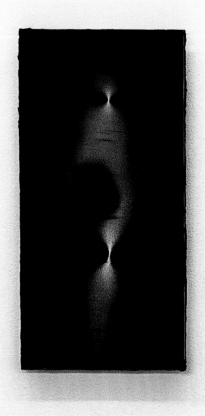

seeing

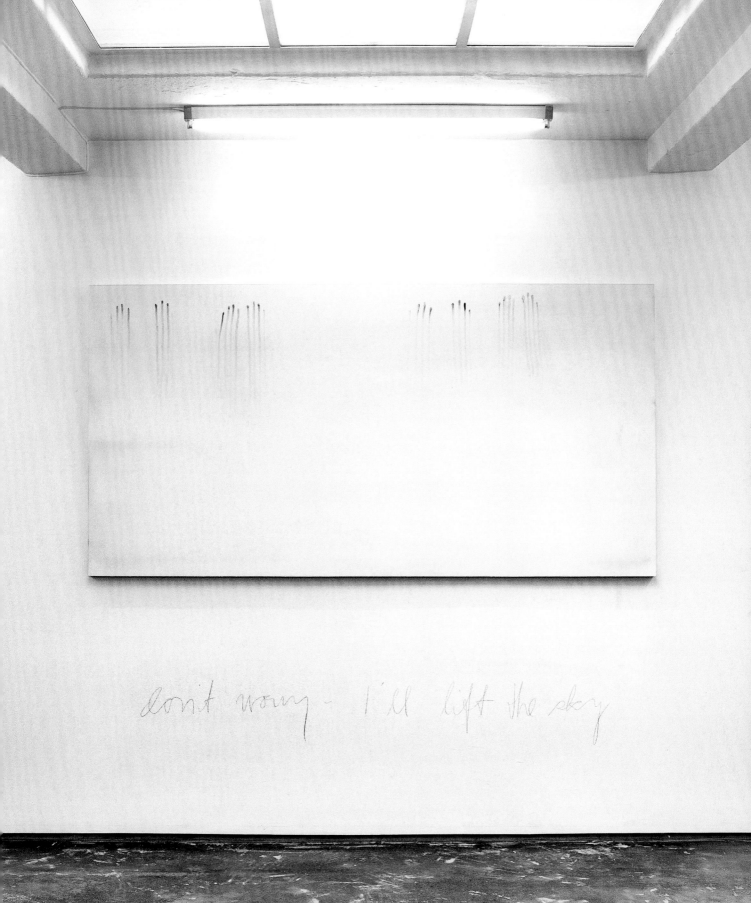

don't worry I'll lift the sky

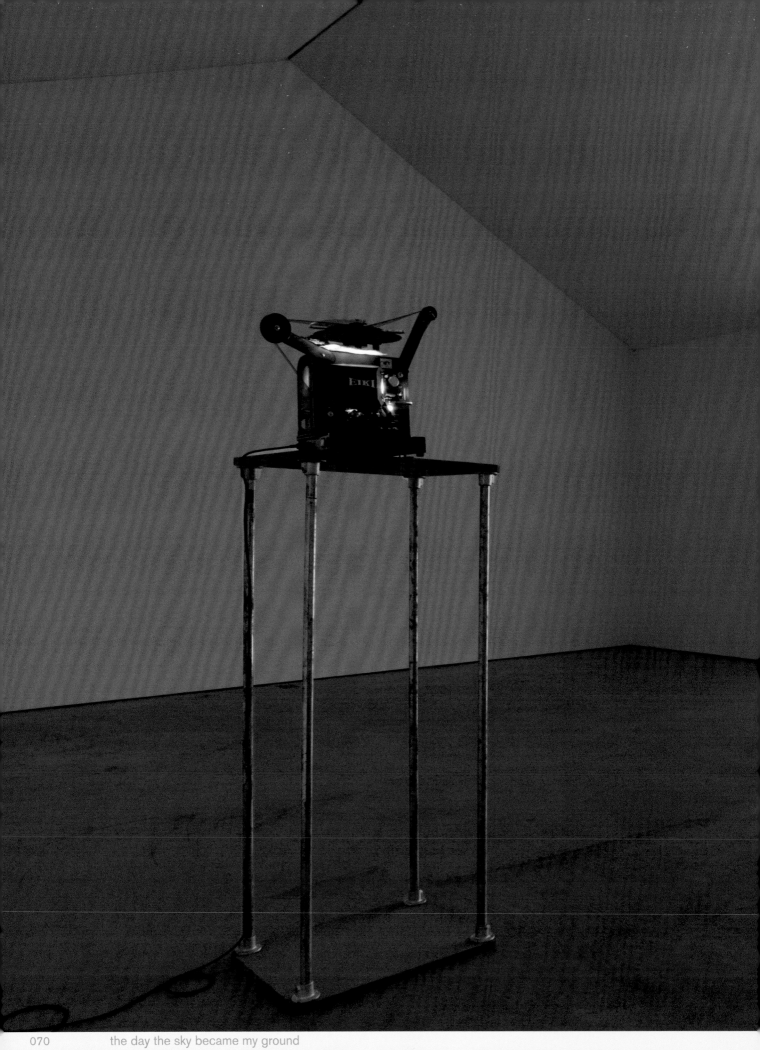

the day the sky became my ground

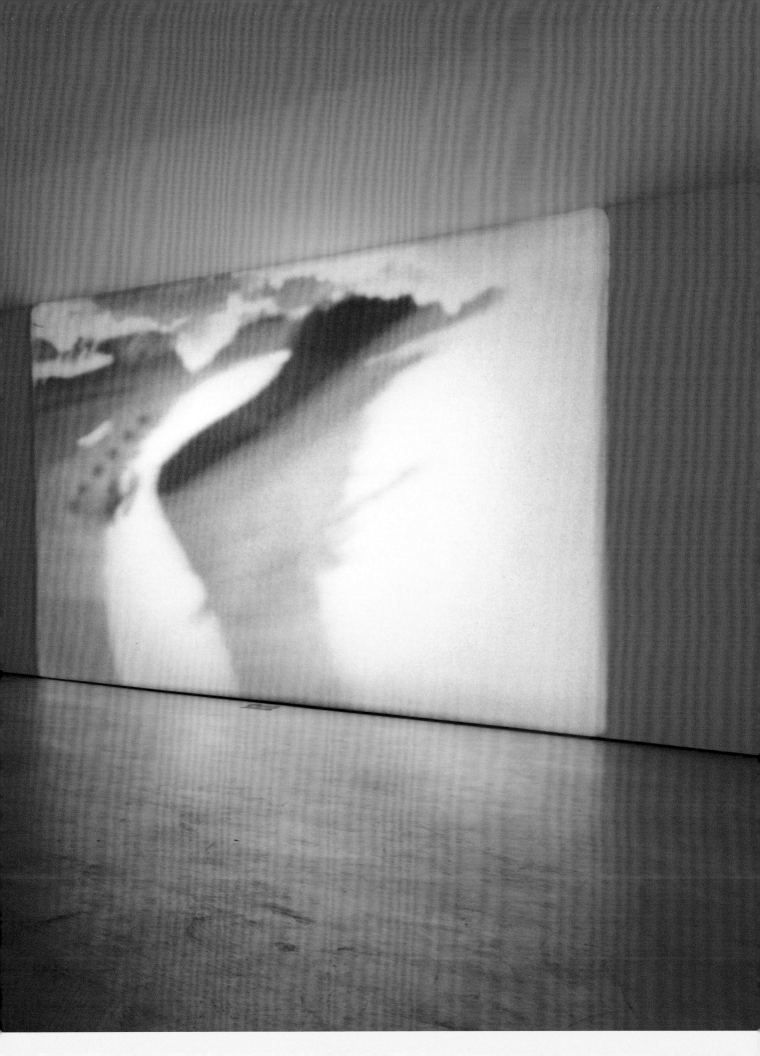

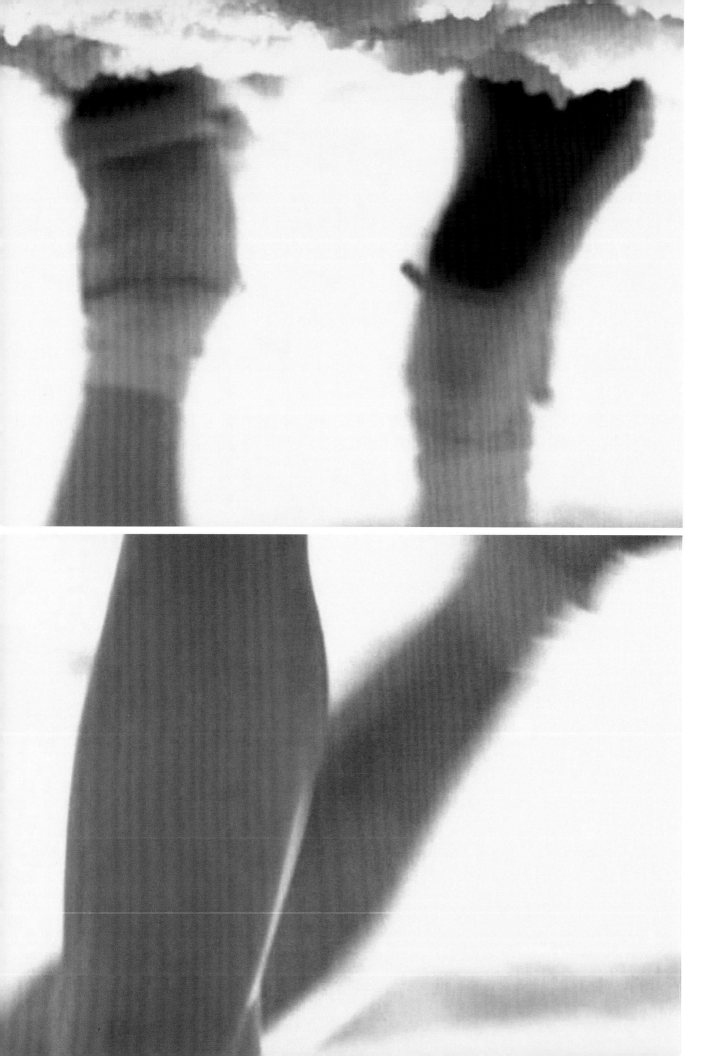

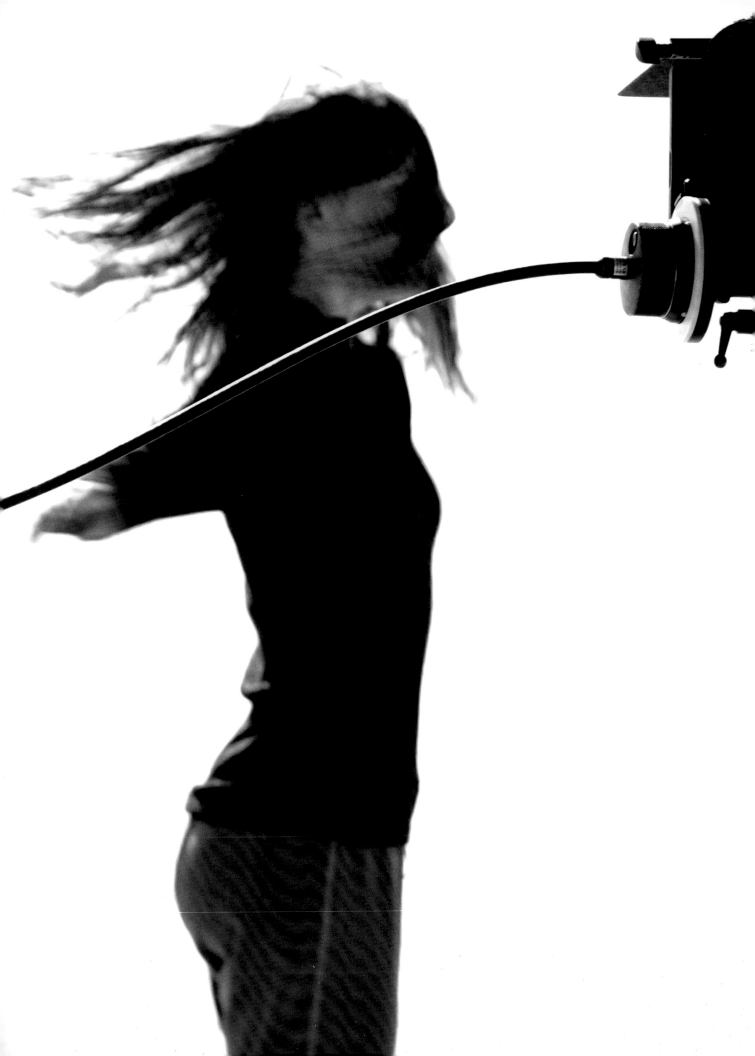

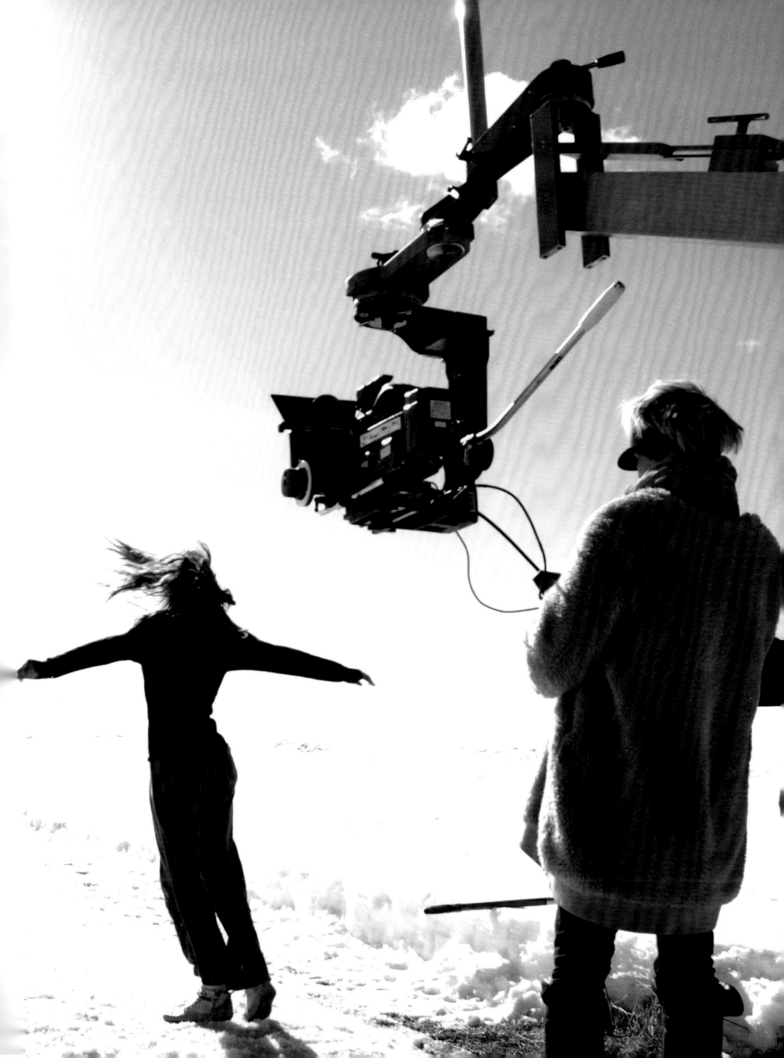

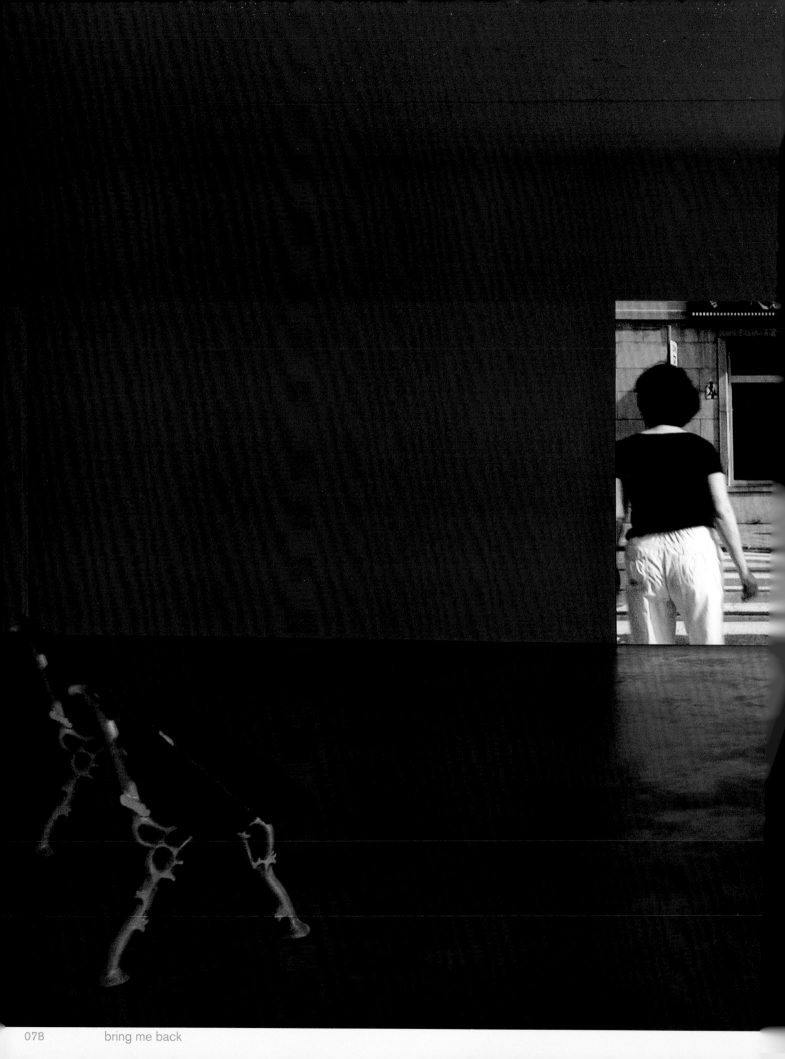

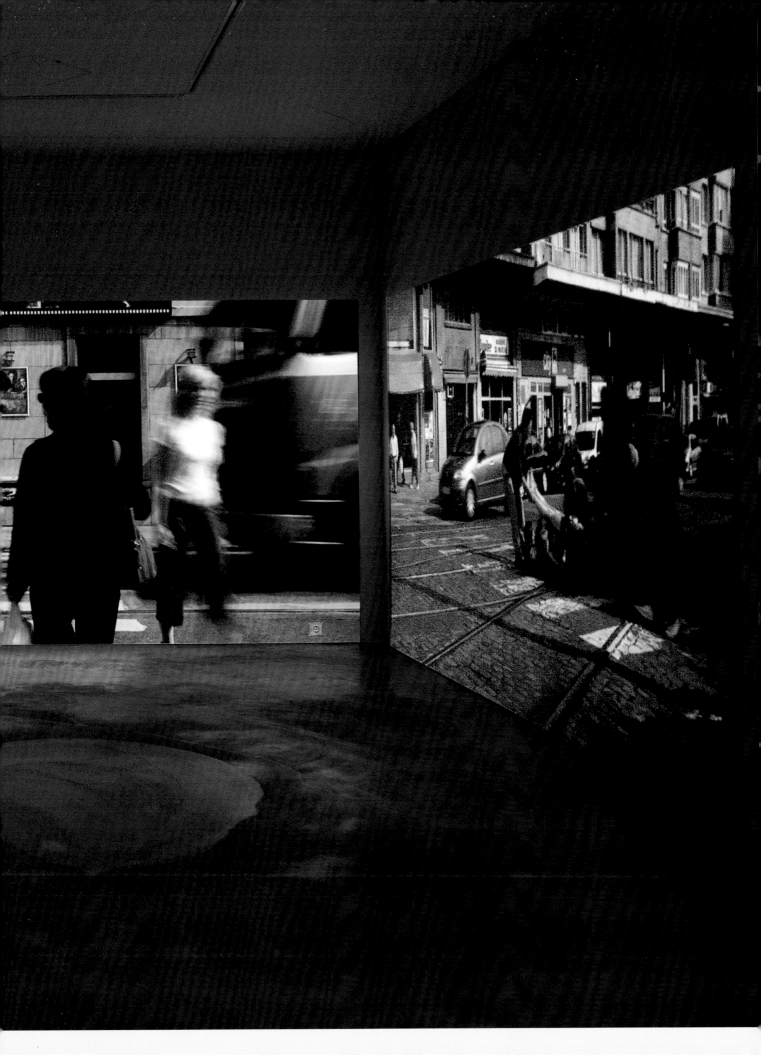

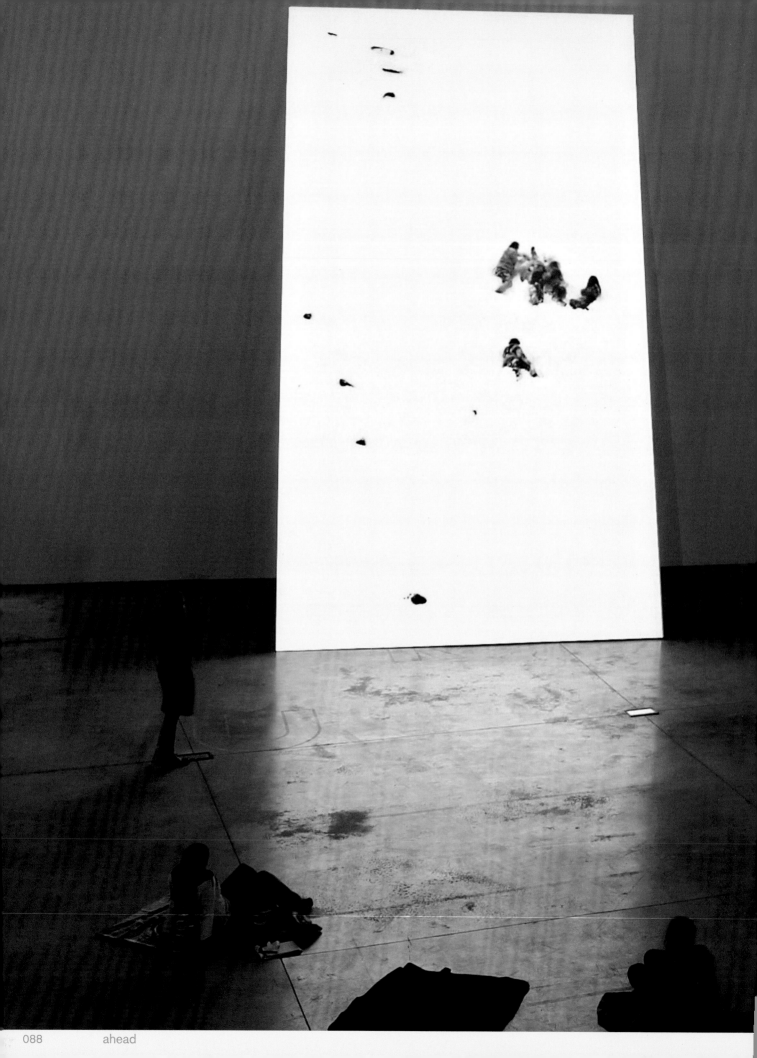

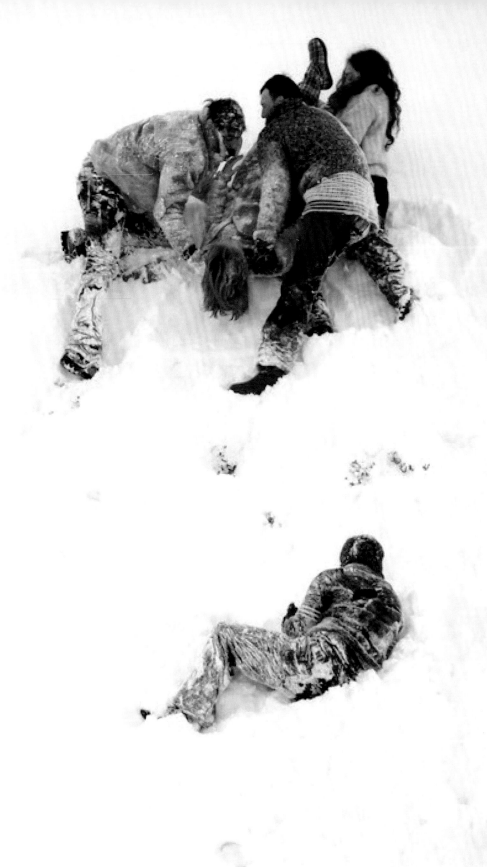

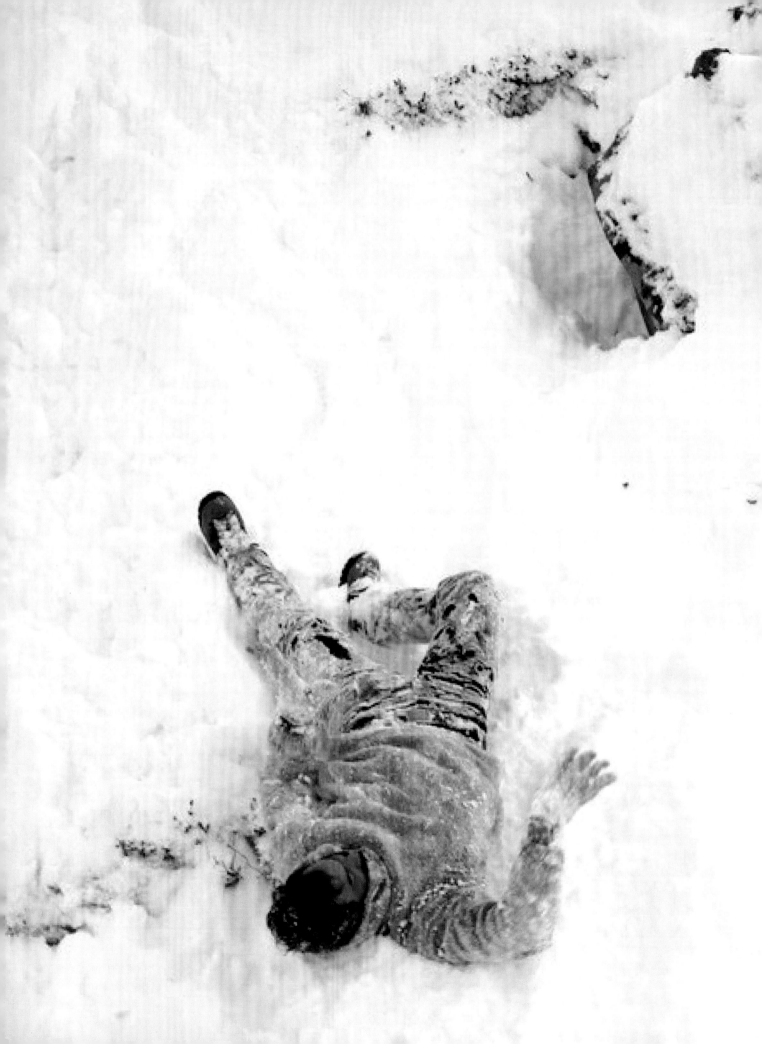

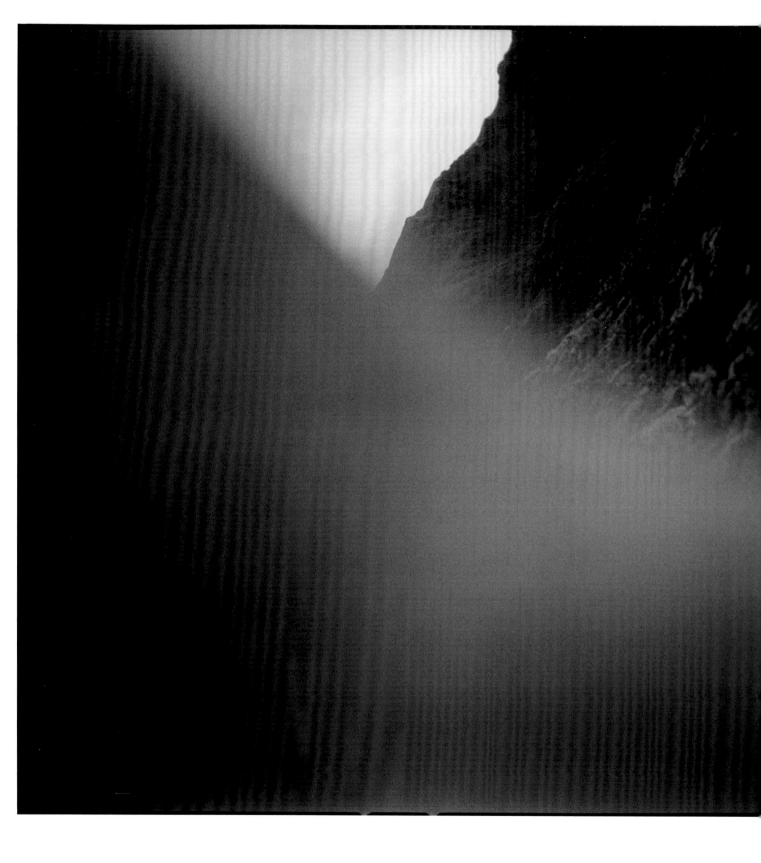

out of balance

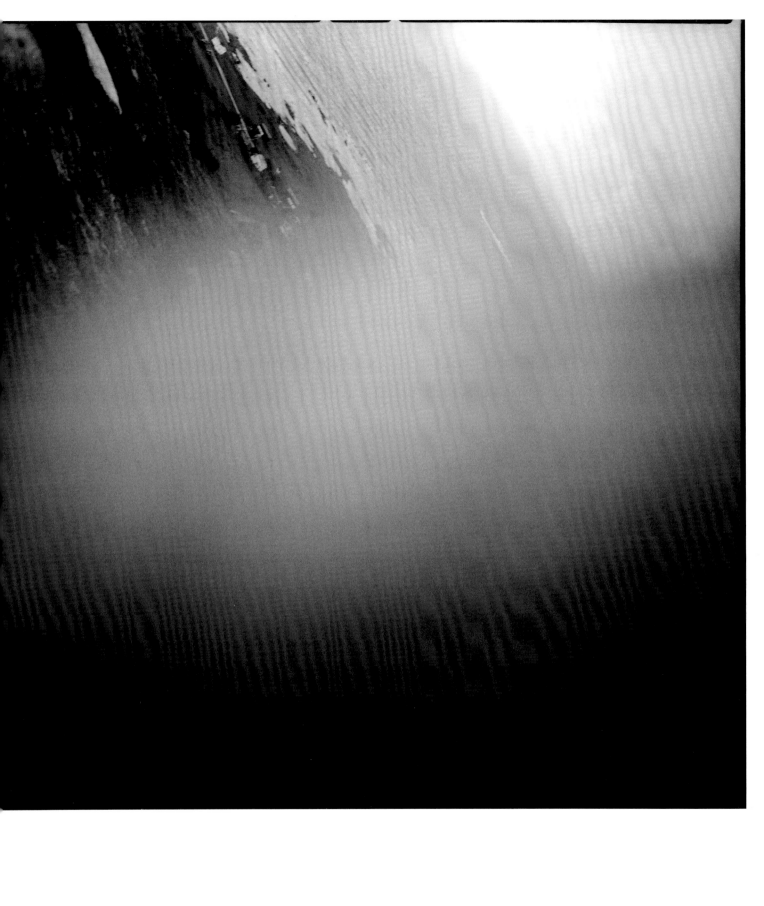

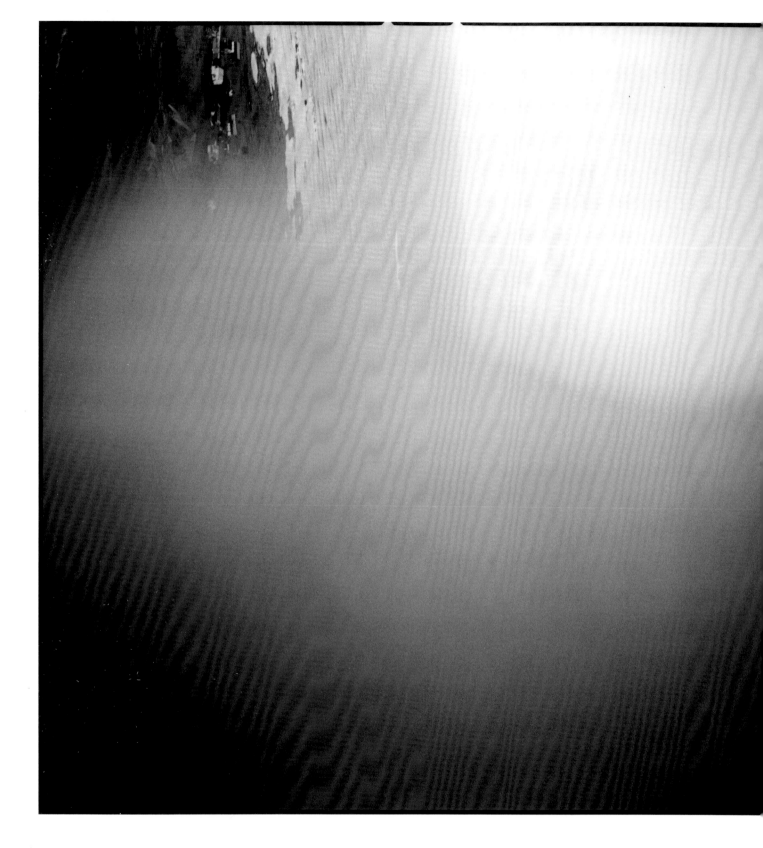

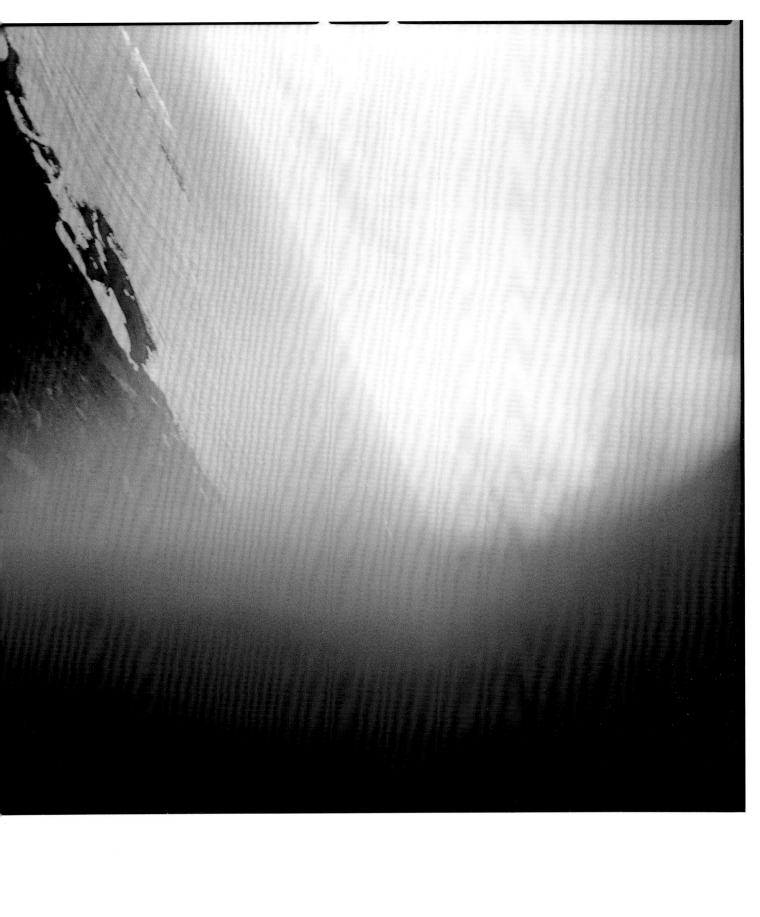

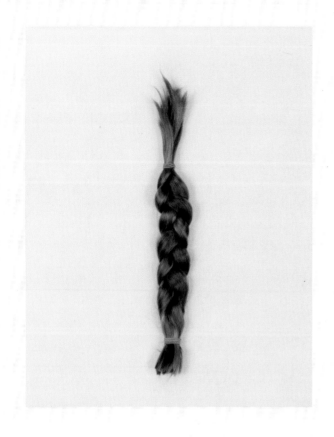

portrait of the artist as a young woman

seeing
is
about
thinking

A4 black, seeing with eyes closed II, seeing with eyes closed I

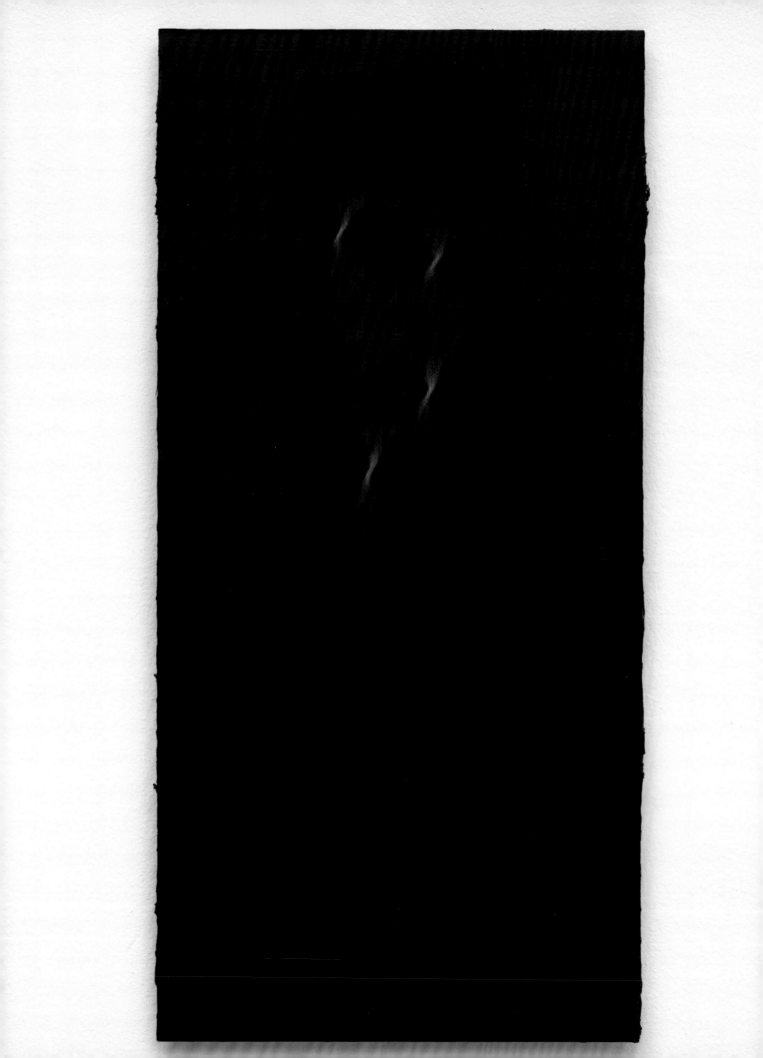

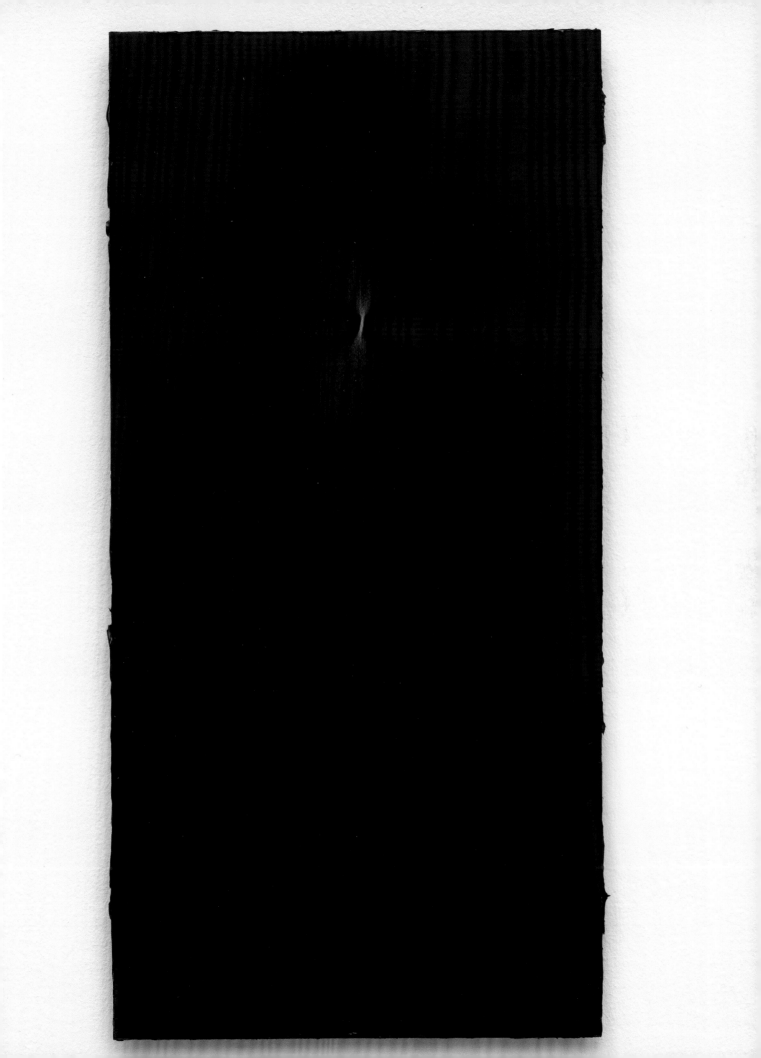

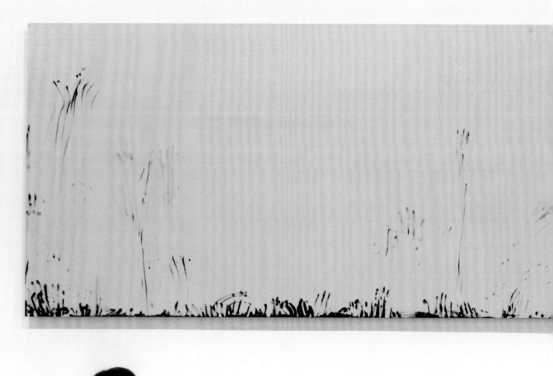

teenagers lifting the sky

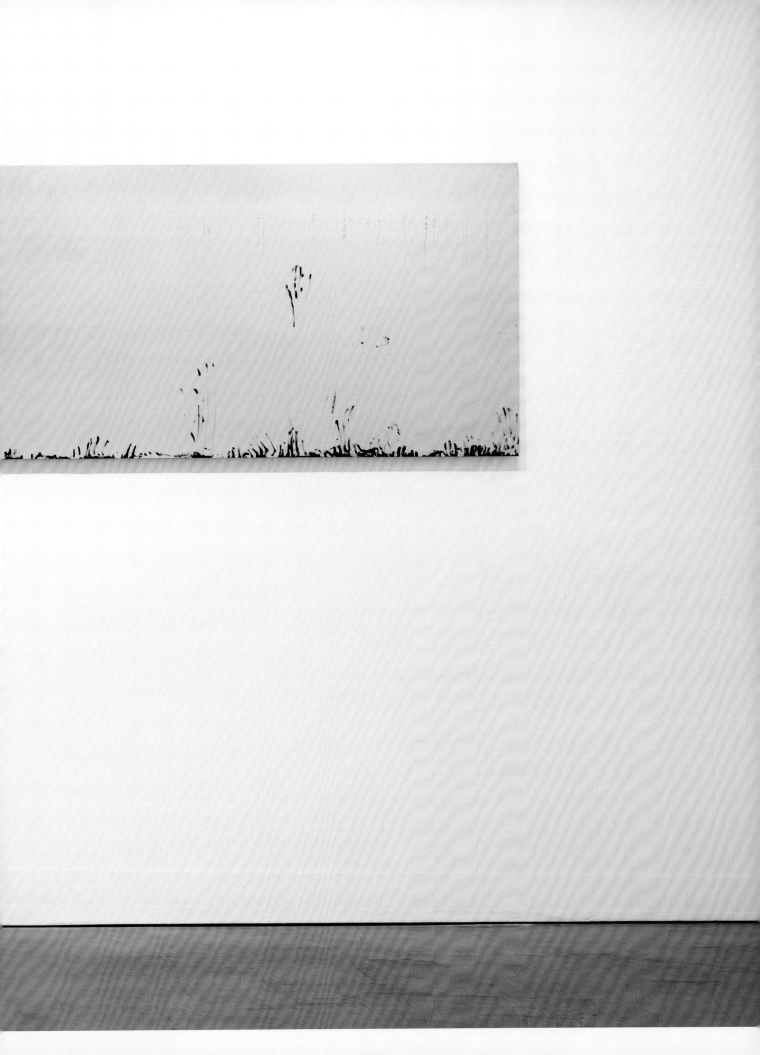

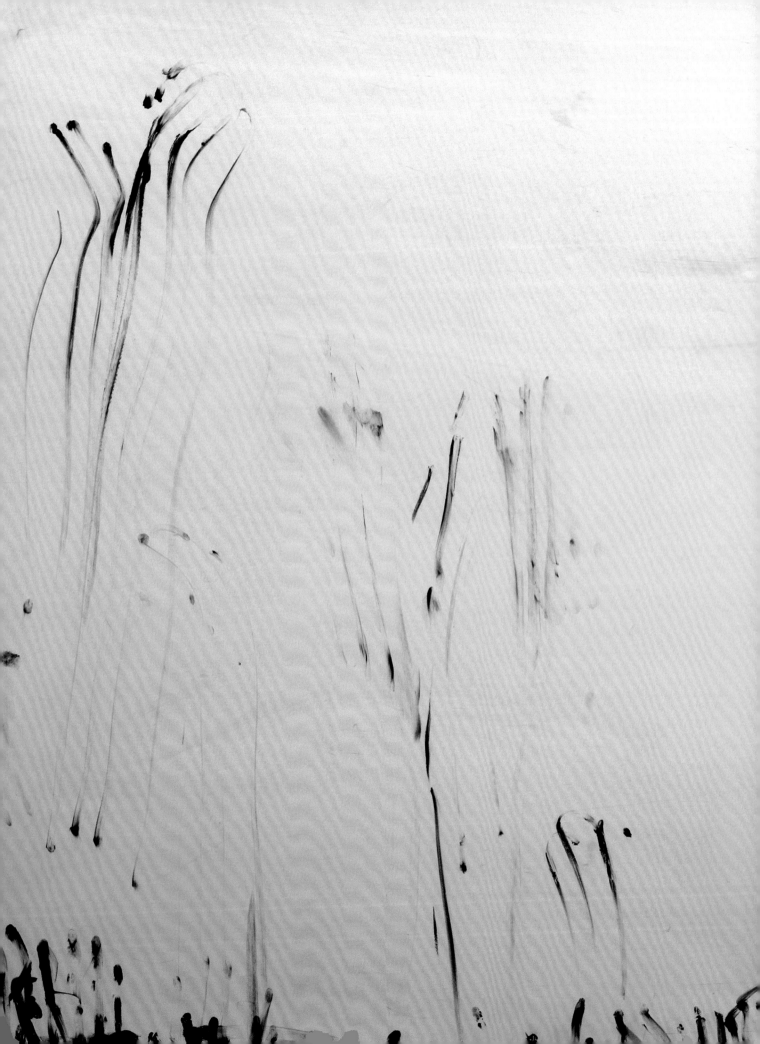

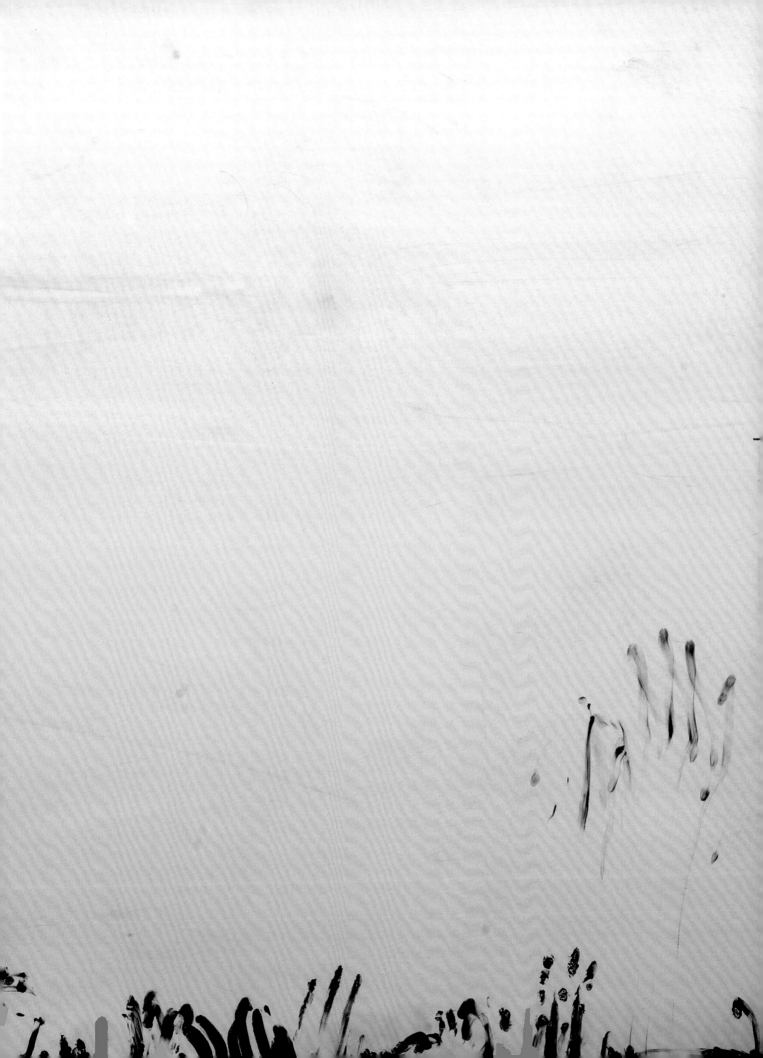

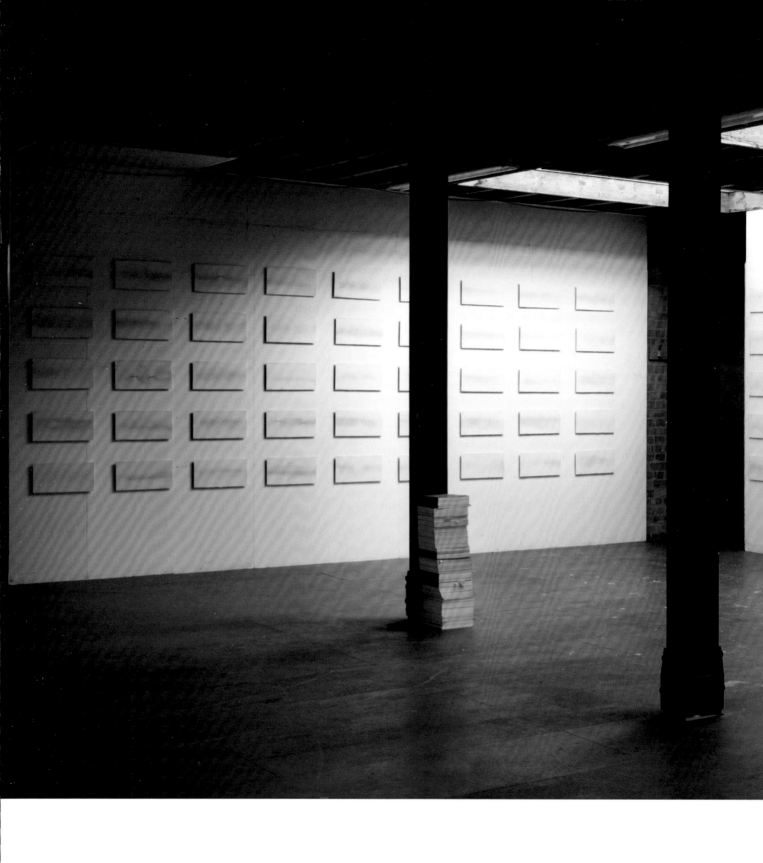

change my way of seeing seeing is about thinking

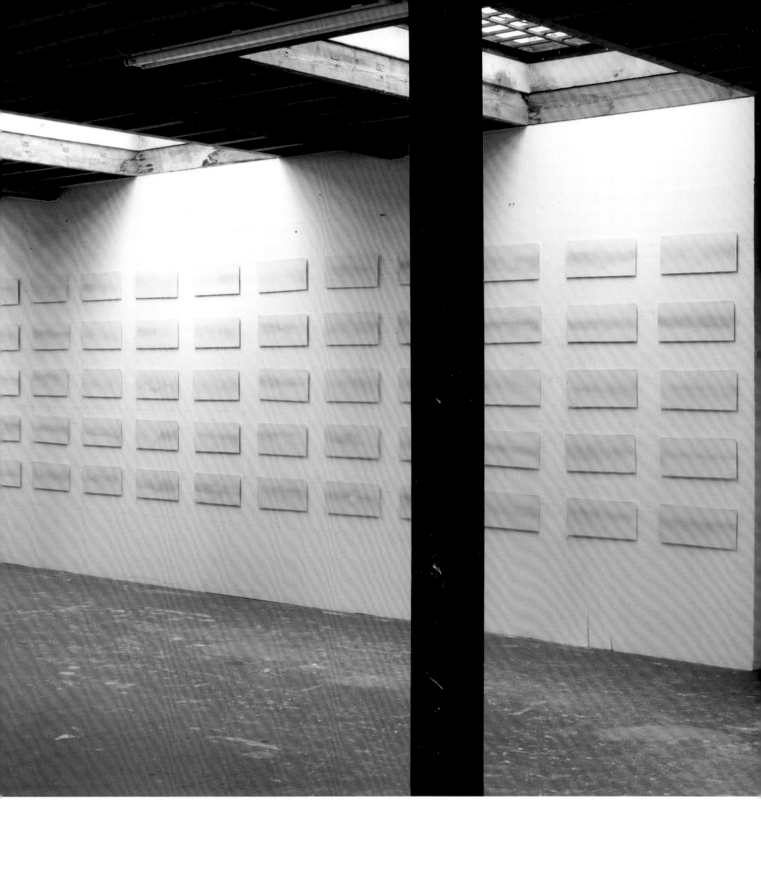

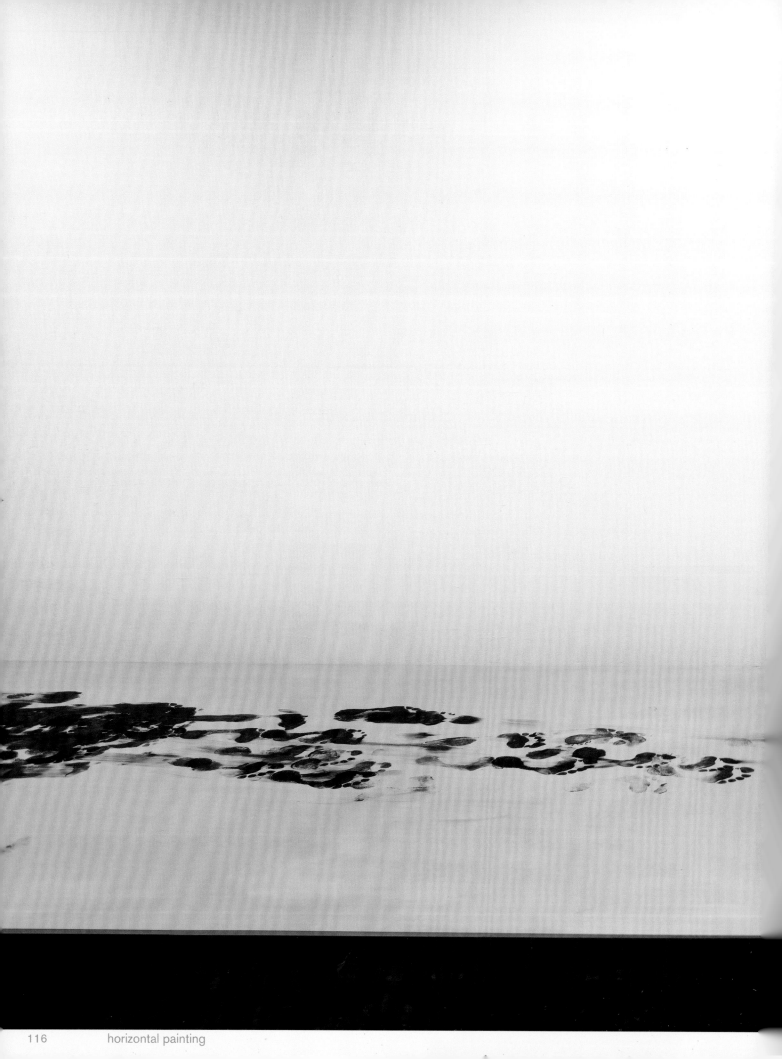

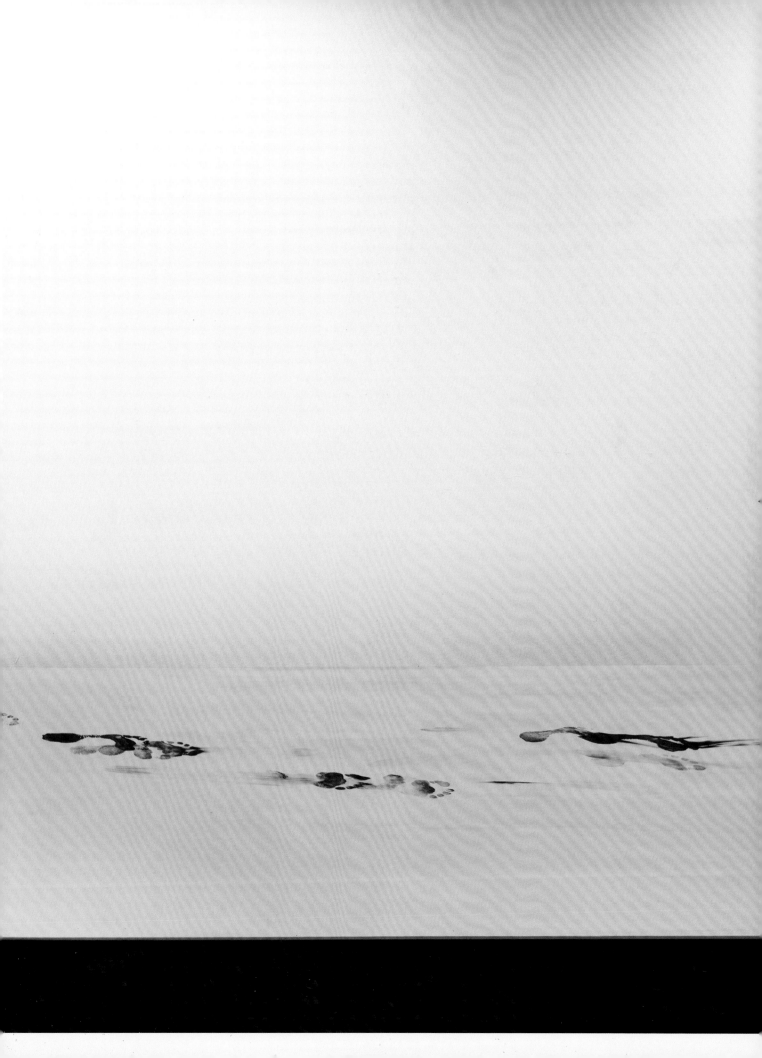

discover
ing
the end

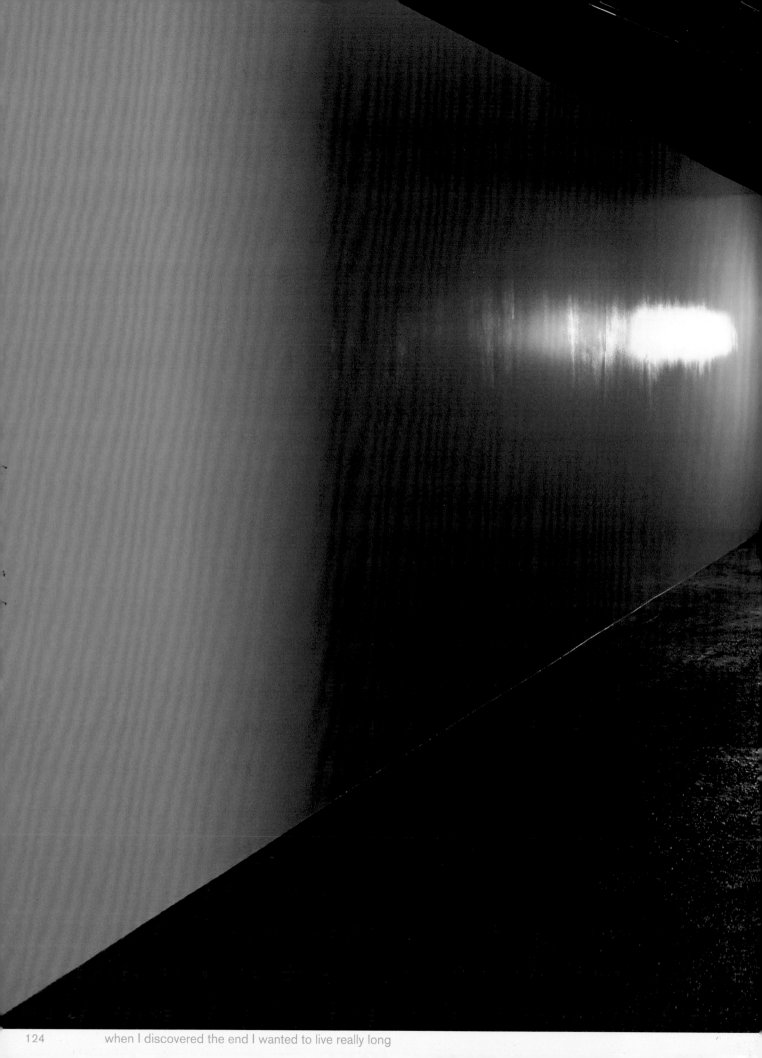

when I discovered the end I wanted to live really long

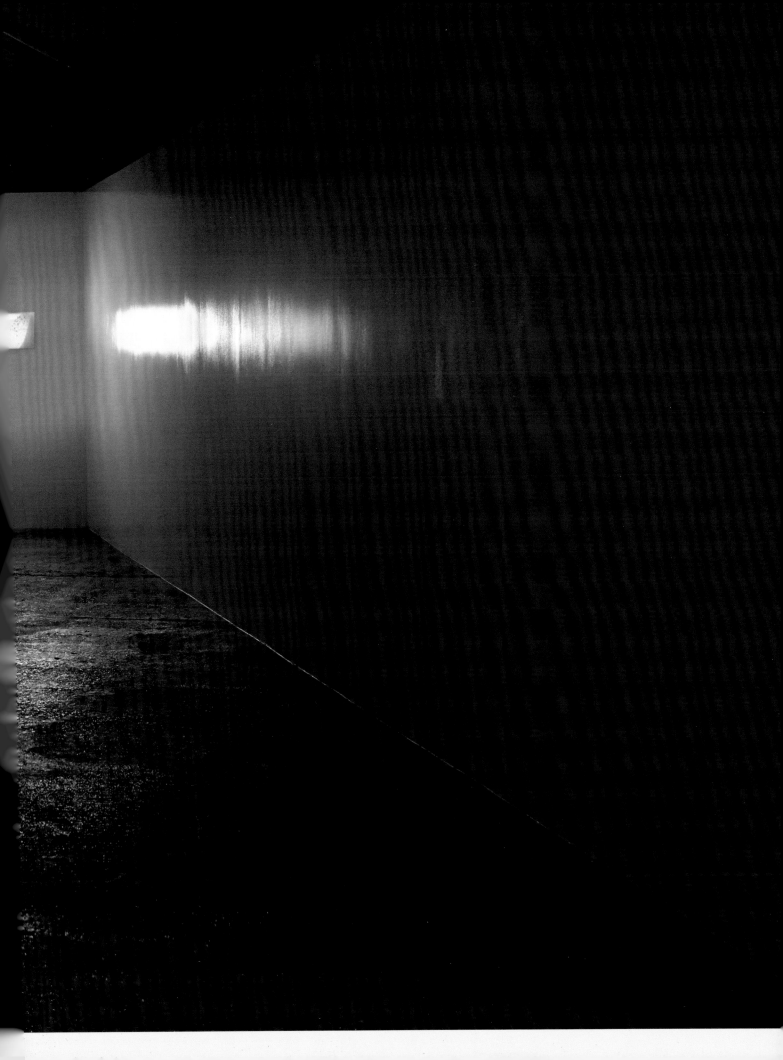

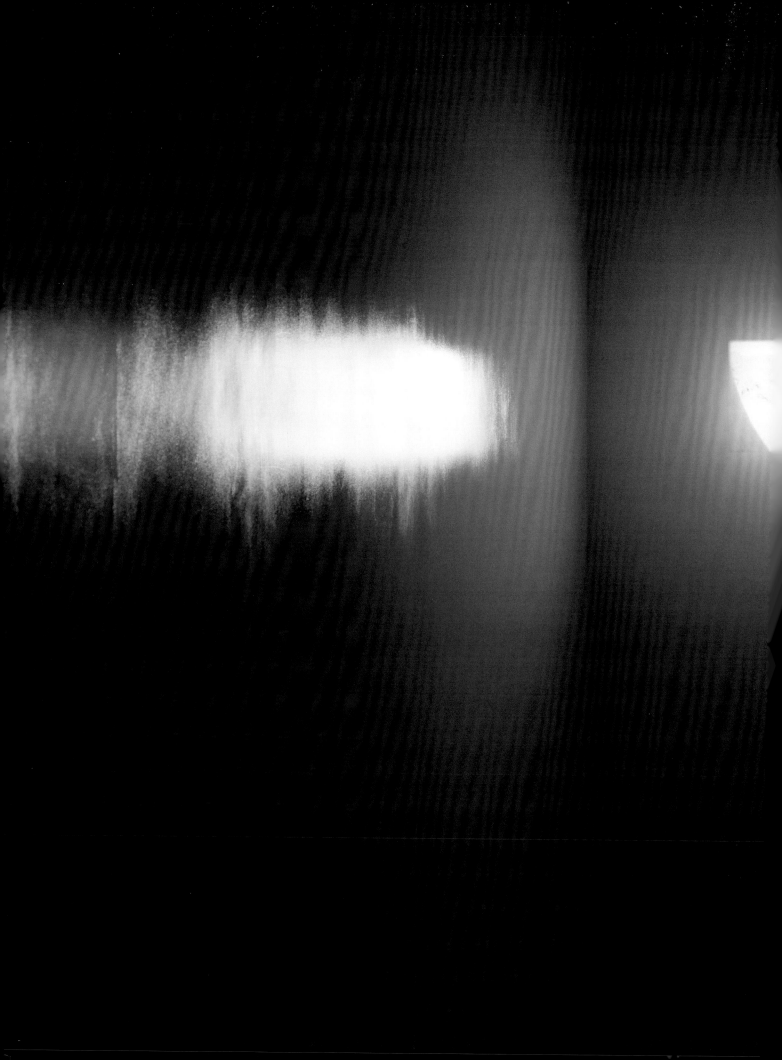

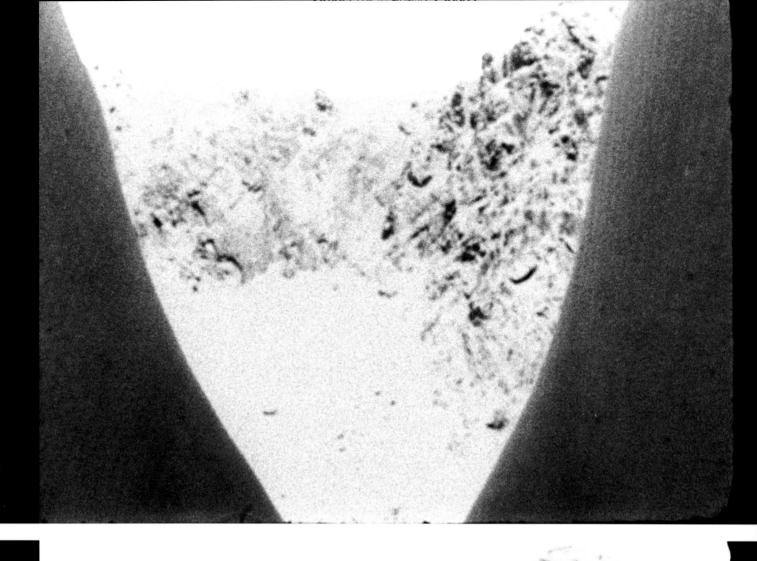

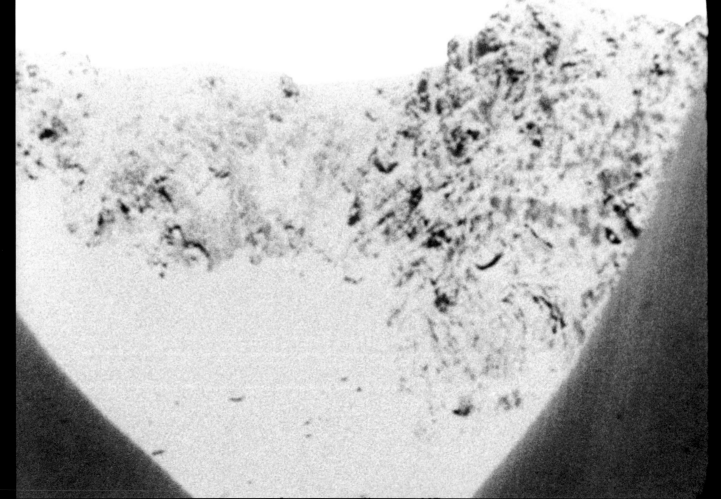

I want to live really long

I would live really lo

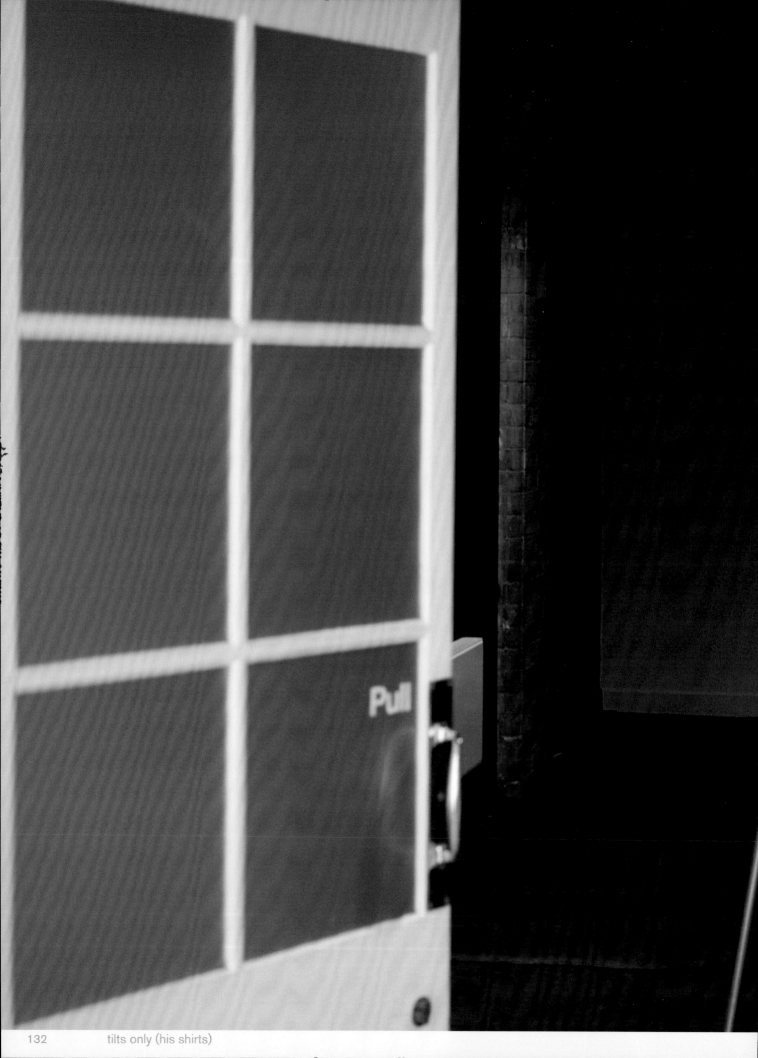

tilts only (his shirts)

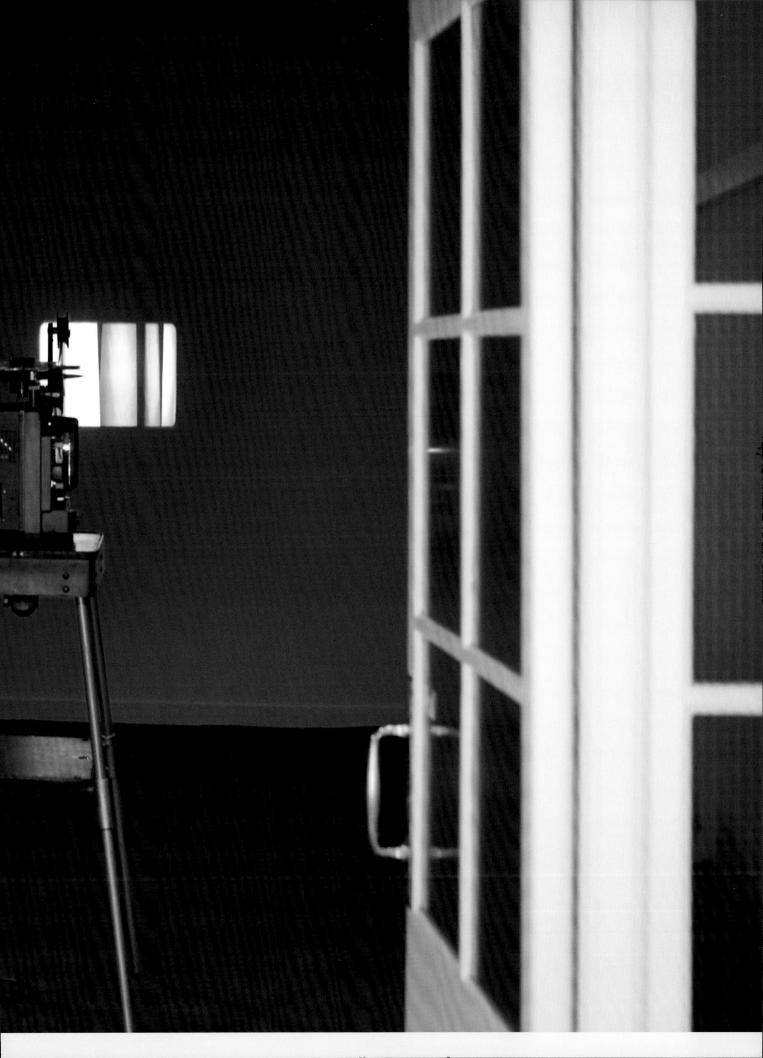

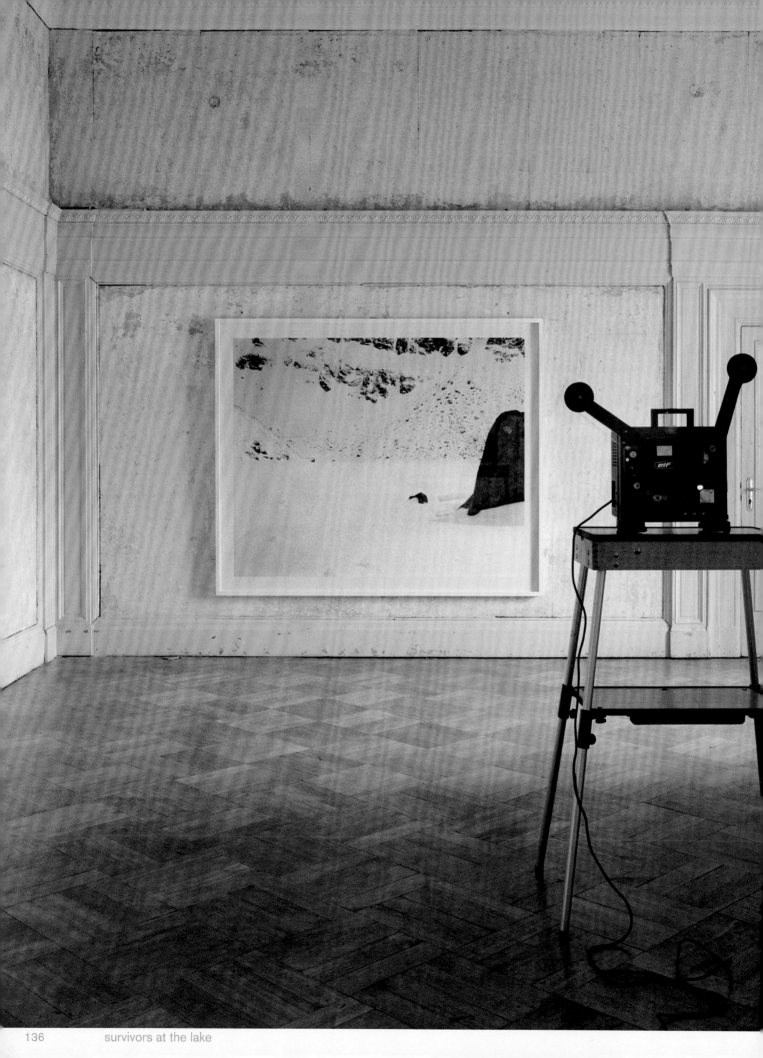

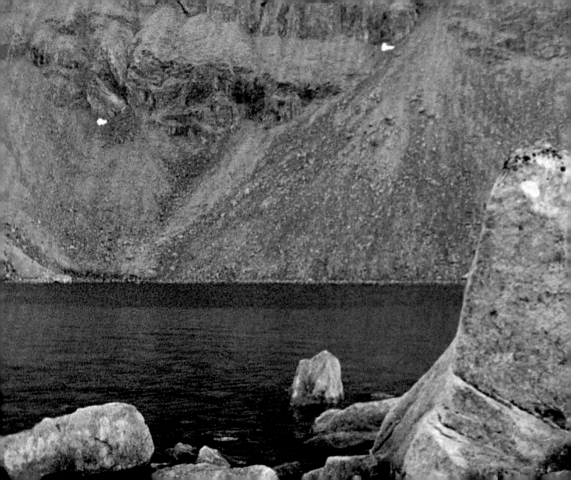

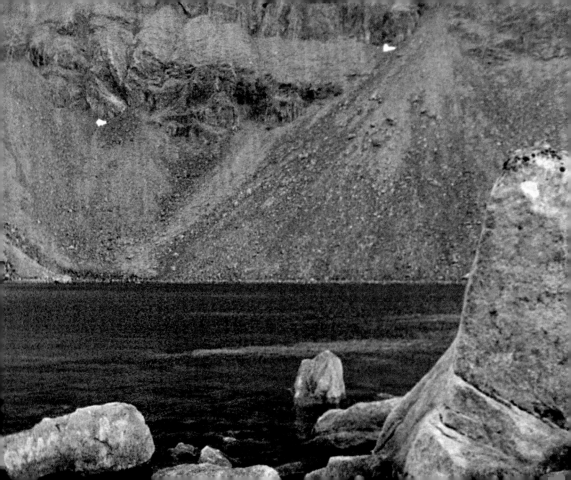

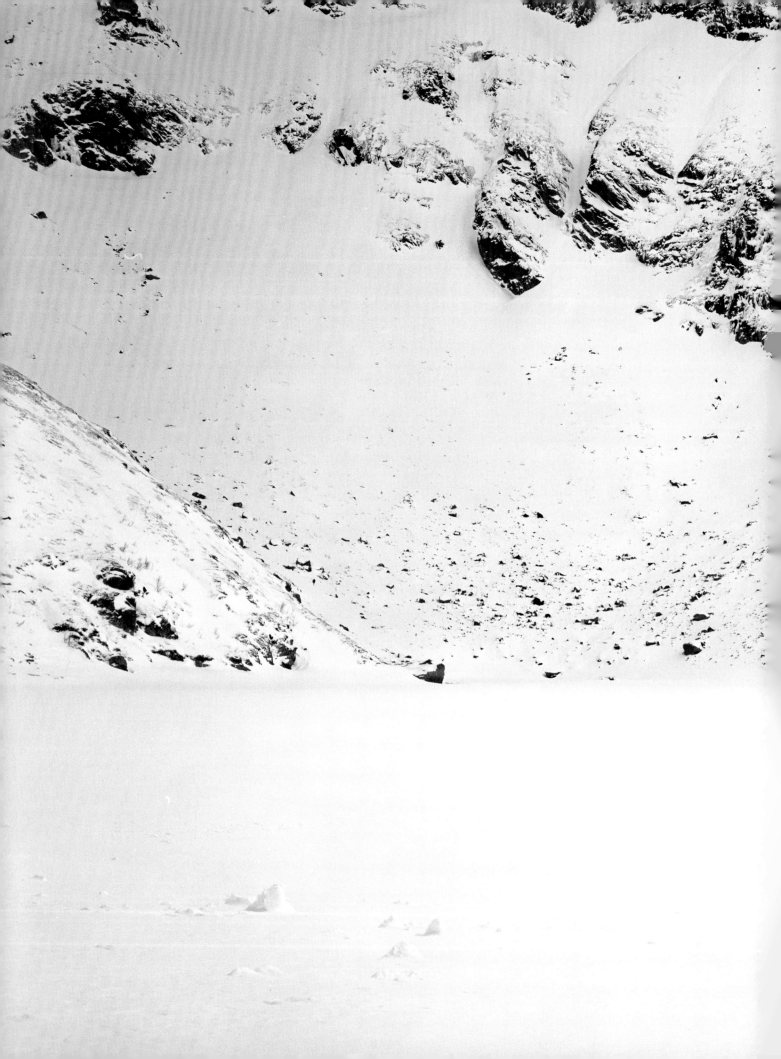

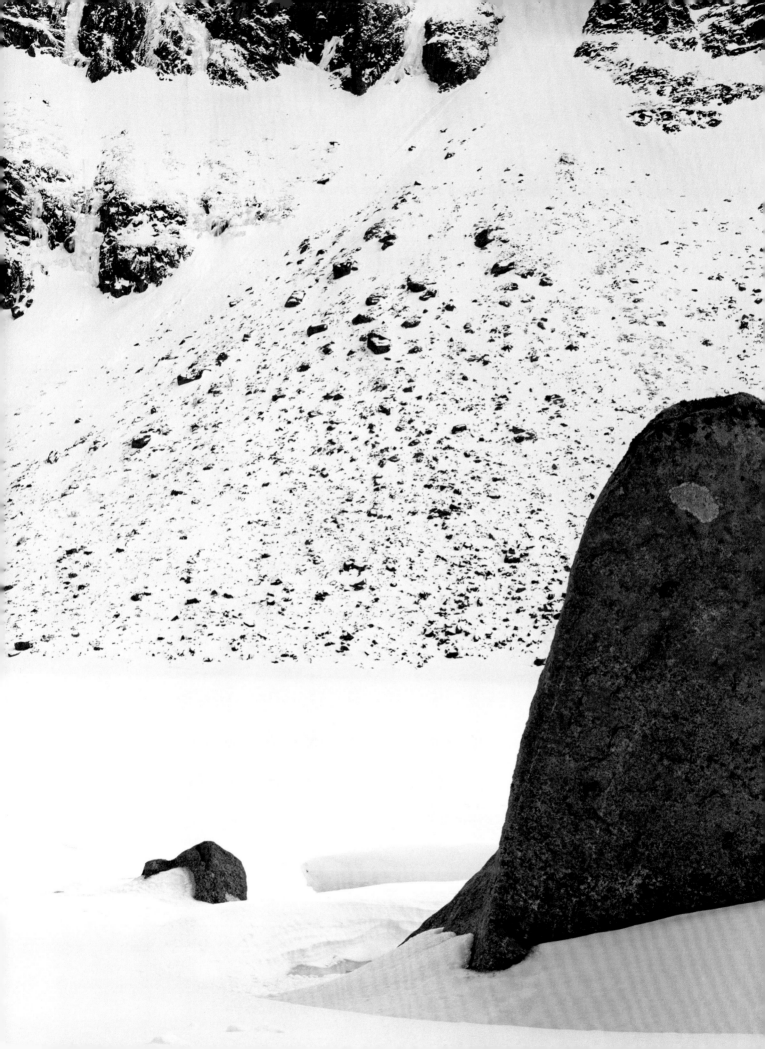

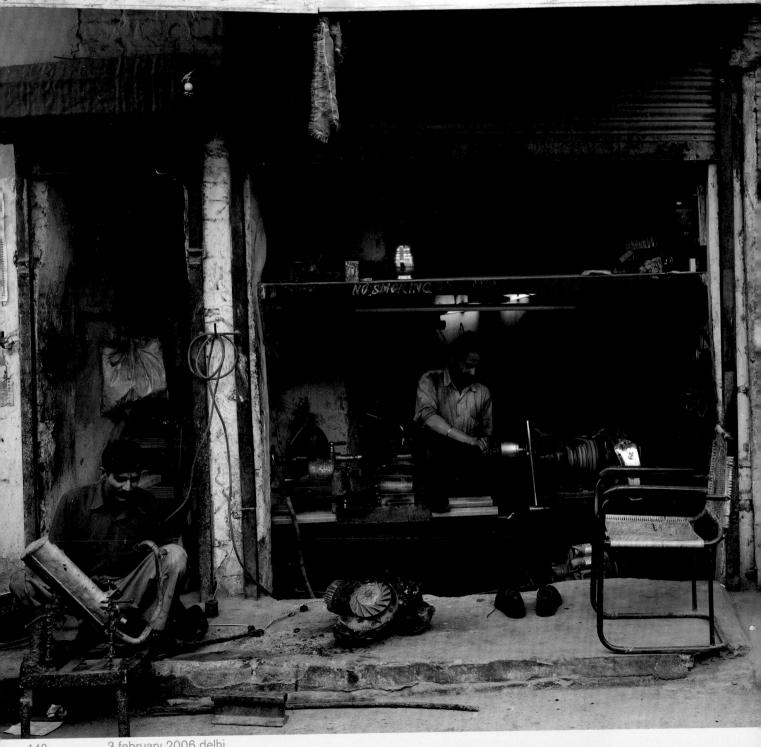

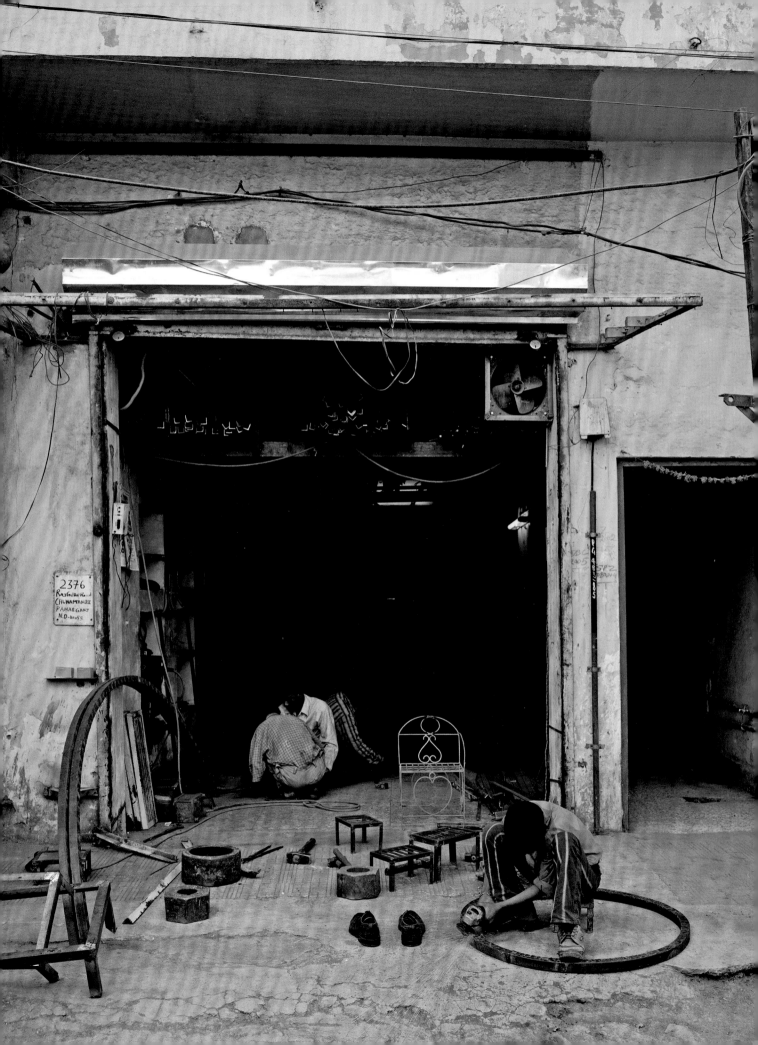

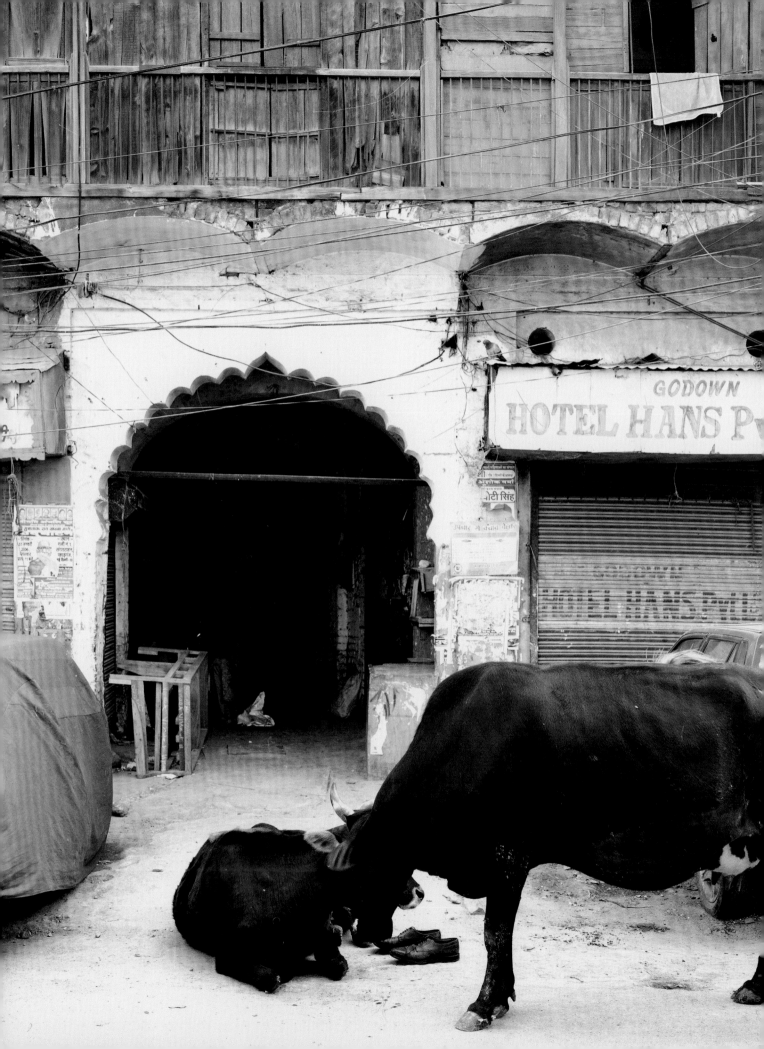

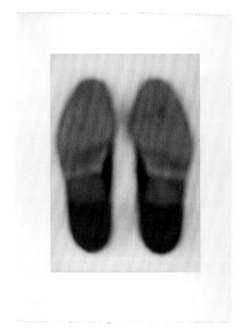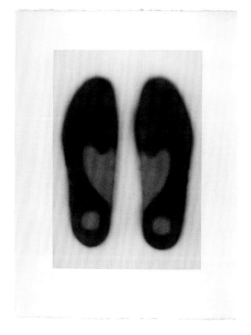

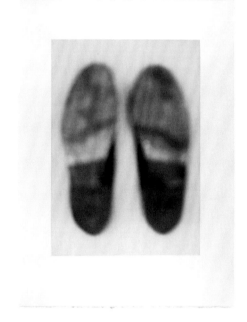

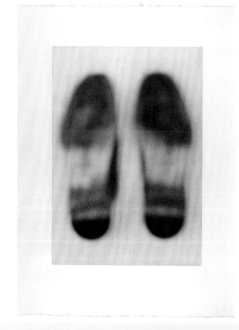

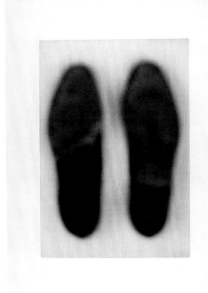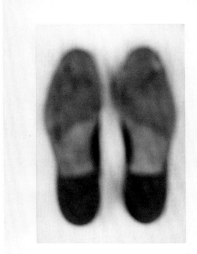

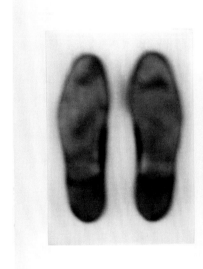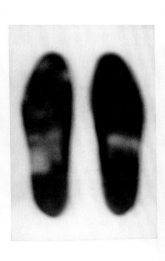

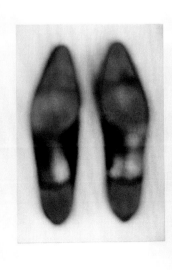

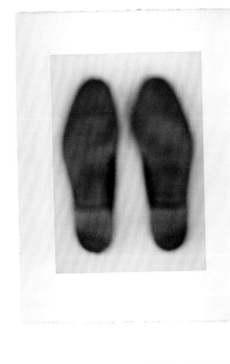

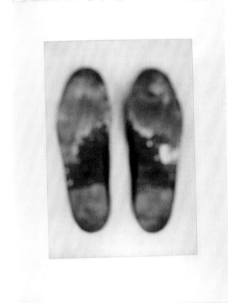
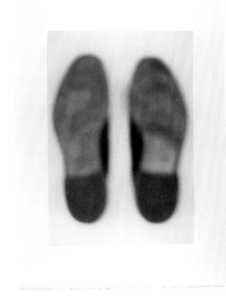
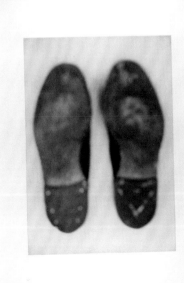
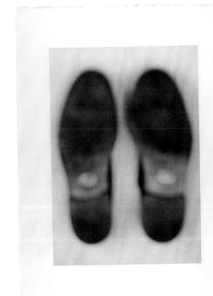

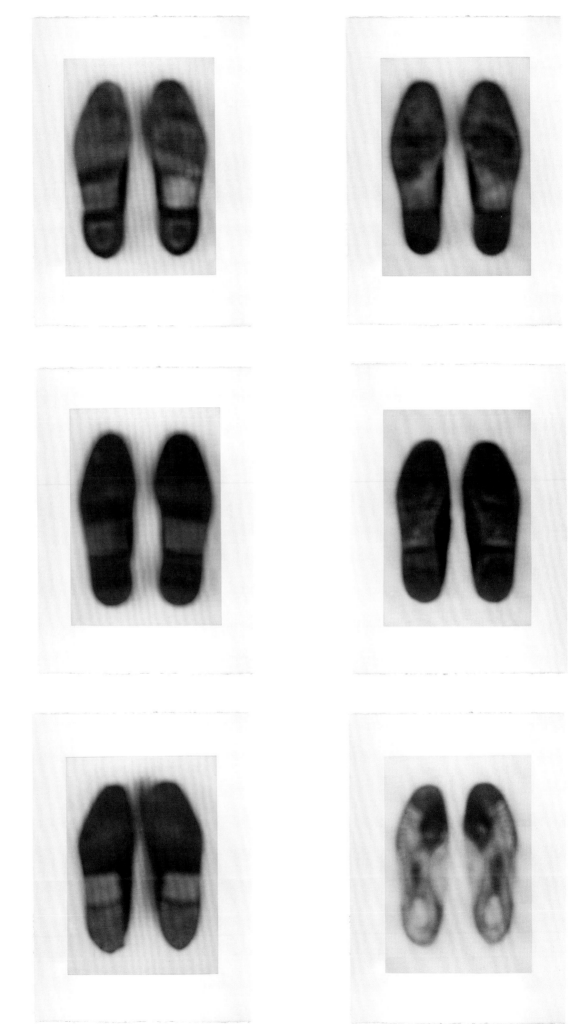

he she
me &
land
scape

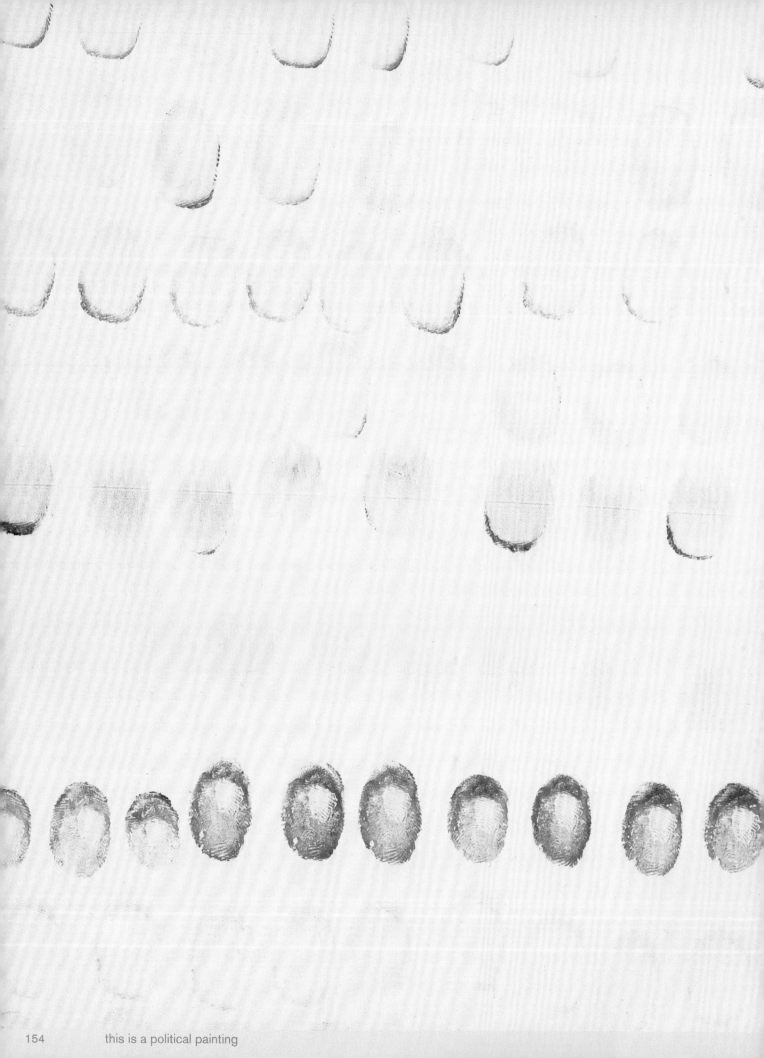

this is a political painting

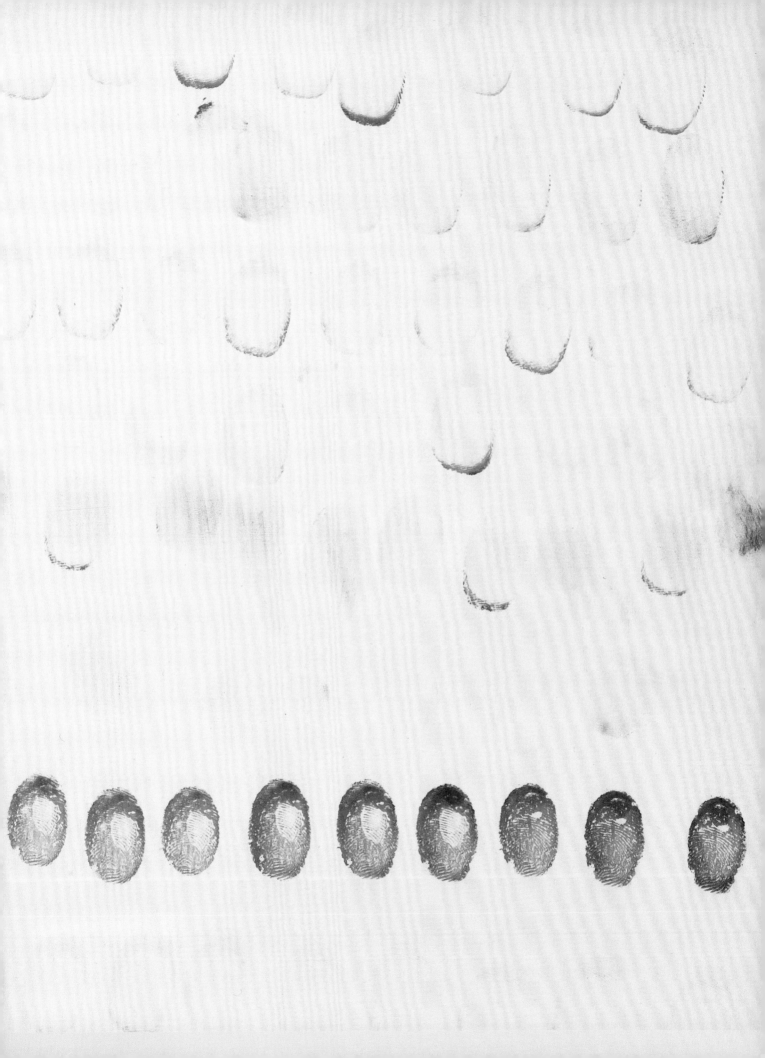

last summer
we went there every m...
and between mornings

I stand still
on top of a mountain
behind my house
in my balcony
68° N
slow arctic
dawn night

self portrait 2010

Berlin february 1989 Lofoten august 2007

complex 1 / at Spa (Oslofjord)

entrance in the rest
balcony in the act – guards watching
I was naked turning 8mm camera (3 min roll)
around the body world spinning
I was very cold
and gent and skin
and written

I'm not afraid of beauty

every
Cate (found
the roll in
a drawer

amazon
2005

16 mm film projection
camera Vegar Moen
edit Vito Mirnch / A K Do...

amazon is mute
but conceptually edited after second movement
Allegro Molto
Shostakovich string quartet No
op 110 a score written
following a visit to Dresden
was confronted with the de...
of the city during the war.

Veje Moen award

when I discovered the end I wanted to live really long 2013

16 mm film
with bolex
camera runs for 2 sec (manual reload) camera behind me
in the cold its slow
the cold makes white frames
 tell me
you are here tell me J Russell 1970
 tell me
 people again Russell

seven voices 2011
sound sculpture
seven young people
L'International from 1871
The hymn belongs to socialist movements worldwide
has been sung widely in 2011, among other
places on the island Utøya Norway

As long as I can 2013 day two
voices John Gorno recorded New York day three
 + Doren October 2012 day four
 22 mn day six
 curator Gaby Hartel oil on aluminium 70×80

new snow
new vinyl Edition Block Berlin 2013
new sound
 we looked for the open way studio work
Nino together before 2011 each morning early
 (Nina was there) daylight
Ostrovich and hammer
Effect of the bombing and hand
 and paint and track

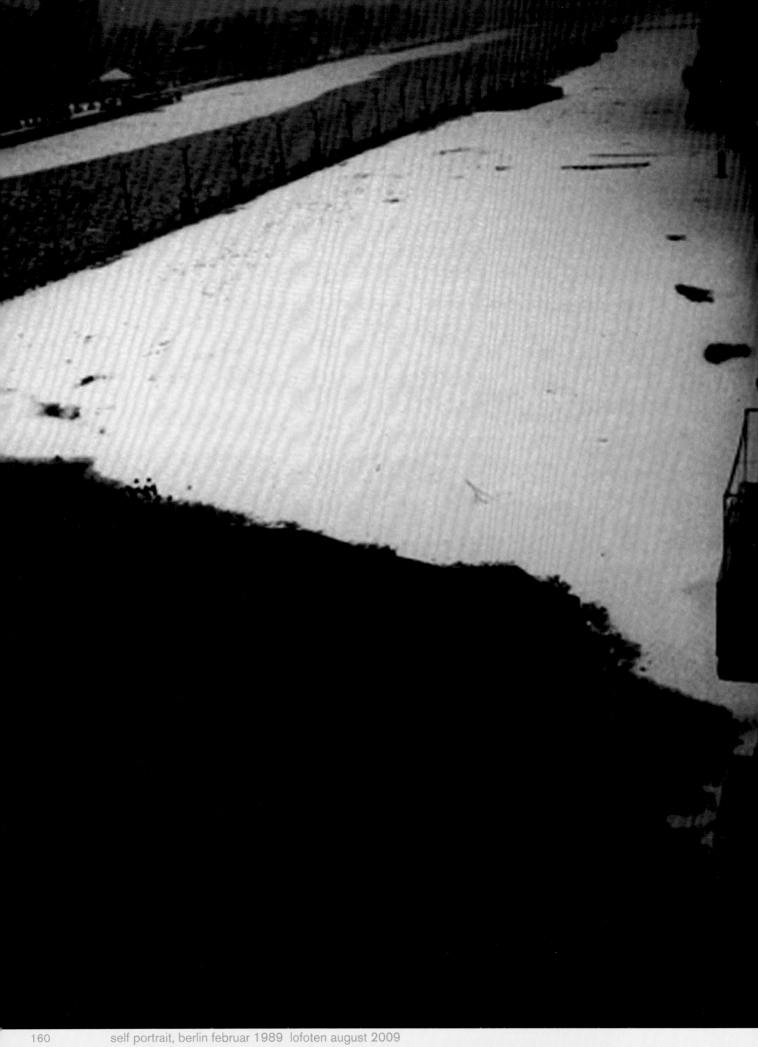

self portrait, berlin februar 1989 lofoten august 2009

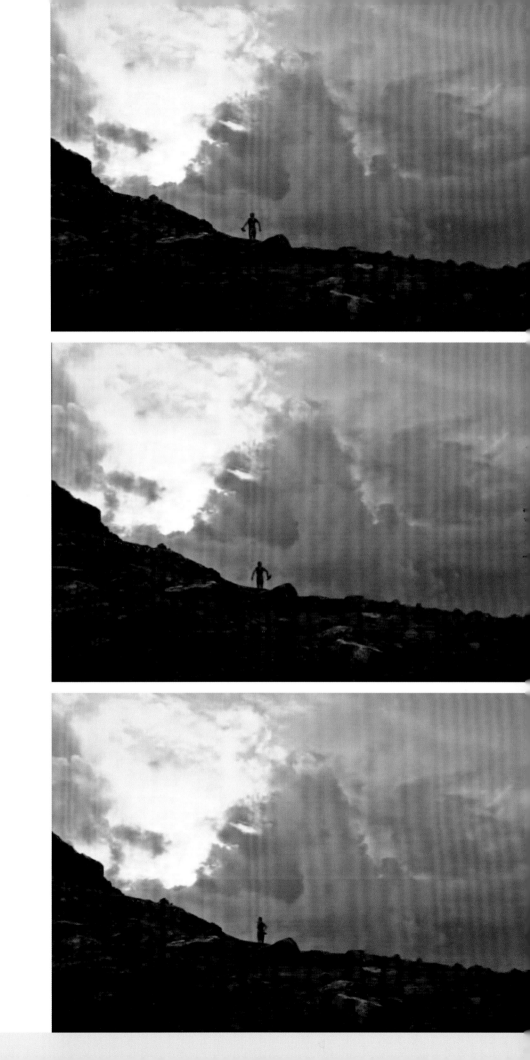

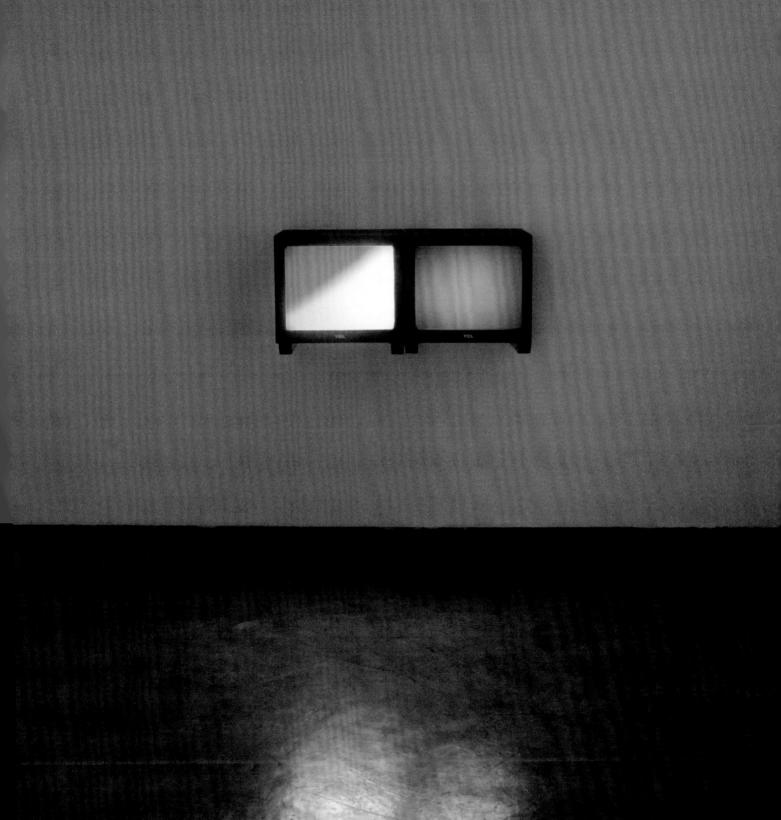

liberty

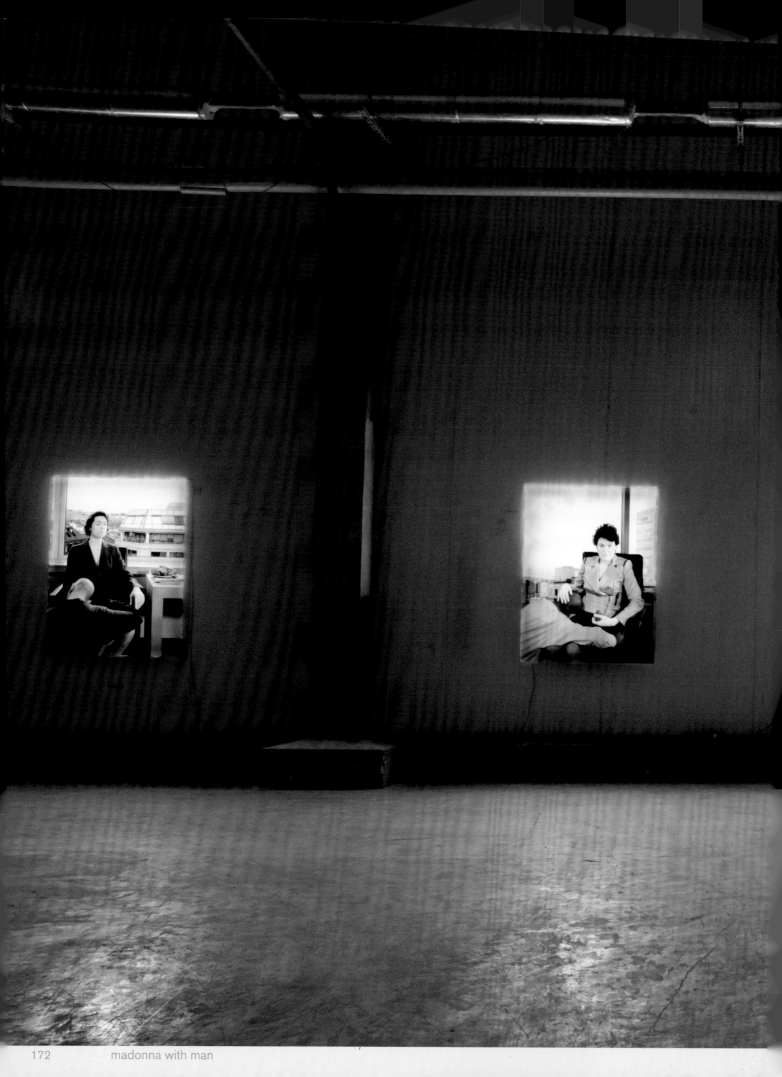

madonna with man

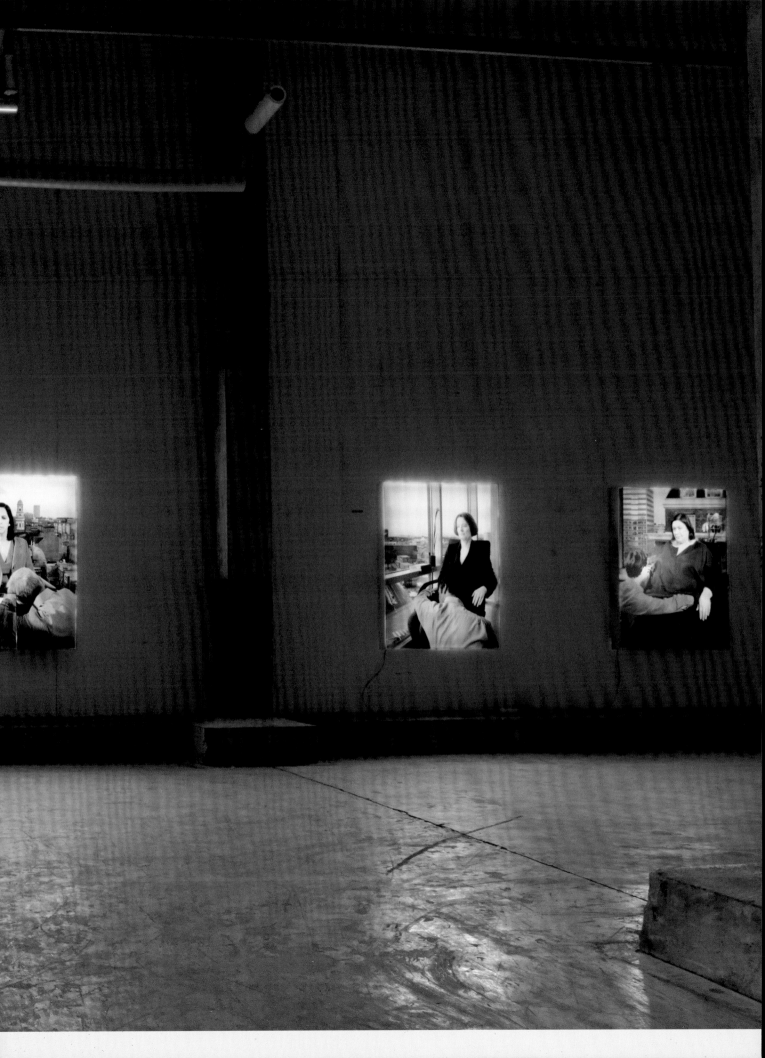

madonna with man and fruit

madonna with man and fig

madonna with man and iris

madonna with man and lily

skrapa komager / gáidaduvvon gábmagat / scraped moccasins

voices

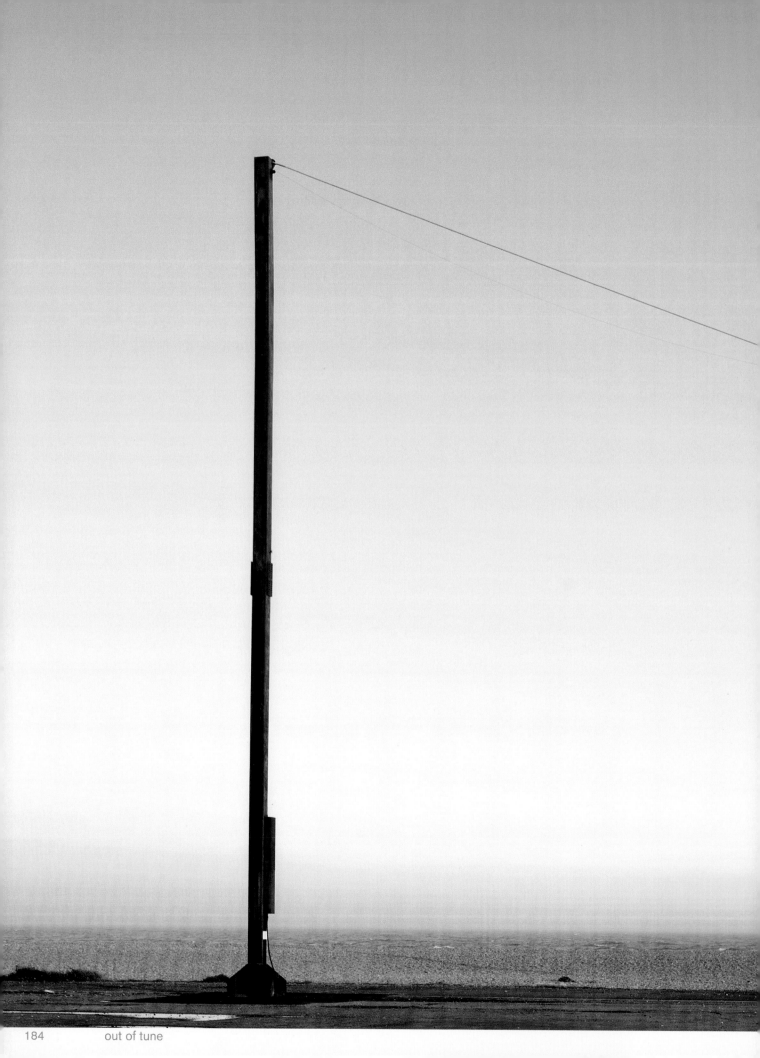

out of tune

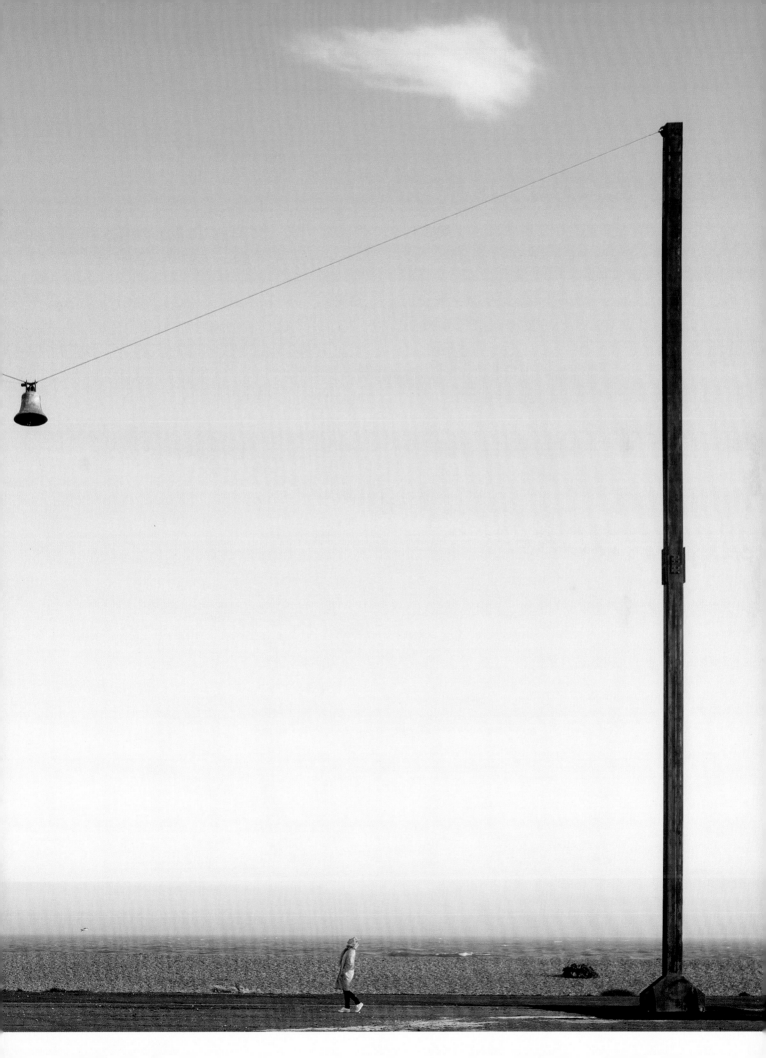

untuned bell

www.jomiplak.de www.jomiplak.de ww

RENN **RENN**

ENN

ANNS

PLAY ME **SOU**

Rolf Wallin:
UNTUNED BELL

Time schedules for melodies played, 5 per day from sunrise to sunset, from the bell tower of Oslo City Hall, situated 500 meters from the Untuned Bell at Tullinløkka.

Before each of these melodies, the first note is played three times.
After each of these melodies, the last note is played three times.
(Note: an accidental is only for the note it precedes)

SATURDAY 30 January 2010 12:31 (solar noon)
Melody no. 1 (3 bells sounding)

14:28 (halfway between noon and sunset)
Melody no. 2 (4 bells sounding)

16:26 (sunset)
Melody no. 3 (5 bells sounding)

SUNDAY 31 January 2010 08:33 (sunrise)
Melody no. 4 (6 bells sounding)

10:32 (halfway between sunrise and noon)
Melody no. 5 (7 bells sounding)

12:31 (solar noon)
Melody no. 6 (8 bells sounding)

14:31 (halfway between noon and sunset)
Melody no. 7 (9 bells sounding)

16:29 (sunset)
Melody no. 8 (10 bells sounding)

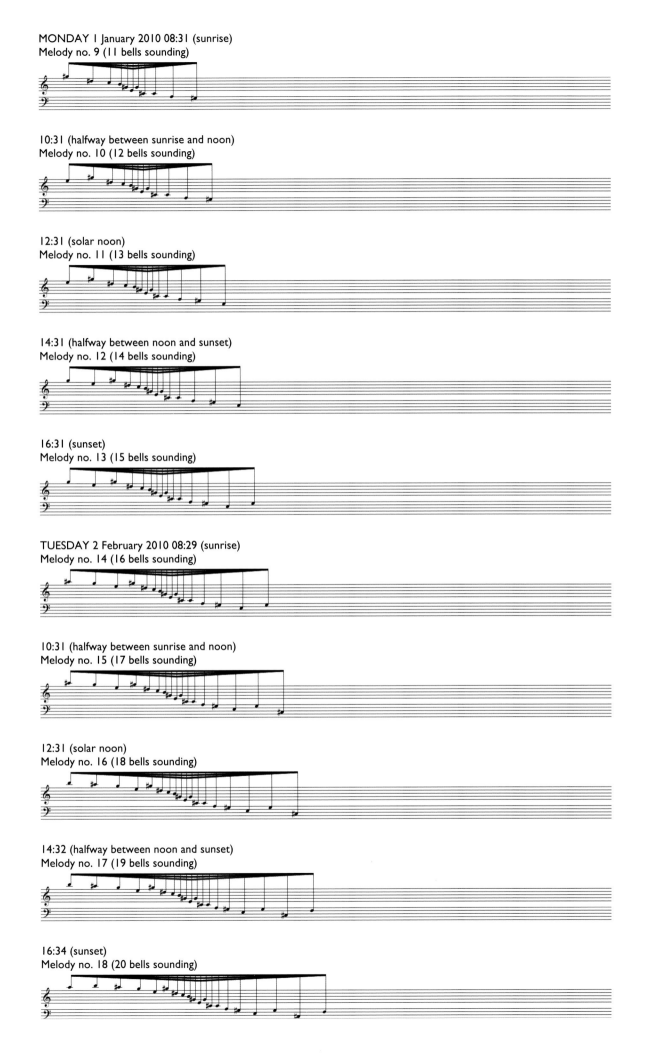

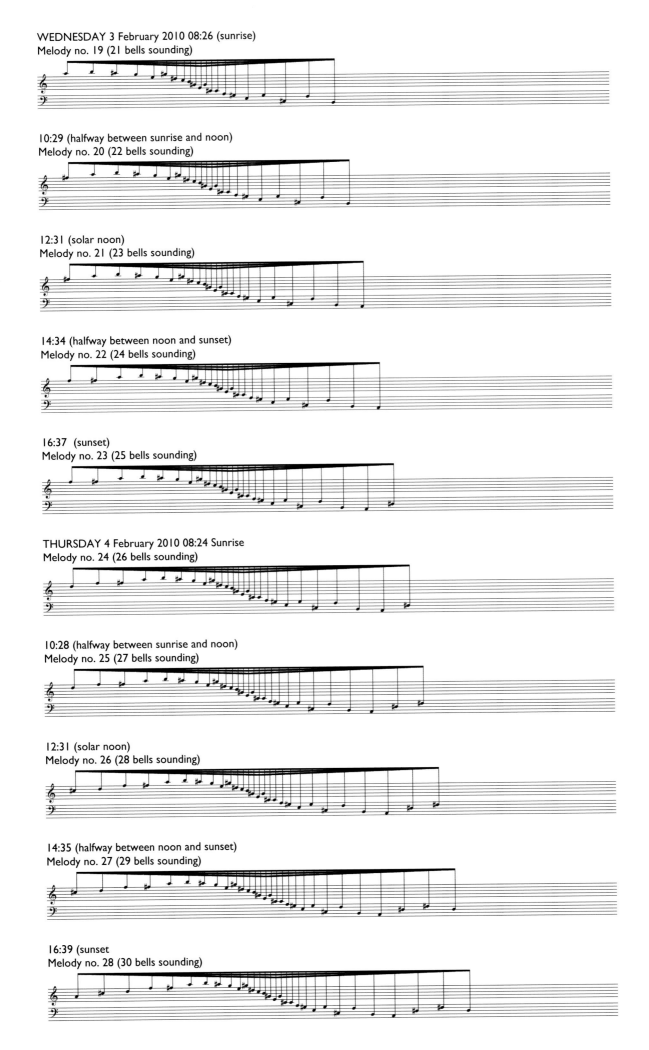

FRIDAY 5 February 2010 8:22 (sunrise)
Melody no. 29 (31 bells sounding)

10:27 (halfway between sunrise and noon)
Melody no. 30 (32 bells sounding)

12:31 (solar noon)
Melody no. 31 (33 bells sounding)

14:36 (halfway between noon and sunset)
Melody no. 32 (34 bells sounding)

16:42 (sunset)
Melody no. 32 (35 bells sounding)

SATURDAY 6 February 2010 08:19 (sunrise)
Melody no. 34 (36 bells sounding)

10:25 (halfway between sunrise and noon)
Melody no. 35 (37 bells sounding)
(The last one, the D sharp, is the bell that replaced the Untuned Bell in the bell tower of Oslo City Hall.)

12:31 (solar noon)
Melody no. 35 (37bells sounding)

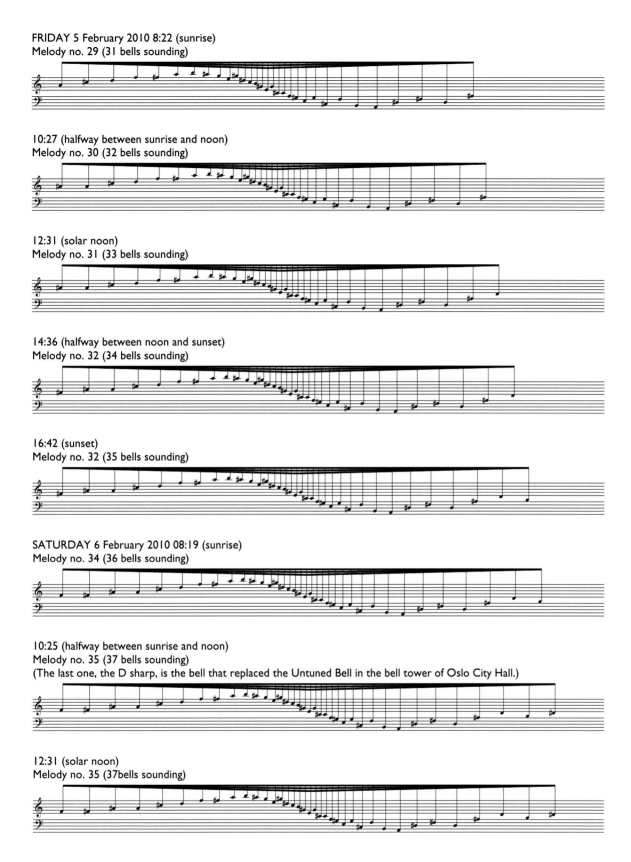

THE INAUGURATION OF THE UNTUNED BELL:
13:45 – 14:15: All melodies are played during the 30 minutes.
The 11 bells that have not been heard until now are also introduced one by one, played by carillioneur Vegar Sandholt.
14:15: The Untuned Bell sounds for the first time.

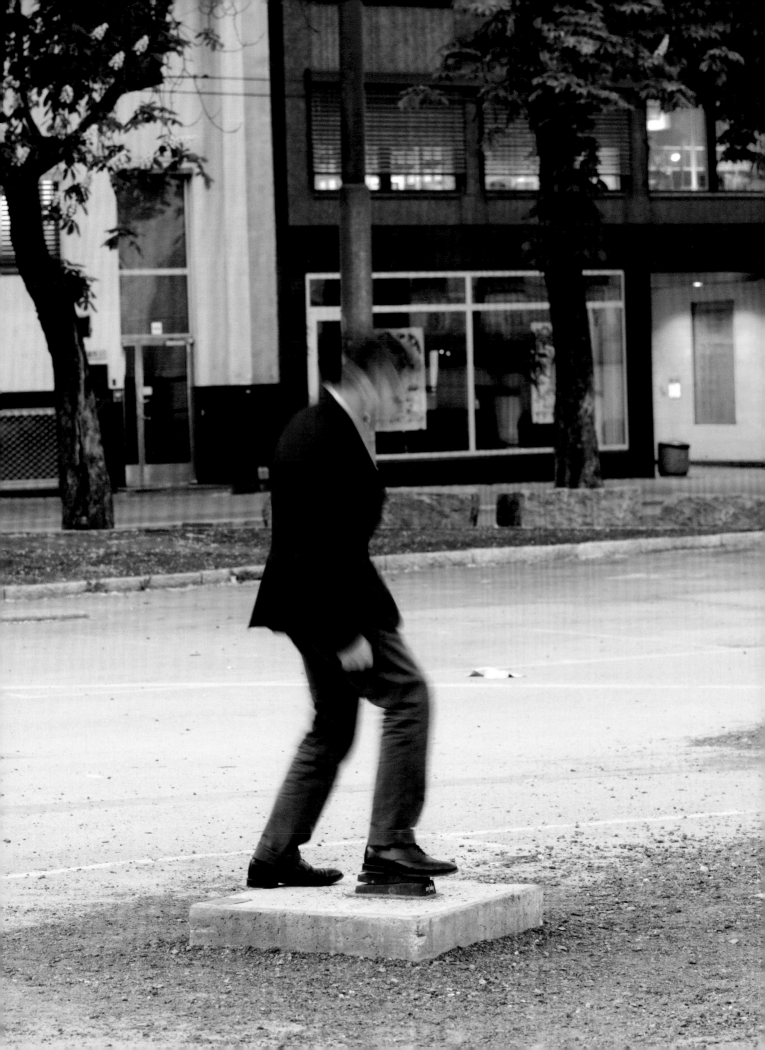

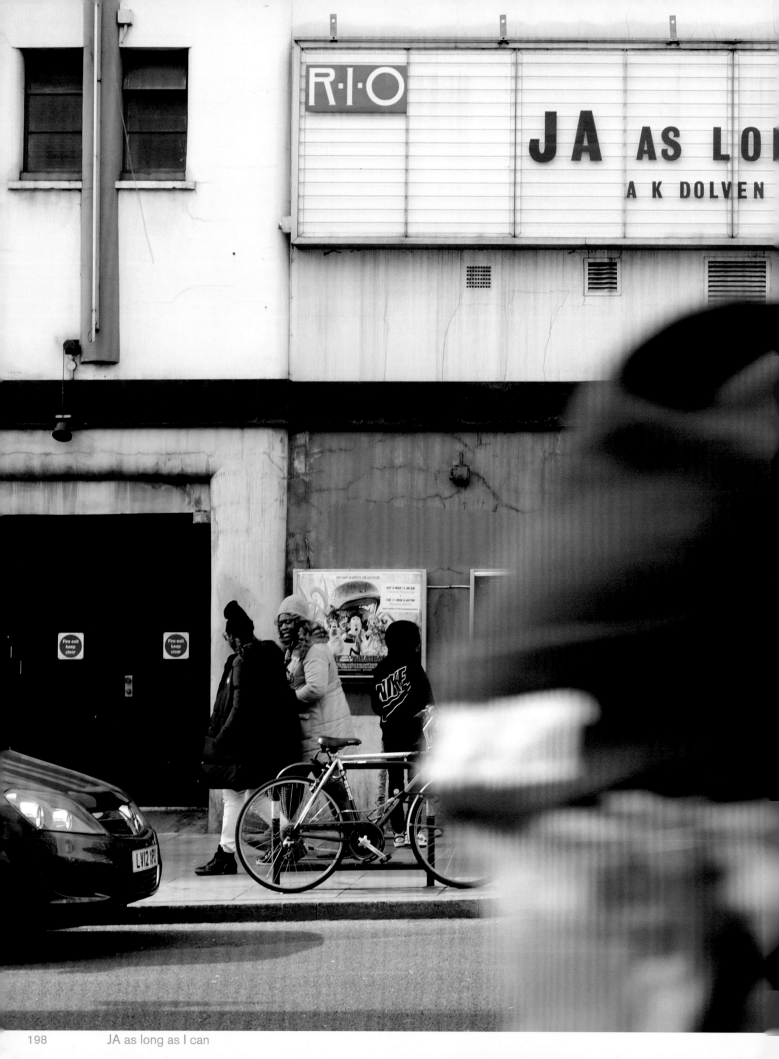

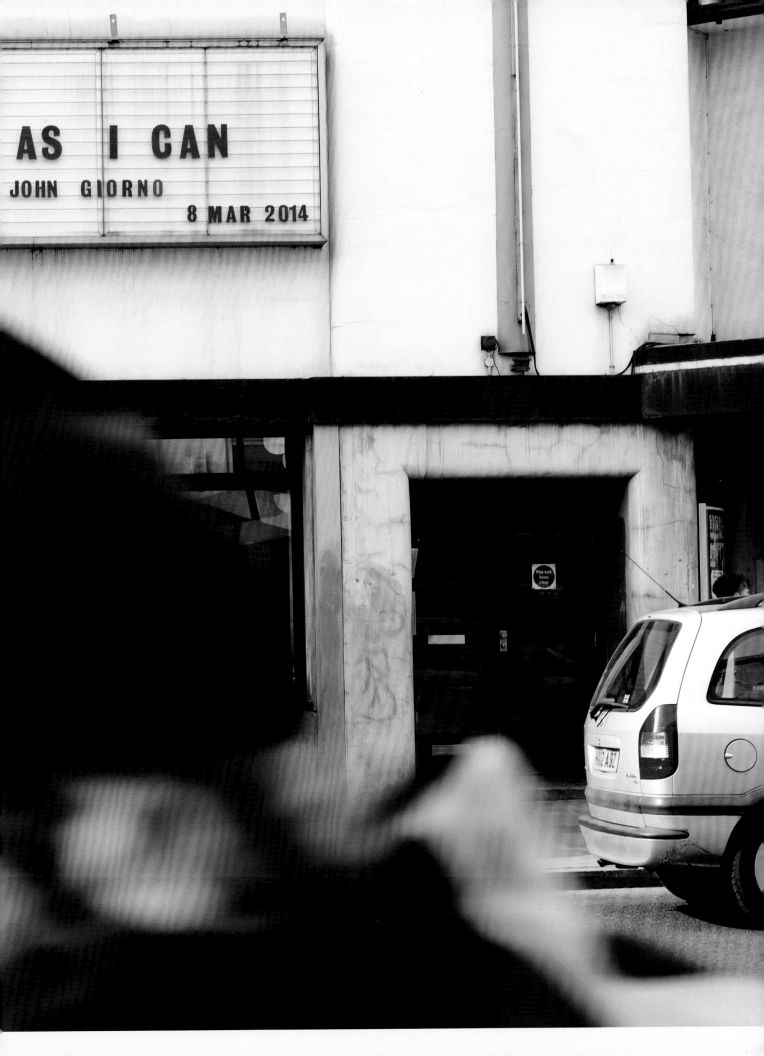

WOMEI

MEN

34 INTERNASJONALEN

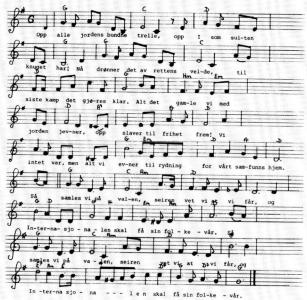

Så samles vi osv...

Tekst: Eugene Pottier
Oversatt av: Olav Kringen
Musikk: A de Geyter

Opp, alle jordens bundne trelle,
opp, I som sulten knuget har! –
Nu drønner det av rettens velde,
til siste kamp der gjøres klar.
Alt det gamle vi med jorden jevner,
opp slaver nu til frihet frem!
Vi intet har, men alt vi evner
til rydning for vårt samfunns hjem.

 Så samles vi på valen,
 seiren vet vi at vi får,
 og Internasjonalen
 skal få sin folkevår.

Arbeider, bonde, våre hære
de største er, som stevner frem!
Vår arvedel skal jorden være,
vi sammen bygge vil vårt hjem.
Som av rovdyr er vårt blod blitt suget,
men endelig slår vi dem ned. –
og mørket som så tungt oss knuget,
gir plass for solens lys og fred.

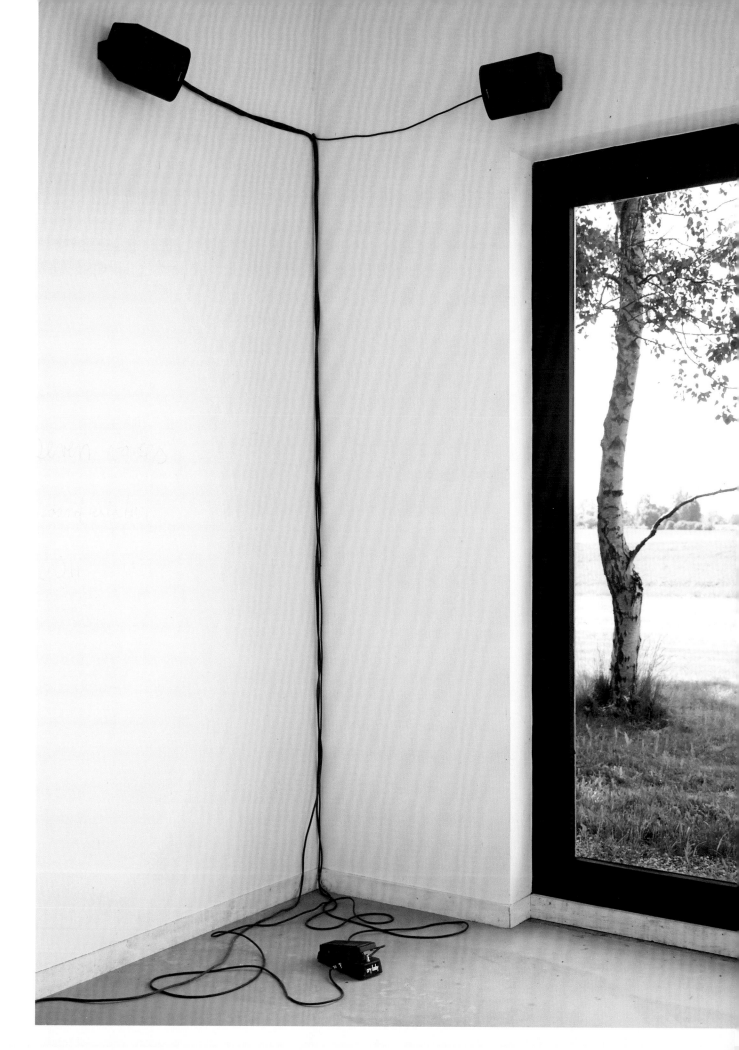

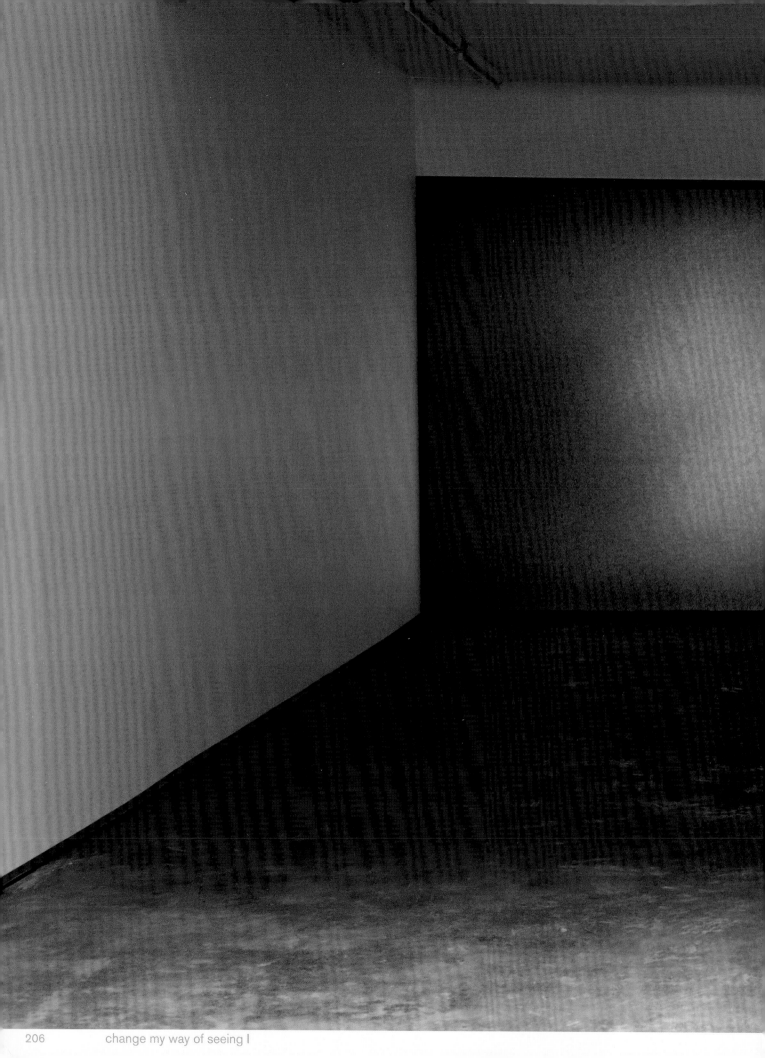

change my way of seeing I

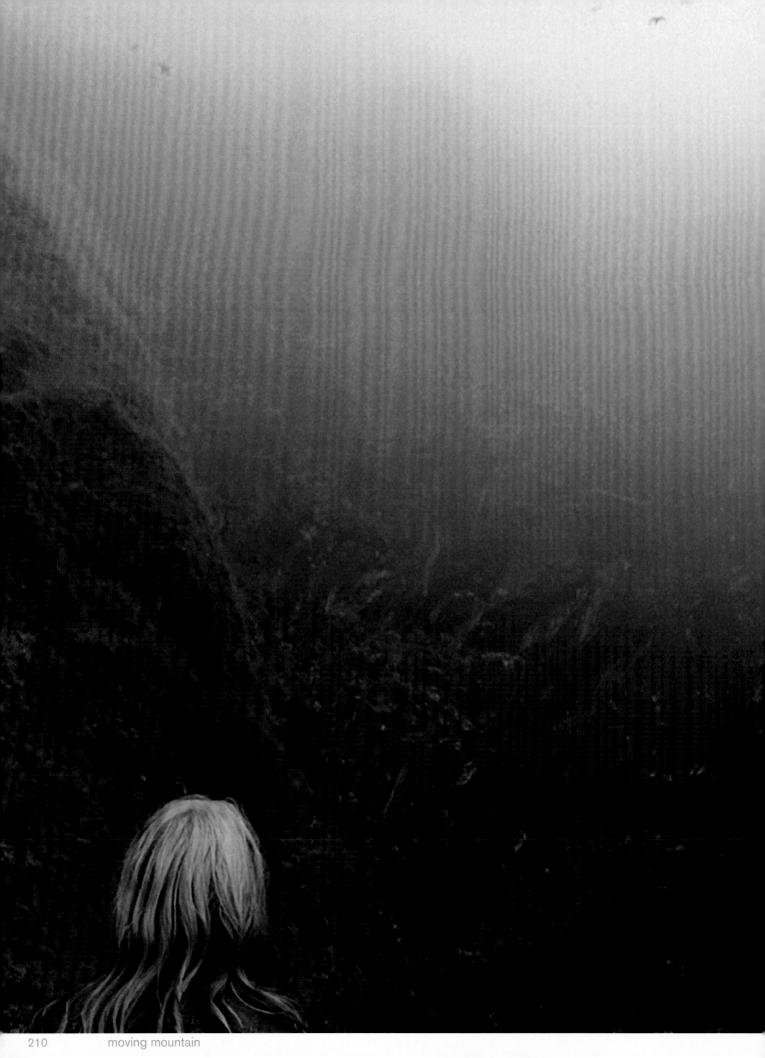

moving mountain

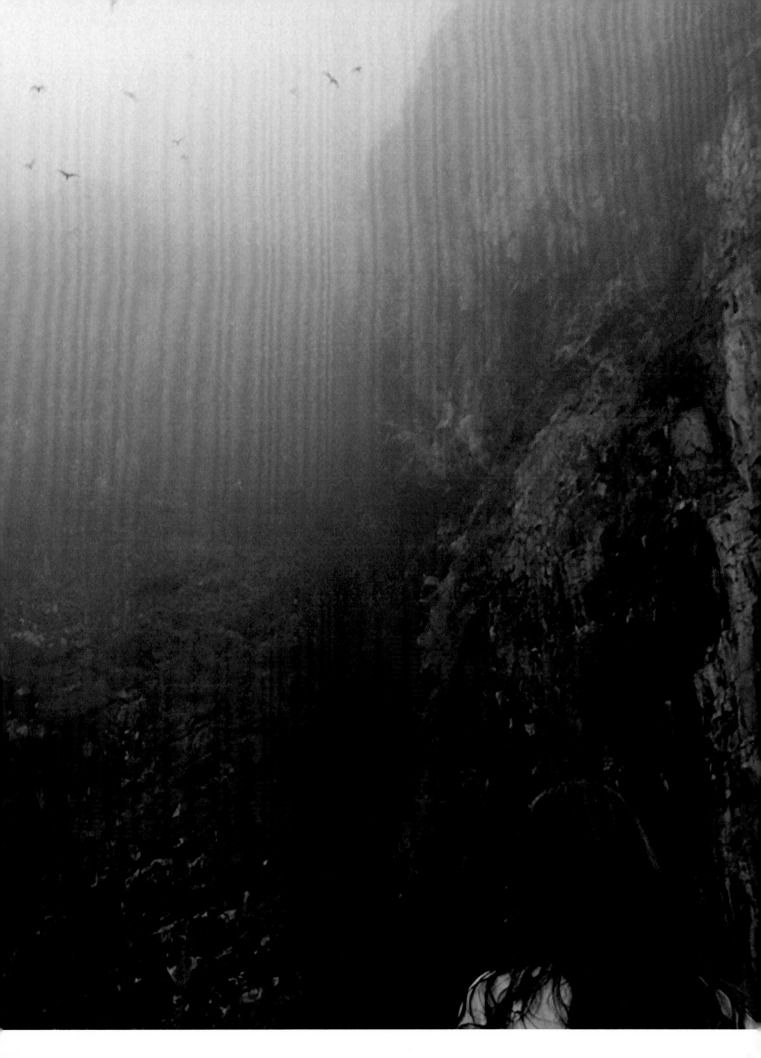

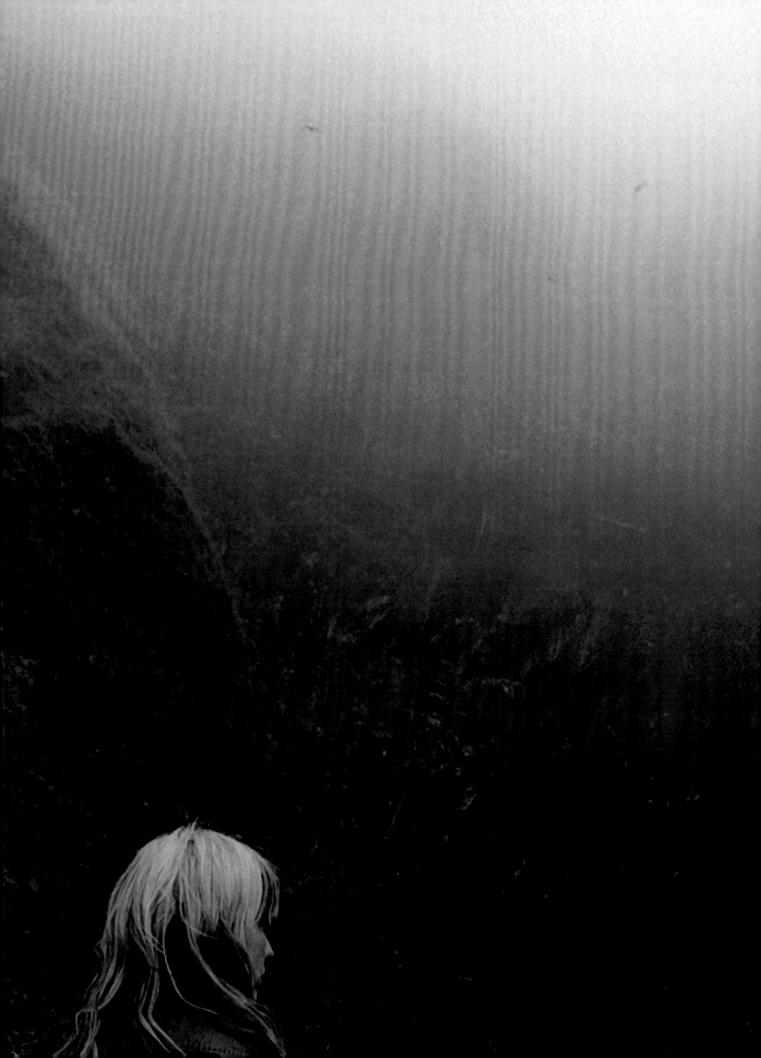

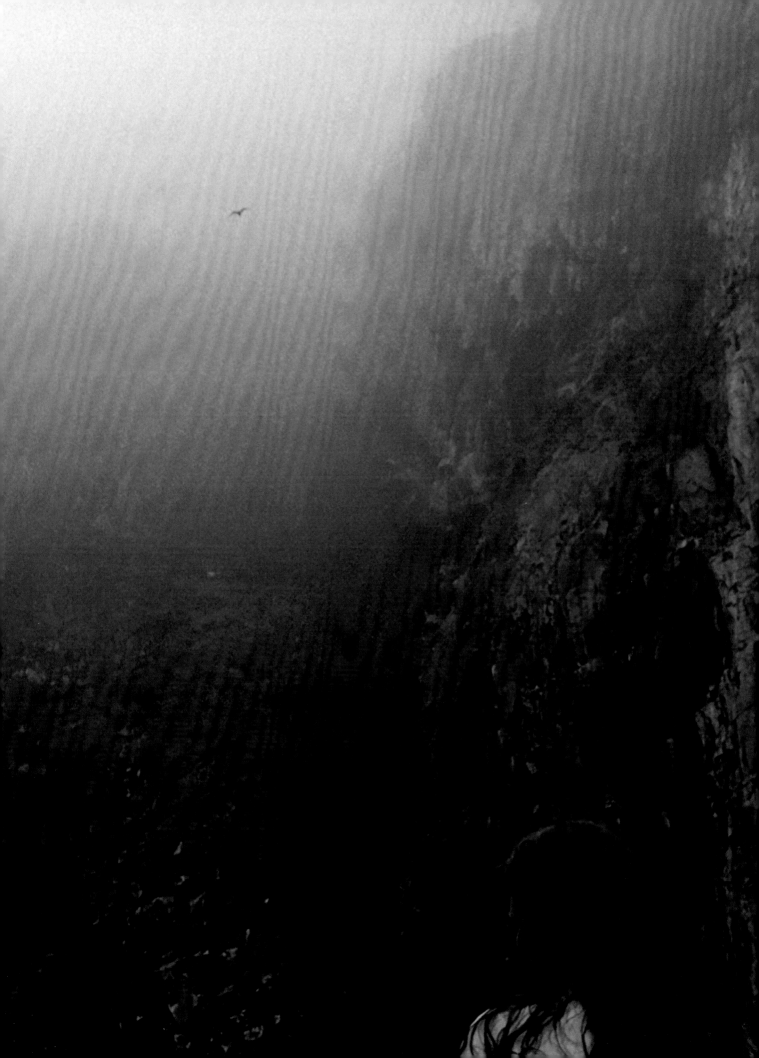

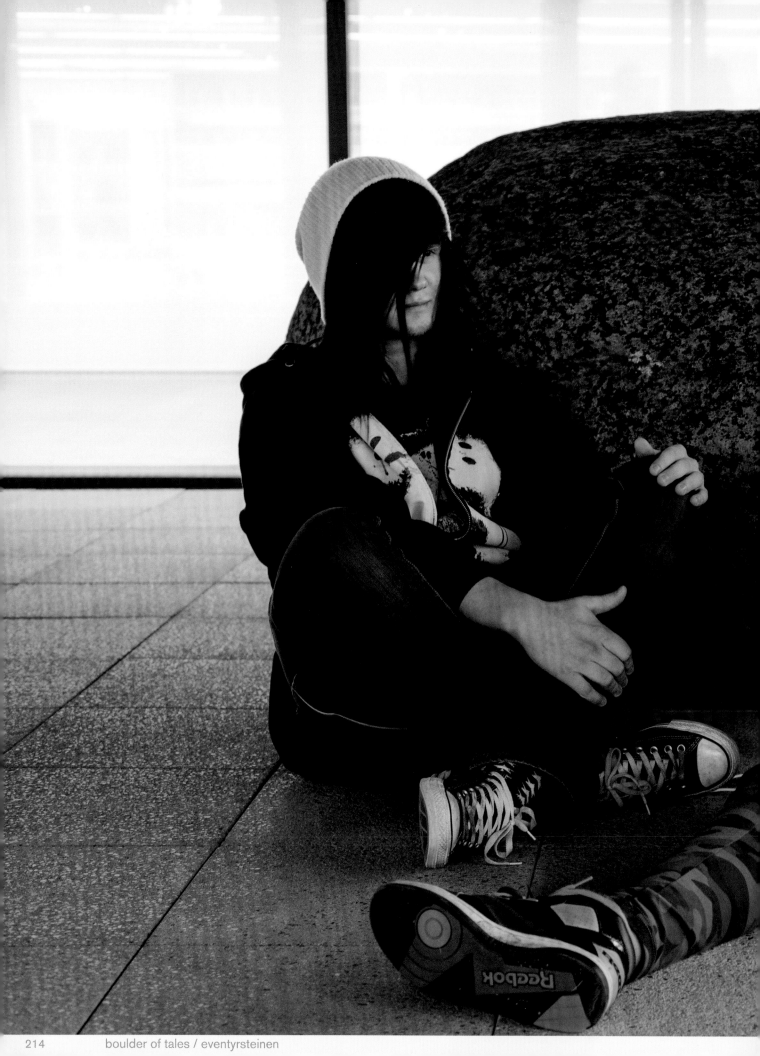

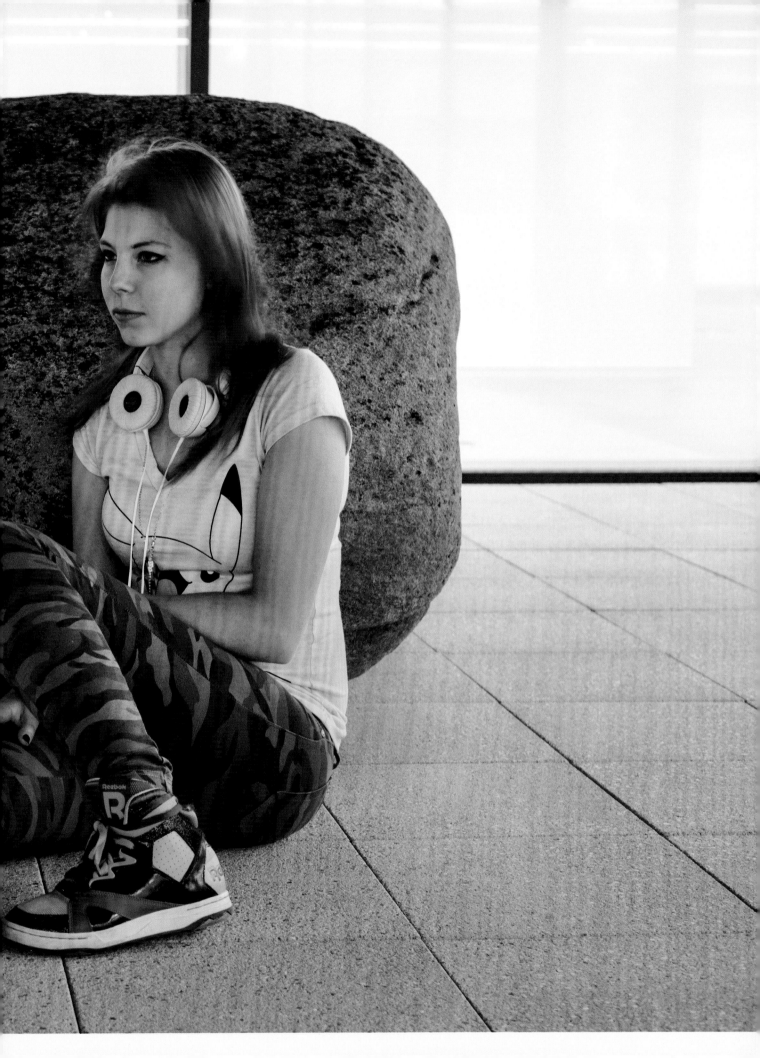

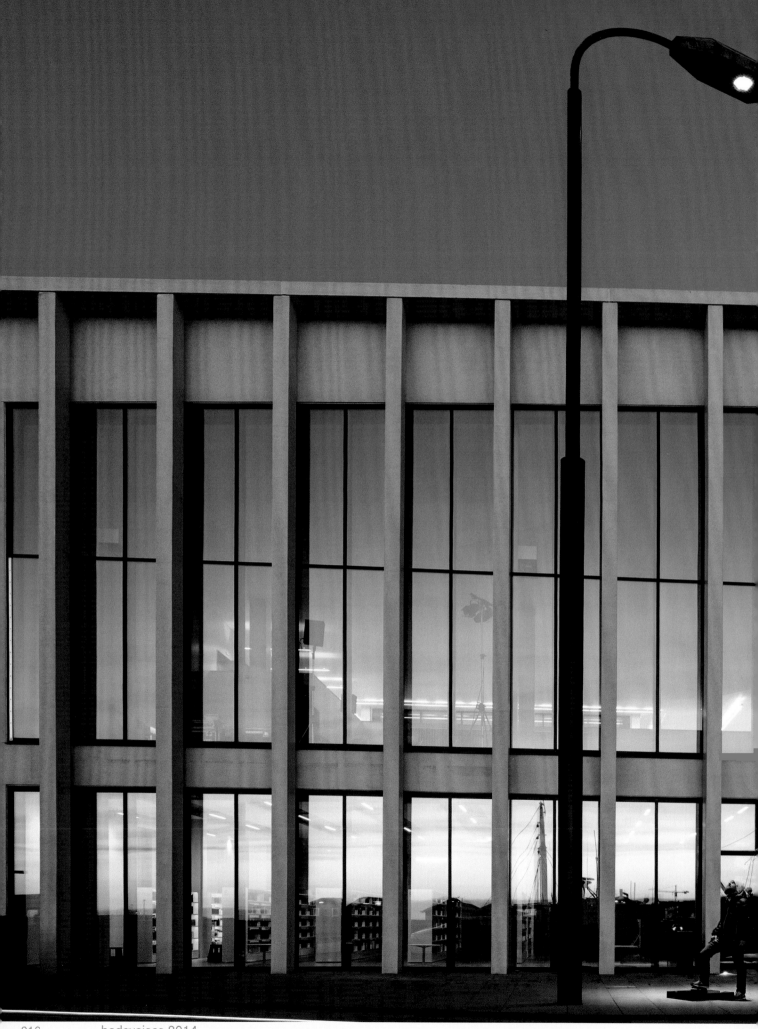

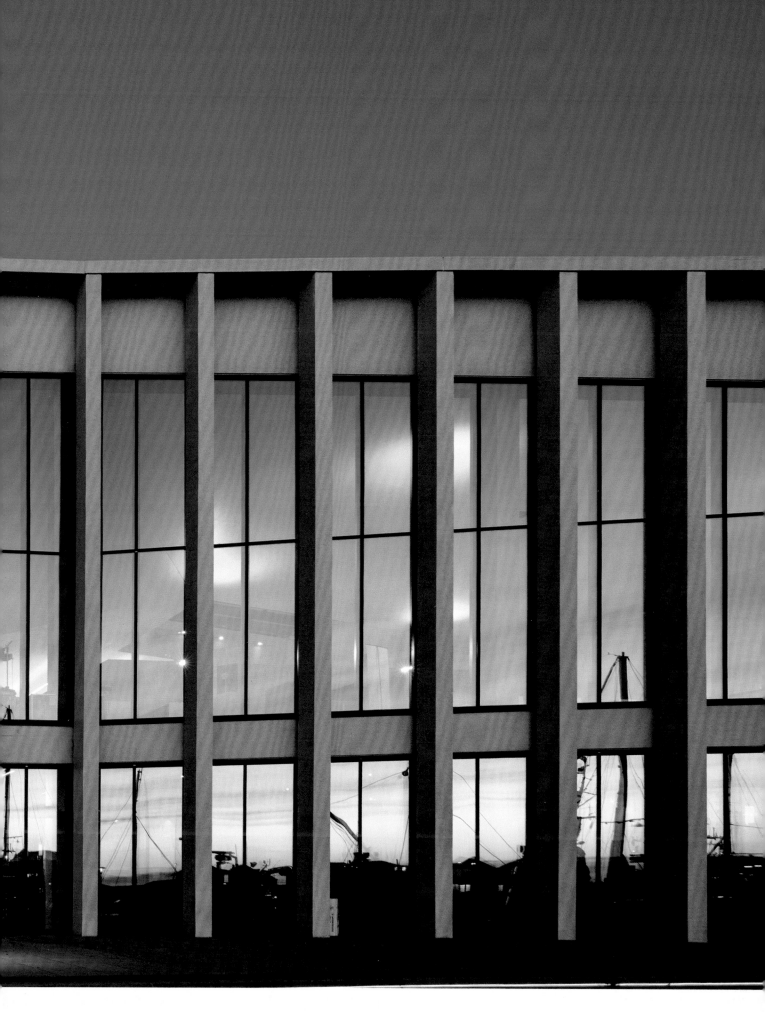

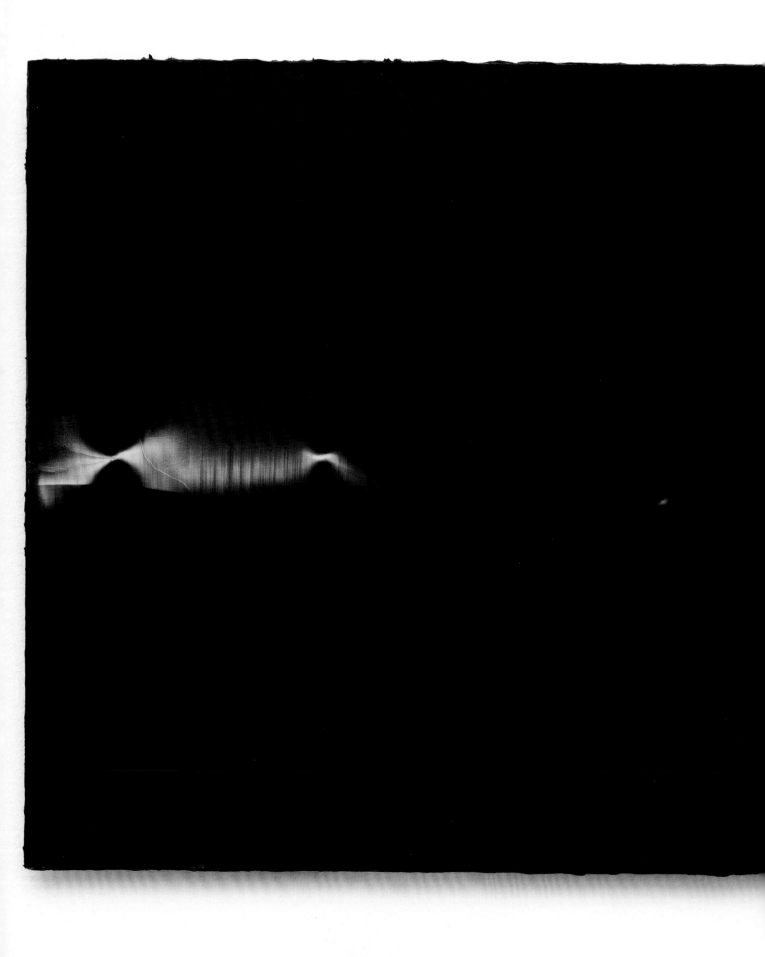

just another sound

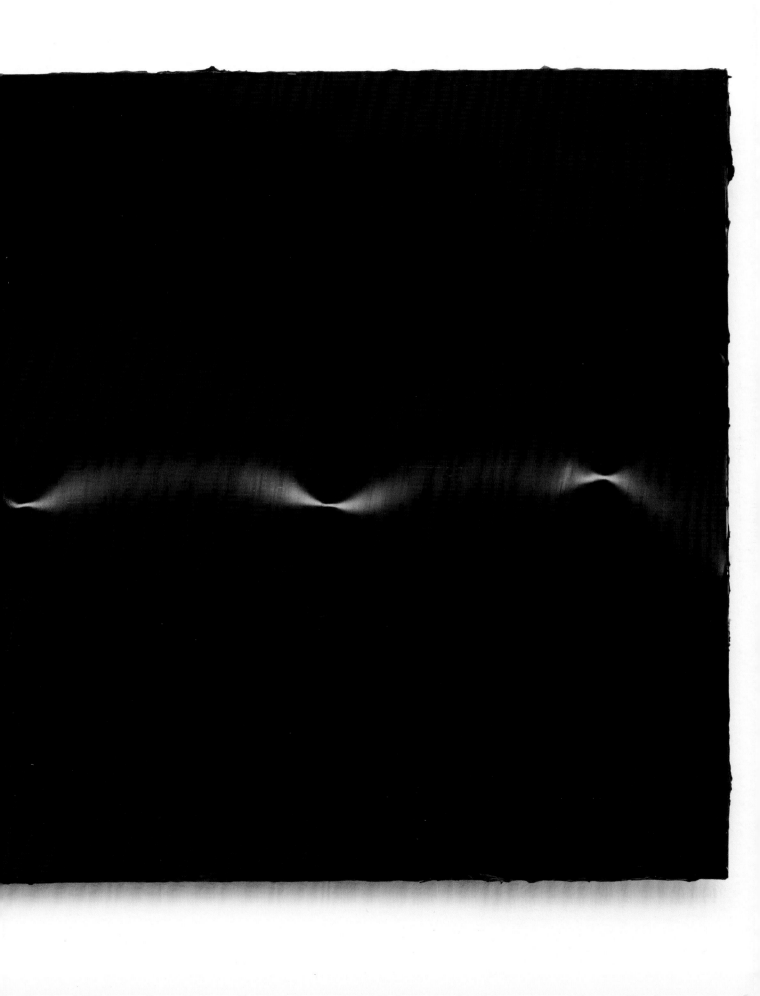

please return

five

essays

balance

Mark Ravenhill

The world is in part a thing to be amazed by: to look upon with astonished eyes, to take pleasure in its mysteries and complexities. To trust that it has an ultimate symmetry, a balance that we can never fully comprehend.

Often I feel that sense of amazement: the fascination of watching fire or water or snow falling, their shifting unpredictable patterns. Their aliveness that has no claim to hidden meaning and yet does have a mystery.

The presence of life in a burning tree or the mountain covered with snow seems to have a secret that is a great pleasure but also a great and surprisingly enjoyable fear.

And sometimes I look at other human beings or myself with that same sense of wonderful fascination: the complexities of our beauty and ugliness, the persistence and flux of our being. There is great pleasure to be had in observing this balance.

Balance.

I hear that word spoken and my first instinct is to counter it, resist it with imbalance or unbalance. To destroy balance.

I am surprised to find that this is my spontaneous reaction to hearing the word 'balance' spoken. I'm unsettled to find that I feel so strongly that balance is an enemy.

But the world is also a thing to be argued with. To be angered by its fixedness, its relentlessly repeating patterns. And this is the dominant passion that I have, this anger, overwhelming any pleasure that I take in balance.

I suppose here I mean mostly the human world, the cruelty and indifference of our dealings with each other, of the harsh mechanisms of power that we construct.

But also the pain of aging, illness and death. It's impossible (for me and, I would guess, for you) to experience these things simply with fascination or amazement. These I want to fight, disrupt, unbalance just as much as I want to disrupt the mechanisms of social power. They come from nature, they are natural but I can't reconcile myself to them. I will fight them.

Nature we are told is made from balance. Look at an isolated moment and we might see cruelty or destruction. But over time and place, nature will always counter and correct and return itself to a state of balance. And this balance, we're assured, is better, greater and wiser than we are.

But my death is not part of that balance. And I am angry that this wisdom of nature could be greater than mine.

To write these words makes me feel very male.

This is not a pleasant feeling for me. I would like to think of myself as somewhere more neutral on the gender scale. Masculinity is not something I take pride in.

But to challenge nature and death, to want to be greater than them is to be a stereotype of the egotistical, arrogant, individualistic self.

I am Faust with an iPhone and a middle-aged belly.

I am ridiculous.

I am a child.

The baby creates imbalance, unknowingly at first. It cries, it shits, it falls. Another returns it to balance. The Mother is there to restore the balance.

At some point the child realizes that it has this power. It can deliberately cause a disruption or disturbance and Mother will restore the balance. Perhaps already at this early stage, it is the male child that makes the greatest use of this discovery, is drawn to creating the greater disturbances.

The boy child is performing for the Mother. It gives the boy child a sense of power, but he also believes that it gives the Mother a feeling of pleasure that she is able to complete the performance by restoring balance.

As men, we carry this performance into the world. We arrive in a situation, a scene and we see what is fixed, what has reached a point of stasis and we act to disrupt that, to create an imbalance.

By this we assert our power.

And we offer the possibility of pleasure for those who offer to restore and heal the wound that we have created. The space that we open up for the female is that of the other who will restore balance to the disorder we have created.

For me, this is an essential element of the theatre that I create. It is a destructive act. I create an opening scene of stability and then introduce an event that will disrupt the balance, introducing more disruptive events until the audience confronts whatever it is that a fixed order of behaviour and belief has concealed. I leave it to the audience to create a balance for themselves after the performance, just as the baby leaves Mummy to clear up the mess.

Something altogether different is happening in A K's work. It seems to be coming from an impulse far away from my own masculine ego. It seems to be profoundly female and also mature. And its ease with itself makes me feel uncomfortable with my own masculinity and my struggle to mature.

A K's work does not strive to disrupt. But nor does it simply observe. It makes concrete interventions into the world, acts that exist alongside and inside the natural and the man-made, confident enough of their own existence that they do not feel the need to attack the order into which they have been introduced.

The Amazon terrified her male enemies partly by her sheer height. She was as tall or taller than a man. But most notably with her single breast, the other breast having been chopped off by the Amazon herself. The Amazon had removed the breast so that she could be an effective firer of an arrow. She was an ur-cyborg. But the certainty of being hit by the Amazon's arrow is less fearsome to the male observer than the asymmetrical woman who has elected to display an unbalanced body.

A K's Amazonian woman has no enemy. The arrow must logically be fired at a target. But here the target is not the completion of the act. The act of pulling and releasing the bow is a finished act in itself.

This woman is not defining herself in relationship with anyone else. She does not want to attack or to heal the other. She exists entirely for herself and for the suspended moment in which she acts.

The camera as an agent of the male gaze has historically often attacked the female body by dismembering it. It isolates the legs or the breasts or the face until the woman is a montage of disconnected body parts. A K's Amazonian is observed in segments but no dismembering takes place. Each body part exists independently and yet in harmony with the others. A breast has gone but the body is reconciled to this. Balance has been achieved.

changing seeing, seeing change

Ina Blom

Seeing, recording, projecting, seeing. That is the habitual order of things when seeing is turned into an image by means of an apparatus that stores its own version of an optical event and presents it for *re*vision. In this respect, it does not matter whether the apparatus in question is called painting or film. In painting, something seen may be recorded by means of paint on canvas, and the viewer knows that the image is not vision as such but a representation or projection made in the medium of paint. In film, a ray of light, reflected off some subject, passes through the lens during the fraction of a second that the camera shutter opens, hitting a strip of plastic coated with light-sensitive emulsion and leaving a permanent record or trace. The final projection relies on the mobilization of these frozen traces to create what everyone knows is an illusion of instant seeing. A K Dolven's *change my way of seeing* undoes this order, blows it apart. On first look, the work seems to be all about pretty, ephemeral light effects in painting and film, the iconography of an age in which the romanticization of natural light segues into a fascination with media light. On second look, however, you see more: a restless contraction, a form of vibration that seems tense and muscular, more *specific*, in fact, than simply flickering light. From this point onwards, seeing has become complicated and seems to indicate some kind of operation or apparatus that needs to be explored. Consulting the work's production of vision and visuality becomes the obvious next step.

What emerges does not necessarily clarify the question of vision. On closer investigation, you encounter only a thicket of interpenetrating visions, projections and recordings. A ray of sunlight has been sifted through the viewfinder of a Super 8 camera, and allowed to travel all the way through the apparatus and out through the lens so that it hits the eye of a person holding the camera at arm's length with the lens turned towards her eye. Throughout this process, the camera is filming, yet it is hard to define exactly what it is recording. In a sense, it is capturing only a projection screen, filming 'off' a screen on which moving light effects are shown. For what is caught on film here is in fact a projection of light *on* the eye of a beholder, an eye that is now forced to function as a screen. Yet, at the same time, this eye cannot escape its duties as an optical apparatus and is struggling to handle the projector beam that hits its pupil. *This* particular screen is, in other words, also a lens mechanism, and has its own shutter functions so as to be able to protect itself from the onslaught of light and portion it out in manageable doses. Human eyes blink and move: this is how they manage to produce a visual impression of a stable world of things. But as in any film, there can be overexposure, a blinding light that cancels out everything else. This eye-lens in *change my way of seeing* is subjected to such overexposure, and the pain it causes is registered in desperate blinking and muscular struggle. The eye-lens clearly tries to escape direct exposure to the ray of light. But since it is also cast in the passive role of screen, it has to stay put and take what comes.

The film camera here is also made to work differently than normal: it first of all functions as a projector. At the same time, it is a projector with a memory: it passively records its own projections on the eye-screen. A film is made, if only in a quasi-automatic way, subordinate to the work of projection: the process is a step removed from the active process of creating cinematic representations of the world. Yet, if the camera is made to act in a non-camera capacity, painting, for its part, seems to step in, to actively produce, in its own way, a quasi-cinematic record of light hitting the eye-screen. A series of small rectangular panels, painted in the bluish-white hues of overexposed media images, functions like a series of film stills that present us with the frozen traces of the eye-screen in operation. All that is needed is another projector to set them in motion. The eye of a viewer moving along the gallery walls where these painting-stills hang in long series might well serve that function.

The thicket of displaced or distributed visions, recordings and projections that make up *change my way of seeing* might simply seem like a confused mess. Yet the work does not really present disruption in relation to representational models of media and media technologies, but a different understanding of the material world. It stages a world of apparatuses that are not strictly separate and specialized

entities, closed in on their own functions, but parts of a dynamic environment where each one takes on multiple functions depending on the way in which it is, itself, 'perceived' or 'used' by the other apparatuses that make up this environment. Modes of seeing that are traditionally understood as belonging to different orders intermingle as parts of the same technical-material continuum. The human eye is no longer at the centre of things, using cameras or painting as prostheses, aides or stand-ins for its visions. In contrast, the biological vision of the human eye-brain, the handicraft visions in painted images and the mechanical/chemical vision of cameras are all presented as machines of sorts. They all seem to exchange or circulate traits and functions, and they all come across as living and active. Each of them has specific and autonomous powers of connectivity and association, depending on what they encounter or connect with at any one moment.

This is a world in which matter – that is, any entity in the world – is understood to be animated or 'seeing', according to a mode of thinking in which no thing in the world can be approached without taking into account its active striving to connect with other things. Whether we are speaking of simple chemical processes or the interchanges of higher forms of intelligence, some sort of cognition is at work in all such events of connection. As political theorist Jane Bennett has pointed out, it is a perspective in which the efficacy of agency – the ability to act and affect the world, traditionally associated with human individuals or collectives – becomes distributed across an ontologically heterogeneous field.[1] Any one thing may be an actor, including a 'passive' light reflector or screen. A camera may not simply 'use' light, but may itself be used by light in various ways. It may be used as a prosthesis for eyes, but may itself connect with other eyes or seeing mechanisms. To see seeing distributed, at work anywhere and everywhere, is not only to change one's 'own' way of seeing, but to change one's way of seeing the various apparatuses of seeing with which humans have such close interaction.

This means, mainly, to view seeing itself *as* change, and to understand the apparatuses of seeing as active agents *of* change, rather than as images. From a purely technical perspective, a seeing screen is a relatively new thing in the world, and so is a projecting camera. But when they appear in *change my way of seeing*, the (by now) ancient

mechanical technologies of film and photography are associated with a digital realm in which such multi-functionality or multisensoriality is the order of the day, and not an exotic exception. Cameras are now everything in addition to being cameras: telephones, movie screens, pocket lights, messaging systems. Screens are not passive receptors of representations but interfaces that put you in touch with a vast multiplicity of interacting agencies, most of them non-human and operating at a level of microtemporal organization inaccessible to human perception. Thanks to such agencies, screens see and remember in a myriad ways, for instance through program affordances that observe your actions and learn to predict your behaviour in the name of increased efficacy and connective power – and, increasingly, through programs that track all the various connective activities you engage in, gathering information about your tastes, passions and interests in vast databases for purposes of commercial and / or political exploitation. Increasingly, seeing screens are instruments of both focused and unfocused surveillance, operating on the principle that any input or information is potentially useful for something or someone in the short or long run, provided that it can be sorted and searched in meaningful ways. This scenario, and the various forms of difficulty and violence it opens onto, is the pain of seeing today, the pain of overexposure, in every sense of the term. By drawing us into the beautiful halo of media light, *change my way of seeing* slowly unfolds its darker powers.

1
Jane Bennett, *Vibrant Matter: A Political Ecology of Things* (Durham, NC: Duke University Press, 2010)

discovering the end

Thomas Macho

We are born into coldness and beauty combined: before the walls and the legs that open and then close again, a dreamlike mountain panorama of ice appears, far to the north in the Lofoten. The way we begin is the way in which we end: walking into the white, not into the dark. 'Out of the uncharted, unthinkable dark we came / And in a little time we shall return again / Into the vast un-answering dark', writes the deaf and blind Helen Keller in 'A Chant of Darkness', a poem published in 1908 in *Century Magazine*.[1] Her own understanding was that she had written a eulogy of the dark, not an elegy; darkness was white for Helen Keller, as it is for me in my encounter with A K Dolven's work: it takes on the form of a bright mourning, a white sensation of mortality and death.

Death is part of life: *when I discovered the end I wanted to live really long.* Certainly, life involves death, it is 'Being-towards-death' – but Heidegger erred at the crucial point: death is not simply our 'ownmost possibility'; it is also our most communal.[2] Dating back as far as the late Middle Ages, it was not only the awareness of the threat of the plague that manifested itself in the dances of death; more importantly, it was also the conviction that death may be experienced as the medium of community, as a celebration of a positively infectious equality that eradicates all social differences, accompanied by an equally infectious laughter that converts fear into the experience of a shared burden, literally the *Communitas* in the sense advocated by Roberto Esposito: *We are all mortal.*[3]

There lies hope in this thought; hope that, according to Cornelius Castoriadis, grounds the political visions of ancient Greece: 'For the Greeks, the fundamental thing is mortality. I know of no other language in which the word "mortal" signifies "human" and "human" signifies "mortal".... Among the Moderns, the fantasm of immortality persists, even after the disenchantment of the world. This fantasm has been transferred onto the idea of indefinite progress, onto the expansion of an alleged rational mastery, and is manifest above all in the occultation of death, which is increasingly characteristic of the contemporary age.'[4]

The will to overcome mortality ranges among the most elementary of obsessions, precisely within a secular, scientifically enlightened modernity. As portrayed by John Gray in *The Immortalization Commission: Science and the Strange Quest to Cheat Death* (2011): 'During the late nineteenth century and early twentieth century, science became the vehicle for an assault on death. The power of knowledge was summoned to free humans of their mortality.'[5] The followers of Spiritualism were many: professors of chemistry such as William Crookes, physicists such as Karl Friedrich Zöllner, and naturalists of the likes of Alfred Russell Wallace; and even the creator of Sherlock Holmes, writer and doctor Arthur Conan Doyle. Ironically, however, Doyle was discouraged when confronted with the scepticism of the magician Harry Houdini, of all people.[6] As advocated in a manifesto of the Russian cosmologists five years after the October Revolution: 'We take the essential and real right of man to be the right to exist (immortality, resurrection, rejuvenation) and the freedom to move in cosmic space (and not the supposed rights proclaimed by the bourgeois revolution in 1789).'[7] We may consider this particular period in history in connection with the Immortalists of the New Age movement, with Ray Kurzweil and his Singularity philosophy, and with those who based their enquiries on the potentiality of progress within the areas of computer science, robotics, and genetics; the Cryogenics and the Transhumanists.[8]

Contemporary popular culture concerns itself with the biopolitical phantasma of immortality in many ways. In genres like comics, sci-fi novels, films, television series and computer games, the immortals predominantly feature as vampires, werewolves or zombies, required to kill in order to preserve their immortal status. Nevertheless, the type of character in question becomes increasingly more likeable, as the *Twilight* saga, the television series *True Blood*, and Jim Jarmusch's film *Only Lovers Left Alive* illustrate. Herein is mirrored the persuasive power of the facts of a medical system which, alone for economical reasons, can stall the deaths of only a select few. Published in 1977 and made into a film by Stanley Kubrick in 1980, Stephen King's bestselling novel *The Shining* was followed by a sequel in 2013, in

which a group of Immortalists and Transhumanists prolong the lives of the members of their group by torturing others to death, preferably clairvoyant children. It is their opponents, however, that are more interesting still than the Manson Family/Voodoo-sect baddies; it is by no means a coincidence that the former group is staged within a hospice and the therein-practised culture of dying.[9] The mortals triumph over the immortals in King's new novel, an outcome that contrasts with our contemporary cultural reality. Besides being a masterly author, King is also a cultural critic: we find documented in his novel a gradual change of consciousness that has seeped into the arts; a consciousness that strives to render a *new visibility of death*,[10] based not on the shock value of *memento mori,* but on the access to new domains of communication among mortals – reflections on shared fear, vulnerability and grief. 'Come, let us talk together / those who talk, are not dead.'[11] In light of this, Gottfried Benn's tried-and-tested verses must be read anew, through fresh eyes; they call for the formation of a community of mortals who do not attempt to subdue and suppress, but instead strive to give shape to that curious interplay between Finality and Being-Alive.

Giving shape involves meditations on the phenomena of parting and of absence, as found in A K Dolven's series of photographs *3 february 2006 delhi*, and in her film installation *tilts only (his shirts)*. We are not confronted with effigies, nor portraits, or any 'literal representations' of an absence for that matter.[12] Instead, we see the shirts in the wardrobe and the shoes that were taken along on a journey. There is no invitation to lean on monuments, to let memory triumph over death; just an acute awareness of the traces that were left – the traces that we ourselves will one day leave behind. *when i leave the world behind.* To depart and to bequeath – the two are closely connected in Irving Berlin's song of 1915 that is referenced in the title of the blurry photos of the soles of shoes in front of a white background, evoking, it would seem, the physical presence of the feet. 'I'll leave the sunshine to the flowers / I'll leave the spring-time to the trees / And to the old folks, I'll leave the mem'ries / Of a baby upon their knees / I'll leave the night time to the dreamers / I'll leave the songbirds to the blind / I'll leave the moon above / To those in love / When I leave the world behind.'[13] The hundred-year-old song has a distinctive, cheerful melody. Little by little, it ascends, without pathos, without melancholy, tiny step by tiny step; and the attitude that it expresses towards death calls to mind – ever so subtly – one of Bertolt Brecht's last poems: 'When in my white room at the Charité / I woke towards morning / And heard the blackbird, I understood / Better. Already for some time / I had lost all fear of death. For nothing / Can be wrong with me if I myself / Am nothing. Now / I managed to enjoy / The song of every blackbird after me too.'[14]

Translated by Tessa Stevenson

1

Helen Keller, 'A Chant of Darkness', in *The World I Live In* (Auckland: The Floating Press, 2013), pp. 84–91, p. 84.

2

See 'possibility-of-Being' in Martin Heidegger, *Being and Time*, trans. J. Macquarrie and E. Robinson (Oxford: Basil Blackwell, 1962), p. 294, section 250.

3

Compare Roberto Esposito, *Communitas: The Origin and Destiny of Community*, trans. Timothy Campbell (Stanford, Calif.: Stanford University Press, 2010).

4

Cornelius Castoriadis, *The Greek and the Modern Political Imaginary*, in *Salmagundi*, No. 100 (Fall 1993) (Saratoga Springs: Skidmore College, 1993) pp.102–29, here pp. 117–18, http://www.jstor.org/stable/40548695 (accessed 10 December 2014).

5

John Gray, *The Immortalization Commission: Science and the Strange Quest to Cheat Death* (London: Penguin Books, 2011), p. 1.

6

Compare Bernd Stiegler, *Traveling in Place*, trans. Peter Filkins (Chicago: University of Chicago Press, 2013).

7

Boris Groys, 'Immortal Bodies', in *Going Public* (Berlin and New York: Sternberg Press, 2010), pp. 152–65, p. 160.

8

Compare *Werden wir ewig leben? Gespräche über die Zukunft von Mensch und Technologie*, eds. Tobias Hülswitt and Roman Brinzanek (Berlin: Suhrkamp, 2010).

9

Stephen King, *Doctor Sleep* (London: Hodder & Stoughton, 2013).

10

Compare *Die Neue Sichtbarkeit des Todes*, eds. Thomas Macho and Kristin Marek (Munich: Wilhelm Fink, 2007).

11

Translated from Gottfried Benn, *Gedichte in der Fassung der Erstdrucke*, ed. Bruno Hillebrand (Frankfurt am Main: Fischer, 1982), p. 467.

12

Carlo Ginzburg, 'Representation: The Word, the Idea, the Thing', in *Wooden Eyes: Nine Reflections on Distance*, trans. Martin Ryle and Kate Soper (New York: Columbia University Press, 2001), pp. 63–78.

13

Irving Berlin, 'When I leave the world behind', in University of Tennessee Library. Digital Collection. Sheet Music Collection. http://diglib.lib.utk.edu/utsmc/main.php?bid=1530 (accessed 28 November 2014).

14

Bertolt Brecht, 'When in my white room at the Charité', in *Poems 1913–1956*, eds. John Willett and Ralph Manheim with cooperation of Erich Fried (London and New York: Methuen, 1987), pp. 451–2.

he she
me
&
landscape

Jonathan Watkins

Anne Katrine Dolven has a house in Kvalnes, an hour's drive from Kabelvåg, on one of the Lofoten islands lying off the Norwegian coast, far above the Arctic Circle. Built according to local tradition, it backs onto the sea while facing a mountain range.

Together, on a wintry morning, she and I climbed the mountain closest to the house. I followed her as she strode up and up with typical resolve along the sheep trails, past rocks and hardy shrubs, until we reached the first ridge below which was a circular lake. Just jagged rocks now as we made our careful descent to the lake's edge and there, in the driving sleet and rain, Anne Katrine proceeded to shout the word 'Come', over and over, her strong voice combining with its echoes bouncing back from the slopes of other surrounding ridges and mountain peaks.

It was an extraordinary experience, watching this diminutive human figure pitting itself against a vast, tough landscape. Her shouts were essential, like animistic invocations in a kind of ritual call and response, binding human presence with its place in nature. Later, in the warmth of her kitchen, I asked Anne Katrine who was addressing whom in her shouts, thinking perhaps she was intending to give the mountains a voice. She replied simply that when people leave you, sometimes you yearn for their return in spite of the fact that you know they cannot come back.

•

please return (2014) is a new sound installation by Anne Katrine Dolven, a recorded version of what I witnessed that day by the lake. First shown as part of her recent solo exhibition at Ikon, Birmingham, at the top of a neo-gothic tower, it was reachable only by six flights of stairs. Not as testing as the mountain climb, but still requiring some physical effort, they led to a room that looked out onto the corporate precinct of Brindleyplace, high-rise buildings occupied by various banks, insurance companies and other financial institutions. There we heard the artist calling loudly – '… come … come … come …' – with ensuing echoes, and were thus transported far away from such an urban landscape to Lofoten.

The art work of Anne Katrine Dolven exemplifies a distinctly poetic vision. It is as unpretentious as it is philosophically ambitious in its representation of human presence foiled by sublime natural phenomena. It is derived from personal experience, inspired especially by the landscape of northern Norway, but in such a way as to encourage generalized observations on our place in bigger schemes of things. The same can be said for Peder Balke (1804–87), the nineteenth-century Norwegian painter renowned for his landscapes of the far north. Without resorting to the kind of religious symbolism that characterizes the paintings of many of his contemporaries, including Caspar David Friedrich, Balke was concerned to convey 'the beauty of nature … while humans – nature's children – play but a minor role, in comparison'. Balke's human figures are dwarfed by their circumstances, either very small in the landscape or with their presence implied by dwelling places or boats at the mercy of the sea. This is unquestionably a romantic vision, while being positivist in its celebration of a world that is usually, magnificently oblivious of humanity.

Dolven has identified with Balke as an artist for many years now, not simply because of the fundamental themes of his work conveyed through visions of the northern Norwegian landscape, but also because he is an ancestor of hers by marriage. While sharing his world view, Dolven puts the human condition more into the foreground of her work, dealing explicitly with the nature of perception and the subconscious functioning of memory and feelings. It is significant that she focuses on densely multisensory situations, in which her main subject is at once very present and resonant with 'lost time'. *please return* is a case in point, with its unsentimental expression of melancholy.

JA as long as I can (2012) is a kind of companion piece. A sound work, it embodies an abstracted physical presence to the extent that only two voices remain, those of a woman and a man – A K Dolven and John Giorno – like

two interacting shadows. Through a subsuming dialogue, they poignantly reveal personal histories, emotional states and cultural location. In *self portrait, berlin februar 1989 lofoten august 2009* (2010), an 8 mm film on video, we see Dolven in a similarly telling dialogue across time with herself.

The earlier footage was shot in West Berlin, overlooking the river Spree, which, in early 1989, was part of East Berlin. Here we see Dolven, standing cold and naked, as she turns the camera around her waistline until the roll of film is used up, all the time being watched by East German border police. The later footage, filmed twenty years on, features the artist making the same gesture with a camera on the mountain in front of her house, in the white light of an Arctic summer night, overlooking the sea.

This self-portrait is ostensibly an art work about the world beyond while being centred on the artist, and her place in time. Likewise, *when I discovered the end I wanted to live really long* (2013) is unashamedly self-referential, while touching on a mortality that concerns us all. Back-projected onto a small screen at the end of a long corridor, free standing in an exhibition space, the film's whiteness turns into movements of a body at a very low temperature, its nervous rhythm in sync with *Cold Genius*, an aria by British composer Henry Purcell that includes the words 'Let me, let me freeze again to death.' In the same vein, *vertical on my own* (2011), also made with 16 mm film, is a video installation by Dolven that depicts a long horizontal shadow, opening and closing, thrown onto a surface of brilliant white snow in an Arctic winter. The figure throwing the shadow is unseen, but their verticality, literally, is vital. The aesthetic result reassures as much as it impresses us with its beauty, signifying consciousness at a location that can be pinpointed – where verticality and horizontality meet – and sufficient strength to survive in adverse circumstances. Horizontality, a merging with the ground, would mean fatality. The minimalist style of this work belies its subtle message of defiance and optimism.

vertical on my own was made on the flat ground behind Dolven's house, where the mountains meet the sea. Like most of her work now, it conveys a fixation on this local landscape, a place that the artist refers to as her 'studio', a spiritual home. Balke visited the far north only once – incidentally stopping at Lofoten – in 1832, when he was a young man, but the effect on his subsequent practice was profound. He returned again and again to the same subjects, especially Mount Stetind and the North Cape with their extraordinarily stark elevations rising above (horizontal) combinations of water and rocks. This is a landscape shaped by ancient volcanic activity and the scouring movement of glaciers, breathtaking and beautiful in its simplicity. By combining her work with that of Balke in the Ikon exhibition, Dolven was engaging the older artist in a kind of conversation analogous to that which she had held with John Giorno in *JA as long as I can*. Conflating a here and now with a there and then, it was an extremely compelling proposition.

Balke's technique was highly unorthodox, developed out of his earlier profession as a painter-decorator. By smearing and scraping thin layers of paint over a smooth ground, he placed emphasis on surface while opening up vast pictorial, atmospheric space. His tendency towards a stylization of subject matter is epitomized by his black-and-white landscapes from the 1860s and 1870s, in which sea, clouds and sky, mountains, rocks, cliff faces, boats and birds are conjured up on small panels through an ingenious use of combs and fingers as well as brushes. Dolven likewise works with paint in ways not hidebound by convention. *teenagers lifting the sky* (2013) and *how to reach every corner* (2013), for example, involve fingerprints and smudges on areas of wide white space of the painting's ground. Such traces of human presence and movement are poignant as they convey an existential fact – 'I was here' – that engages us easily while providing evidence of someone else's unique identity.

just another day (2012) is a series of paintings that through their medium – layered colour on aluminium panels – small scale and minimalist, most obviously alludes to Balke. But as well as representing bleak landscape, the mix of gesso, cadmium orange and white oil paint results in a human skin tone. The panels bear the wounds of hammer blows, struck hard by Dolven into the surfaces that she has carefully prepared. These are the emphatic traces of an artistic act that refers at once both to the marks we make and the marks made on us through a lifetime.

time, sound and memory: the sheltering bell

Esther Kinsky

A bell against the night sky. The dark shape on a wire strung between two tall columns, against the luminous spring-and-summer blue of the northern night sky, against the bright illumination of the building in the background, a dark answer, its meaning as yet undisclosed, against the distant light of the universe suffusing the blue above, against the man-made light that endows the building with predictable meaning. A bell against the day sky, the brownish surface colour warm against the opaque grey of the winter sky, the uniform layer of clouds, against the snow-covered ground, criss-crossed by so many lines: footsteps, the tracks of bicycle tyres, pram wheels. Traces. A bell for ringing. For setting something in motion. A sound, a tune, out of tune with other bells. A pitch unto itself. A bell retrieved and reinstated into its function of sounding. A voice traced and reclaimed from oblivion.

'PLAY ME – SOUND ME – LIFT ME' encouraged a number of posters put up in Berlin in preparation of the work's installation in Oslo. The posters show a bell, greyish in a bed of glistening brown autumn leaves, against the backdrop of a landscape, a field, the edge of a winter forest, a white patch of water very far away. A landscape suited to the colour of the bell. A bell suited to the tune of the landscape. This was A K Dolven's invitation to help raise a voice that was nearly forgotten. The bell, once discarded, and now installed above the square in front of the National Museum in Oslo, should be rung, heard, taken to heart, like every voice.

I remember that as a child I thought I could see the air. My grandfather tried to explain to me that this was not possible. 'The air is invisible', he said. 'The air is as invisible as a voice.' Still, I held on to my conviction that I could see the air, its tiny, transparent particles of weightlessness circling and whirling in front of my eyes. Once we were walking past a church and the bells started ringing. It was a winter day, morning dawn, probably my grandfather had taken me along when walking my older sister to school. There was a thin layer of snow on the ground, bluish grey as the darkness gave way to light, criss-crossed by the feet of people hurrying to work, of schoolchildren, of old women in black

scurrying to church. When the bells set in, everything seemed to sway and tremble to the sounds that had no visible source but such an instant overwhelming presence, doubling and trebling, overlapping and separating, sending ripples through the dawn-coloured texture of the air, that I turned to my grandfather suggesting that now, surely, he too could see the air. Yes, he agreed after a while, as we were walking down the hill with the belfry at our back, now he had indeed very briefly seen the air. But only because of the bells, he added.

This little incident, nestling in some recess of my memory as a minor miracle of *making see*, came to my mind when I saw images of A K Dolven's installation *untuned bell* in Oslo. Was it the writing in the snow of intersecting tracks of footsteps that conjured up this scene from my childhood, or was it the bell itself? The anticipation of the sound it would make, so exposed and visibly ready to ring – by a pedal push, perhaps by the wind – and, with its ringing, bring something to mind, a memory, a vision, an insight? We will never know what it is that brings up a memory. What it is that 'rings the bell' in our minds to bridge immeasurable stretches of time gone by. The bell is one of the mysterious associates of our capacity to remember and to give shelter to things past in our brain. The bell that rings to allow us not to forget is both repository and dispenser of memory.

'Sound makes us see', writes A K Dolven in her description of her installation *out of tune* in Folkestone, where again a discarded bell, one that had been in service for almost five hundred years, was mounted on a wire between two steel columns. This time, the bell was set against the backdrop of the sky and the sea. It is a stark image, both beautiful – the slender steadfastness of the rust-covered columns, and the solid, rounded, compact shape of the bronze bell – and forlorn against the shifting, drifting greys and blues of sky and sea, a tender writing against oblivion spelled into a landscape exposed to the constant turmoil of erosion and erasure by the forces of nature. A bell that can be rung – traditionally by pulling a cord – to release its peal or knell against the noise of wind and waves appears forceful in its ambition and vulnerable

in its fragility. It makes a statement in the language that clapper and bell wall have taught each other over five hundred years of people's desire to mark joy, sorrow, danger, fear and relief with a particular sound, and sets this statement against the heaving and sighing of the indifference of nature. Appearing so fragile against the vastness of the horizon, it is a memorable monument to the human need and duty to remind and to remember, to warn against forgetting and to save from oblivion.

What is striking in *untuned bell* as much as in *out of tune* is the nakedness of the bell as an object. A bell is an instantly recognizable icon written into the repertoire of forms and shapes we are all familiar with, but we seldom see one just dangling in space, against the backdrop of sky or landscape, unhoused, unobfuscated by consecration, unencumbered by identifiable purpose. Most bells are housed in belfries – we know their sound rather than their sight; and where bells are visible – on ships, by gates and doors – their function is obvious. They are defined by expectation of alert or alarm. Or by the need for the measuring and naming of time – helpless pre-emptive actions against human forgetfulness. Exposed and bare as they are in the installations, juxtaposed with the angular frame of the columns, the bells stand out as sheltering shapes, harbouring their clapper-tongue, housing sound and memory. At the same time, they are marked by their singularity. They are one-offs, abandoned into oblivion, then lifted by the artist from their abandonment to become new instruments of art, of a new art of engaging with the Other. A K Dolven's installations with bells that have fallen out of tune with their time, and thereby out of favour, release the object from its bygone purpose as well as from its forsakenness. They liberate the bells into the singularity of their voices, but also offer liberation through the act of ringing, of setting free a sound we can entrust and endow with something of ourselves, be it joy, sorrow or anger. They encourage the freedom to choose a voice for a dialogue with the void in the hope of an answer.

I remember how, on a gentle sunny September day by a canal in Berlin, A K Dolven told me of her grandfather, who had for decades sailed the Southern Ocean around Antarctica as a cook on a whaling boat. When he was old and firmly based at home, he told his granddaughter stories of his time on the boat, of a life involved with places and incidents that must have seemed and sounded unbelievably distant and foreign to a little girl in Oslo. I imagine those afternoons of storytelling and listening were a first experience of embracing the foreign as something deeply associated with the grandfather, with the familiar. Bells may have played a part in these stories – the way they mark time at sea in different terms from counting the hours on land – and wind, and voices. Every reader of *Moby Dick* will be familiar with the drama played out in sounds and voices on deck and below, in the dark. Perhaps these exchanges of telling and listening were an initiation into the art form of dialogue that is so characteristic of A K Dolven's work, be it visual as in *change my way of seeing*, or aural, as in *seven voices* and *JA as long as I can*, or both, as in *moving mountain*. They are all carried by the fine-tuned exchange between taking and giving, acceptance and challenge, offering and blessing. They all – including the bell installations – strike me as forms of prayer, tentative invocations, coined somewhere between the very Ancient and the very Now, outside all denominations and currencies of religion, and relying on angels, the carriers of messages as yet undisclosed.

So much in A K Dolven's work seems to be about waiting. Patient waiting in the sense of leaving room for things to happen. Unconditional anticipation. Offering a bell, an image, a word, a sentence, a sound, then listening out for the voice that nature, coincidence, history find to respond. Listening out for a response from a space that holds answers to all prayers, be they forgotten, forsaken, foregone or unsaid.

archive

info

vertical on my own
2011
16 mm film transferred to
HD large-scale video projection
with sound
2 min 55 sec
Edition 5 + AP

A long horizontal shadow stretches from one side of the frame to the other. We know that only something vertical can cast a horizontal shadow. A human standing upright in the Arctic winter throws extremely long shadows in the full moon or the low sun of the winter. The shadow moves, opens and closes on the snowscape. The soundtrack consists of an unedited recording of non-lingual sounds made by a human voice.

A large-scale video projection, stretching from wall to wall and floor to ceiling; 11–15 metres. The sound should almost be inaudible. The image may be cropped to fit the wall space. The sound is issued from two speakers, positioned on the walls to either side of the projection.

The installation is ideally situated in a narrow room and projected by means of two overlapping projectors.

pp. 48–51 Galleri Bo Bjerggaard, Copenhagen

Filmed in Kvalnes, Lofoten Norway

Supported by
Norsk Filminstitutt

Camera
Jakob Ingimundarsson

Edit
A K Dolven / ProAV

Voice / Sound
Eldbjørg Raknes /
Stian Westerhus

Performers
Tale Dolven, Federica Por

> 'Moments change us, more so than time.'
> Charlotte Wolff

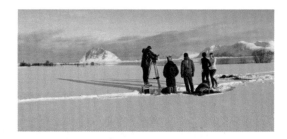

amazon
2005
16 mm film, mute
1 min 34 sec
Edition 5 + AP

amazon is a 16 mm film projection of an androgynous figure shooting a bow and arrow. A fast edit gives the 1 min 34 sec film the sense of a single shot. The camera is intimately close to the body: neck, chest and arm muscles snap between tension and rest. The camera exposes the torso as that of a single-breasted woman. In harsh sunlight, the woman relentlessly shoots arrow after arrow. Her target is never visible. *amazon* makes reference to the Greek myth of a matriarchal society, brave female warriors who are said to have cut off one breast to hit their target better. It was conceptually edited (150 cuts, some just 4 frames) after the second movement, Allegro Molto, of Shostakovich's String Quartet no. 8b in C Minor, op. 110, a score composed following a visit to Dresden, where Shostakovich was confronted with the devastating effects of the bombing of the city during the war. In the end, however, the film is mute.

A 16 mm projector with 50 mm lens runs the film on a looper, projected on the wall in a darkened room. Size 58 × 78 cm.

A single black extension cable runs from the table to a power socket nearby. There should be a generous length of cable loosely coiled on the floor.

Although the film is mute, it is accompanied by the sound of the projector that stands in the space.

pp. 54–5 carlier I gebauer, Berlin

Filmed in south Sweden outside Malmø

Camera
Vegar Moen

Edit
A K Dolven and Ulrike Mu

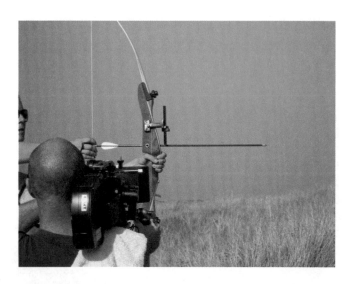

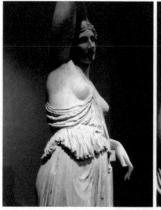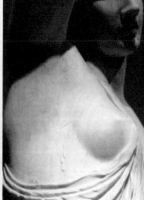

Wounded Amazon, by Polykleitos of Argos, Altes Museum Berlin

k	description	installation	info

o reach every corner

aluminium
250 cm

The artist reinvents a title that she originally used twenty years ago for a painting. The work shows the artist performing in her studio. The centre of her body is aligned with the centre of the painting. With black and white oil paint on both hands, she stretches to the four corners of the work. Oil on anodized aluminium and gesso are applied in the same way as in the work *don't worry I'll lift the sky*.

The painting is to be mounted so that its centre is aligned with the centre of the adult onlooker's body (relatively low).

pp. 64–5 Wilkinson Gallery, London

Painted in the artist's studio in Laburnum Street, London

'My binoculars would hang on the studio wall in Berlin. I looked across the river Spree – at the guards on the other side in their watch towers. I sometimes waved but they never waved back. There were always two. The smallest ripples on the water would make me look extra carefully to see if it was a bird or a person.'

A K Dolven, Berlin, 1988

g with eyes closed

aluminium
30 cm

Performative act where the artist struck the aluminium, with varying strength.
The traditional oil paint on gesso is here applied with flat tools rather than brushes.

Unframed, installed directly on the wall at head height.

p. 68 OSLcontemporary, Oslo

Painted in the artist's studio in Laburnum Street, London

worry I'll lift the sky

aluminium
250 cm

Several coats of white titan oil paint with a tint of cadmium orange are layered horizontally on a coat of gesso on anodized aluminium.
It is not until several years later that the artist applies the black and white oil paint as a performative act; with paint on both hands, she stretches to her utmost limits, applying paint to the upper edge of the painting.

The upper edge of the painting should be 235 cm from the floor. If possible, a title, handwritten in pencil (ideally by the artist herself), should be located beneath the painting.

p. 69 OSLcontemporary, Oslo

Painted in the artist's studio in Laburnum Street, London

'Round and round
the merely going round.
Until merely going round is a final good.'

Wallace Stevens, *Collected Poems*

the day the sky became my ground
2009
16 mm film projection, mute
9 min 42 sec
Edition 5 + AP

The film is shot in one take on 16 mm film. A young girl spins continuously in a cold, white and icy landscape. Except for pale-green trainers on her feet, she is naked. She swirls without stopping, while the camera moves slowly from the crown of her head down to the trainers on the snowy ground. The film strip itself has been reversed and mirrored, resulting in an inverted image where the sky becomes the ground and gravity itself is turned on its head. No longer on snow, she spins on clouds. Filmed facing the sun, the image is intermittently bleached; her body, sometimes obscured, becomes one with the landscape. The camera movement is steady and repetitive.

Projected on a white wall in a partially dark space. The dimensions of the projection are variable (minimum 3–6 metres wide), but span from floor to ceiling. The film is mute, only the sound of the projector can be heard; its sound references the spinning motion. The projection can be exposed to natural light, which may vary during the day and make the image paler.

pp. 70–1 Wilkinson Gallery, London

Filmed at Stolpestad, Nor▮

Camera
Jakob Ingimundarsson

Performer
Tale Dolven

Still cameras
Dana Munro, Kristian Sky▮

'Winter is an abstract season: low on colors [...] and big on the imperatives of cold and brief daylight. These things train your eye on the outside with an intensity greater than that of the electric bulb availing you of your own features in the evening. If this season doesn't necessarily quell your nerves, it still subordinates them to your instincts; beauty at low temperatures is beauty.'

Joseph Brodsky, *Watermark: An Essay on Venice*

bring me back
2007
3-screen HD video
with synchronized
13 min 44 sec
2-channel audio

The middle screen shows people and cars passing. The morning sunlight throws a long shadow, and all seem busy and purposefully moving forward. The cityscape provides the soundtrack. In the urban bustle, a female voice humming a simple melody is suddenly heard, and a second projection appears to the right of the first. Here, in another part of the city, a group of young people is carrying a woman backwards across the road. The woman is horizontal on her back, feet forward, and the others form a human bridge, constantly moving from the back of the group to the front, so that she can glide over their bodies. This ritual later continues in the centre screen, and eventually in the left-hand screen. The right- and left-hand screens disappear immediately when the woman's journey reaches the edge of the frame, while the central one shows the busy yet calm rhythm of daily life.

The three-screen HD projection is installed in a corner of the room, on two walls forming a 90-degree angle. Two screens are shown on the left-hand side wall, and one on the right. The projection is aligned flush with the surface of the floor, and the screens spaced 20 cm between each and from the corner.

Seating is provided for viewers in the form of an iron-and-wood park bench, placed facing the corner, about 4 metres from the left-hand side wall and centred with the left screen. A pair of concealed speakers provides audio.

pp. 78–9 Anhava Gallery, Helsinki
pp. 86–7 Théodore Géricault, *The Raft of the Medusa*, 1819, Musée du Louvre, Paris

Shot in Brussels, Belgium

Performers
Tale Dolven, Clinton String
Bostjan Antoncic, Ihar Shy
Benjamin, Justin François,
Ellen Våland Mauritzen

An international group of friends living in Brussels

ad
3
video projected on a
m tilted screen,
in 43 sec
ideo on monitor,
ns looped
annel audio
cue blankets on floor
on 5 + AP

A three-part installation consisting of a large-scale HD video projection, a separate video on a monitor placed on the floor and an intermittent soundtrack from speakers placed on the floor. There are a number of thick rescue blankets on the floor for the audience to sit on.

Shot in a single take and without edits, the scene shows an untouched snowy hillside in the Arctic. A group of young people appears in the bottom of the screen, carrying another young woman backwards towards the top of the frame. Dressed in casual clothes, they move through the snow, forming a human conveyor belt and taking turns at the front of the procession. The woman glides over their bodies, feet forward, progressing through the frame. The prints and tracks they leave behind records their task. The second part of the work is an examination of the detail of the first scene. A hand-held video camera records details of the large projection, in a fast-paced edit. The quality of the resulting image – recorded, projected, re-recorded is finally displayed on a small monitor. The sound, a female voice breathing in now and then, is out of sync with the projection. The observation in the monitor draws attention to some of the less obvious elements of the story, bringing up selected aspects and assembling them into a new body.

The projection is shown on a 9:16 screen which is 6–8 metres in height, depending on available space. The screen leans against the wall at an angle of approximately 30 degrees, filling the available space floor to ceiling. The screen is constructed from aluminium.

The projection is played from uncompressed HD video files from a HD-ready PC. The sound from the speakers placed on the floor is played back via two active speakers connected to the PC, or using an amplifier.

The monitor part is displayed on a black CRT monitor or a simple TV set. Rescue blankets local to the national location of where the work is installed are spread on the floor.

pp. 88–9 LABoral Centro de Arte, Gijon

Video shot in Rekdal, Lofoten, Norway

Monitor reshot in Helsinki

Camera
Jakob Ingimundarson

Still camera
Kjell Ove Storvik

Voice
Thora Dolven Balke

Sound
Chris White

Video monitor edit
Thora Dolven Balke

Performers
Tale Dolven, Clinton Stringer, Federica Porello, Igor Shyshko, Bostjan Antoncic, Ivan Castiñeiras

of balance
3
ogue black-and-white
tograph on baryté paper
31 cm
on 3 + 2 AP

A hand-held Hasselblad camera, shooting 6 × 6 negative film, is turned around a body. The body is a blur and the focus is in the distance (an open seascape or mountains in the background).

The photographs are installed in white box frames, roughly on the level of the onlooker's torso.

Photo taken high up in the mountains, Kvalnes, Lofoten, Norway

Production
Laboratoire Cyclope, Paris

Printed in cooperation with the artist

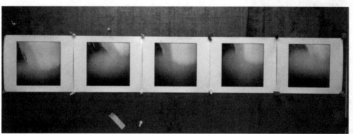

At Laboratoire Cyclope, Paris

'Who, if I cried out, would hear me among the Angelic Orders? And even if one were to suddenly take me to its heart, I would vanish into its stronger existence. For beauty is nothing but the beginning of terror, that we are still able to bear, and we revere it so, because it calmly disdains to destroy us. Every Angel is terror.'
Rainer Maria Rilke, *Duino Elegies*. © 2001–9 A. S. Kline, All Rights Reserved.

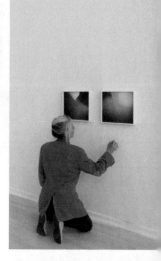

the clock
2003
Series of 4 prints
Photogravure
78 × 96 cm
Edition 24 + AP

The work is based on an action in the artist's studio that took place in cooperation with photographer Vegar Moen: a large plastic clock was thrown around in the room. Polaroid pictures were taken and later transformed into etchings in cooperation with the Niels Borch Jensen Editions print workshop in Copenhagen.

Four prints are installed in white box frames. They are hung in a row, relatively high up so that the viewer must look up at them.

pp. 96–7 Artist's studio, London

Performance photographed the artist's studio in Laburnu Street, London

Print
Niels Borch Jensen Editions Copenhagen

Camera
Vegar Moen

Supported by
Galleri Bo Bjerggaard, Copenhagen

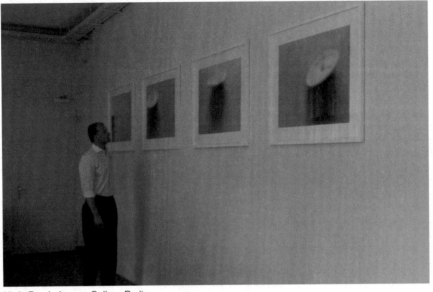

Niels Borch Jensen Gallery, Berlin

portrait of the artist as a young woman
2006
Polaroid

A plait of the artist's hair as a young girl is photographed in the artist's studio, together with a wig. The images are shifting in focus and are in either colour or black-and-white film.

One of the plait images was used on the back of T-shirts for Moldejazz, 2006.

pp. 98–9 Artist's studio, London

Photographed in the artist's studio in Laburnum Street, London

Camera
Vegar Moen

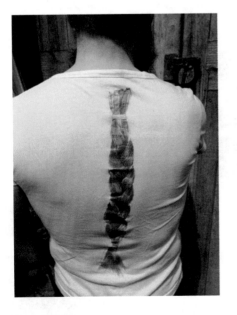

'The dramatis personae of his poems are not so much human beings as sighs, rays of light, optical images, and above all, those nonmaterial impulses and messages he calls "spirits". A theme by no means "light" such as the suffering of love, is dissolved into impalpable entities that move between sensitive soul and intellectual soul, between heart and mind, between eyes and voice.'

Italo Calvino, *Six Memos for the Next Millennium*

lack
n aluminium
30 cm

This A4-sized oil painting is part of an ongoing project by the artist since the 1990s, named 'A4 oil painting for travellers'.

For individual use by travellers, the painting can be placed on any wall or on any shelf in any room.

pp. 102–3 Wilkinson Gallery, London

Painted in the artist's studio in Laburnum Street, London

ing with eyes closed II
4
n aluminium
30 cm

These three black paintings are the result of a performative act where the artist struck the aluminium with varying force.

The traditional oil paint on gesso is here applied with flat tools rather than soft brushes.

Unframed.
Hung directly on the wall at eye level.

p. 104 Wilkinson Gallery, London

Painted in the artist's studio in Laburnum Street, London

'The eye hath this sort of enjoyment in winding walks, and serpentine rivers and all sorts of objects, whose forms, as we shall see hereafter, are composed principally of what, I call, the waving or serpentine line. Intricacy in form, therefore, I shall define to be that peculiarity in the lines, which compose it, that leads the eye a wanton kind of chase, and from the pleasure that it gives the mind, entitles it to the name of beautiful.'
William Hogarth, *The Analysis of Beauty, Written With a View of Fixing the Fluctuating Ideas of Taste*

From the artist's studio wall

ing with eyes closed I
4
n aluminium
30 cm

'Gradually, your whole physical being seems to expand into the undefined and vast velvety blackness. For the non-claustrophobic, this unexpected feeling of floating is mostly a pleasant sensation, fit to denounce all negative connotations that our culture reflexively attributes to all matters black.'
Gaby Hartel, 2014

Unframed.
Hung directly on the wall at eye-level.

p. 105 Wilkinson Gallery, London

Performed and painted in the artist's studio in Laburnum Street, London

nagers lifting the sky
4
n aluminium
× 500 cm

Performed by the artist in her studio. On the untreated anodized aluminium, finely washed in thin oil, the artist moves from left to right along the five-metre-long diptych, using her bare hands as tools.

The painting is installed above adult head height.

pp. 106–7 Wilkinson Gallery, London

Painted and performed in the artist's studio in Laburnum Street, London

nge my way of seeing
ing is about thinking
1/2014
n aluminium
× 40 cm

'The paintings seem to resonate with the sunlight transmitted through the painter's eye onto the sensitive plate of the work itself. It is a hazy, misty, lively light.'
Gaby Hartel, 2011

Like frames on a roll of film or notes in a musical score, these works have their individual existence as well as coming together to form a whole.

The paintings can stand as individual works, or they can communicate with one or more of the others.

The paintings have been permanently installed in the foyer of the concert hall in Stormen, the cultural quarter of Bodø.

pp. 110–13 Artist's studio, London
pp. 114–15 Stormen Concert Hall, Bodø

These paintings were all done in daylight. The first were produced in the early morning, in the artist's studio in Laburnum Street, London. The majority were made over several summer months in 2014 in her studio in Kvalnes. Two of the paintings have a dark

**change my way of seeing
seeing is about thinking
(cont.)**

A K Dolven

change my way of seeing

PART II
10.02.11 – 26.02.11

www.akdolven.com/changemywayofseeingII.html

palette, while the remaining
images have a soft – nearly
white – palette. The alumini
panels bring the daylight in
which they were painted in
the space. Their horizontal
orientations are made with
classical oil paint on gesso,
applied not with a brush, bu
large palette knife. Some h
traces of a physical attack
made on them by the artist
Together, they form one bo
of work, 7 × 8 metres, and
be read either as individual
paintings or as a unified wh

Card made for visitors to MGM Gallery, Oslo, 2001, with a link to a text about the work

Granite boulder
19 tons

The found 19-ton boulder sits on the ground inside Stormen Concert Hall.

The heavy boulder is placed on the lower-ground floor in the concert hall. As the heart of the building, it becomes a place to meet. The boulder was placed inside the building before it was closed, like a ship in a bottle. There is a lightness to the wall of paintings, above the boulder, rising through two floors. The piece encourages the viewer to gaze upwards.

Boulder donated by Gunn Helmersen from her land a the sea in Gildeskål, north of Norway

Project manager
Magnus Jorde

Transport
Nordlandskrana

Produced by
KORO

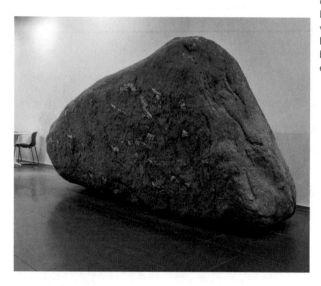

horizontal painting
2015
Oil on aluminium
125 × 500 cm

The oil painting consists of a washed-out layer of paint, upon which the artist has applied more paint with her bare feet.

The installation stands freely in the space. The diptych rests horizontally on knee-height ready-made objects – if possible, used monitors. The objects are placed flush with the edge of the work on both ends and in the middle. A smaller object provides support in the middle. A black speaker, but also other equipment or ready-mades, may be used.

pp. 116–17 Artist's studio, London

Performed in the artist's stu Laburnum Street, London

Supported by found objects the studio

'There is something primordial about travelling on water, even for short distances. You are informed that you are not supposed to be there not so much by your eyes, ears, nose, palate or palm than by your feet, which feel odd acting as an organ of sense. Water unsettles the principle of horizontality, especially at night, when the surface resembles pavement.'

Joseph Brodsky, *Watermark: An Essay on Venice*

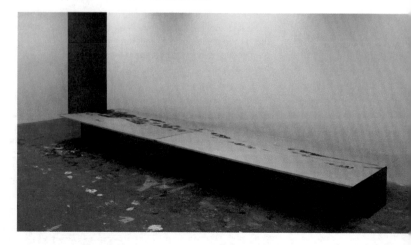

ack I II III IV

n aluminium
29 cm

Inspired by a walk in the dark, these new black works were developed for Ikon Gallery during the autumn and winter of 2014/15. These A4-sized oil paintings, entitled 'A4 oil painting for travellers', is part of an ongoing project, dating back to 1990.

The work will be installed among Peder Balke's small black-and-white works in the Ikon Gallery show in 2015. For individual use by travellers, the painting can be placed on any wall or on any shelf in any room.

pp. 118–21 Artist's studio, London

Painted in the artist's studio in Laburnum Street, London

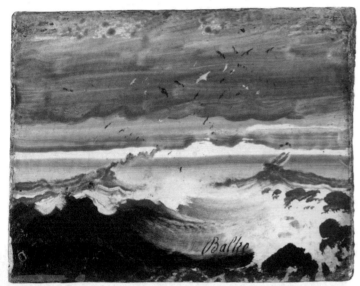

Peder Balke, *Fugleflokk over opprørt hav*, 1870, 8.5 × 11 cm, oil on wood. Nationalmuseum, Oslo

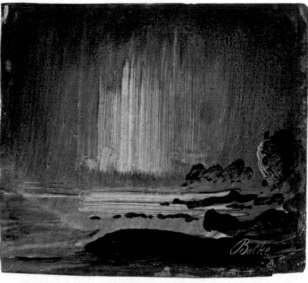

Peder Balke, *Nordlys over klippekyst*, 1870, 10.5 × 12 cm, oil on cardboard. Nationalmuseum, Oslo

head of a woman and
central station
illustrated)

al print
× 180 cm

In 1993 the artist made her first Super 8 film, *forehead of man and winter mountain wall*. Twenty years later, she approaches the title again, reinventing it in black-and-white photographs and with herself as subject. The artist's forehead appears at Oslo Central Station.

During her professorship at the National Academy of Fine Art, Oslo, the work was shown in the context of a Christmas calendar project made by her students. It was displayed in a glass encasing for twenty-four hours, outside Oslo Central Station.

Photo taken outside Oslo Central Station, night-time

Camera
Vegar Moen

lose your physical eye so that
u first see your painting with
ur spiritual eye. Then bring
 light what you saw in the
rkness, so that it may act on
hers, from inside to outside.'

spar David Friedrich, quoted in Hubertus
ssner (ed.), *Die Erfindung der Romantik* (Essen
 Hamburg: Museum Folkwang and Hamburger
nsthalle, 2006), p. 130 (quote translated by
by Hartel)

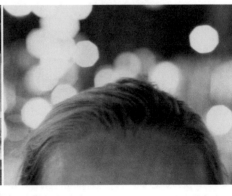

forehead of woman and oslo central station, 2013

forehead of man and winter mountain wall, 1993

**when I discovered the end
I wanted to live really long**
2013
Black-and-white 16 mm film
1 min 29 sec / 25 fps
Edition 3 + AP

The film shows the artist performing in the Arctic winter, captured by a 16 mm camera positioned behind her. The film has to be wound up manually in the camera, and runs for maximum of 20 seconds for each take. Due to the cold weather, the film runs at variable speeds, the flashing frames and overexposed material reference the extreme conditions on site. The situation, both technical and practical, informs the nature of the work.

The whiteness in the film turns into nervous movements of a freezing body – the rhythm is taken from Henry Purcell's 'Cold Genius'– aria in his opera *King Arthur*: 'Let me, let me freeze again to death.' The work, however, is mute.

Two long free-standing white glossy walls make a 'V' shape in the exhibition space. The construction lead us towards an end where a back-projection of a black-and-white 16 mm film appears on a small-scale screen.

The film is part of this whole installation. The size can vary depending on the exhibition space, but the length of the walls are preferably between 5 and 8 metres and 120–150 cm tall.

The V-shaped structure is built of wood, with a smaller end wall that is 80–100 cm wide. Inside, the structure is white and glossy. Outside, the natural wood and the support of the walls are visible.

In the end wall, a 58 × 78 cm rectangular is cut out. A screen is installed for back-projection of the work. The 16 mm projector with looper is placed on a supporting table of steel (no plinth). Floor and ceiling already exist in the space. The audience can walk inside, as well as around the structure.

pp. 124–9 CCC de Tours, Tours

Film shot in Vestvågøy, Lo
Norway, in February 2012
Camera
Vegard Moen
Edit
A K Dolven and Ulrike Mü
Post-production
DeJonghe, Kortrijk, Belgi

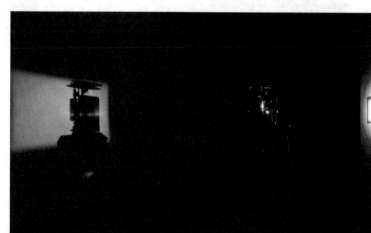

I want to live really long
2012
Oil and pencil on aluminium
29.7 × 21 cm

The painting is made of titan white oil paint with a tint of cadmium orange. The artist's handwriting is partly visible in the paint. The A4-sized work reflects the idea of oil paintings for travellers – a recurring theme in the artist's practice.

The painting is installed at eye level.
pp. 130–1 OSLcontemporary, Oslo

Painted in the artist's studi
Laburnum Street, London

nly (his shirts)

m film
22 secs looped
n 5 + AP

'*tilts only (his shirts)* is a mute 16 mm film projection that explores a sense of longing. The camera is fixed on the flimsy surface of a man's shirts hanging side by side on a rail. The closeness of the lens creates optical distortions that render the camera's object at once familiar and strange, intimate and distant. The tangibility of the shirts is fleeting. In their place there is an abstract, almost infinite colour field of lines and stripes that echo Barnett Newman's *Onement*. The camera's tilting movements are repetitive and relentless, looking its object over, again and again from top to bottom, in a mechanical yet erotic gaze.'
Nina Perlman, 2007

There are two installation forms for this work:

16 mm film projected on a wall from a 16 mm projector with looper. Dimensions variable.

Video projection from DVD, size approx. 100 cm wide, 30 cm from floor.

pp. 132–3 Camden Arts Centre, London

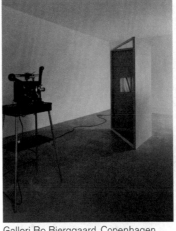

Galleri Bo Bjerggaard, Copenhagen

Filmed in the artist studio, Laburnum Street, London

Camera
A K Dolven

vors at the lake

m film
43 sec
t photograph
220 cm
n 5 + AP

'*survivors at the lake* is a two-part installation: a 16 mm film titled *snøflekker* and a large-scale framed photograph.

The film was shot in summer. The photograph was taken in the winter in the same location from the same position. Possibly the two spots of snow in the film are left over from this winter landscape or they are covered with snow in the photograph and might reappear next season.

snøflekker (2005), depicts a micro-event. On the background of a desolate mountainous landscape we find two patches of snow that have survived in the hillside above the calm Arctic lake. While the blank surface of the waterline receives a breath of wind, the stone face of the mountain slope remains unimpressed. It is a sort of visual *haiku* poem, summing up the truth of a moment by elementary narrative means. *snøflekker* verges in its very constitution on nothingness. The laconic narrative opens up several questions: is it a *memento mori*, a depiction of life's brevity? or a meditation on the universes we can find inside a drop of water? is it the first sign of winter, or the arrival of spring? The almost-still image of the dramatic, Norwegian setting resonates in 19th-century national romantic landscape painting, and the way it would make grand claims of historic continuity. Here, the land which held the bones of her forefathers would look back at the beholder. In Dolven, we are more likely to identify with the snow spots. Sometimes it takes so very little to become a witness.'
Lars Bang Larsen, 2006

Film and photograph are installed in the same room with daylight (or close to daylight).

Projection size: 33 × 45 cm

76 mm lens on 16 mm projector

Photograph size with frame: 177 × 220 cm

In official viewing, the two parts must be shown together. In private viewing, the film can be played from hard disc on a small digital screen. The large-scale photograph might be placed in another space.

pp. 136–7 Galleri Bo Bjerggaard, Copenhagen

Location for the film and photograph: 700 metres up the mountains at Kvalnes, Lofoten, Norway

Camera
Vegar Moen

In 2014, the artist found a book of Kittelsen in her family home. She discovered that, in her youth, she had made notes with a pencil next to the drawing that Kittelsen made of two spots of snow in the mountainside above a lake.

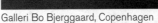

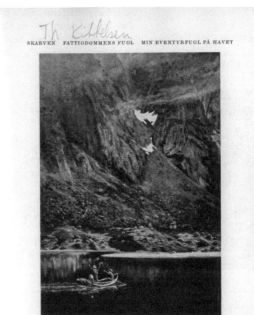

work	description	installation	info

3 february 2006 delhi
2006
4 × 5 in transparency film

A pair of men's shoes is placed at the entrance of shops in Delhi. The artist travelled to Delhi with her cameraman and friend Vegar Moen. The artist shows the following text, written in her sketchbook, to the shop owners: 'My husband died / He has never been here, may I take a photo of you with his shoes?'

As of yet, the work has not been shown. It materialized during the making of this book.
pp. 142–5 Artist's studio, London

Photographed in Delhi, Ind
Camera
Vegar Moen

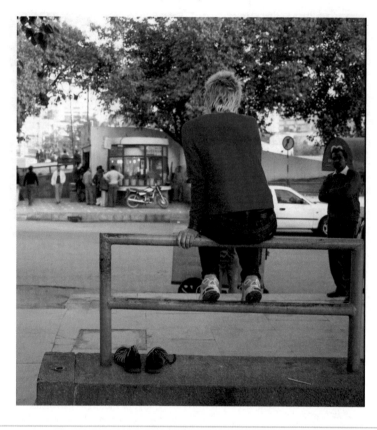

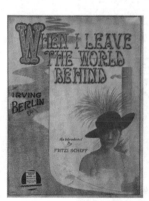

when I leave the world behind
2006
Series of 24 framed prints
Photogravure
Somerset White Satin 300 gsm
57.4 × 42.5 cm
Edition 12 + AP

All the shoes belonging to one man were mounted on nails in the artist's studio and photographed out of focus with a Polaroid camera. They were later transferred and printed to photogravure by Nils Borch Jensen Editions, Copenhagen. The title for the work is taken from the song by Irving Berlin (1888–1989), 'When I leave the world behind' (1915).

Framed prints installed in a long row just above eye level.
pp. 146–9 Art Basel, Basel
(below) South Karelia Art Museum, Lappeenranta

Photographed in the artist'
studio in Laburnum Street,
London
Camera
Vegar Moen
Print
Niels Borch Jensen Edition
Copenhagen

[1st verse]
I know a millionaire
Who's burdened down with care
A load is on his mind
He's thinking of the day
When he must pass away
And leave his wealth behind
I haven't any gold
To leave when I grow old
Somehow it passed me by
I'm very poor but still
I'll leave a precious will
When I must say good-bye

[chorus]
I'll leave the sunshine to the flowers
I'll leave the springtime to the trees

And to the old folks, I'll leave the mem'ries
Of a baby upon their knees

I'll leave the night time to the dreamers
I'll leave the songbirds to the blind

I'll leave the moon above
To those in love
When I leave the world behind …

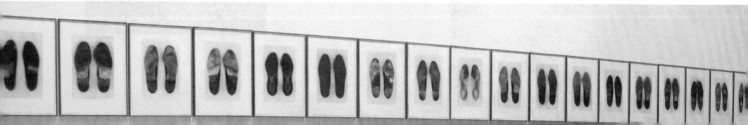

2

drawing with pencil

This text was written for a book produced by students at the National Academy of Fine Art, Oslo. They ran a small gallery under a staircase called Semi-colon.

()

As long as you breathe – *så lenge du puster* – you can.
You can feel something so close.
And it makes you think.
You want something as long as you breathe.
More than anything you want to enjoy as long as you are breathing.
And you can still see.
If you can no longer see, you can hear – see with your hearing.
And then, when you breathe and see, new thoughts are produced.
Change my way of seeing – seeing is about thinking.
To see is to think, says John Cage.
I have been there, in hell.
Two and a half times I was there.
I could not breathe and I managed.
Not everybody around me managed.
In this confined space, where hell was, we created different things to look at.
We did it instinctively – spontaneously.
There was already something to look at when we entered the room; a Madonna painting.
That was the first thing I noticed.
It was straight ahead on the wall.
And nourishment, of course, nutrition is necessary.
There was little food, but what we had, we prepared as beautifully as we could, even in a paper cup (sick bowls) we did it as nicely as we could.
Nothing left to chance.
For there was something to arrange, but we were in hell.
This is how we could think ahead
The others (who also survived) did the same.
I discovered that we all put items together in a beautiful and thoughtful way.
More thoughtful than usual, we spent time on this in a different way than before.
A flower near a book, which was on top of another book, next to a small cotton scarf, on a tiny table.
Now as I am writing, I am sitting on an airplane.
A few years have passed since I was in hell.
We're going to Vaasa from Helsinki. A propeller plane. It's only in the aisle I am able to stand up; otherwise it is low and very stuffy. But here we are, together. We get something to drink. In cardboard cups decorated with modernist flowers on a baby blue background. It works, it's actually stimulating. If the engine had had enough food, an unlimited amount of fuel and we could have stayed for a few days up here in this room, I would have organized myself better. I probably would have put my coat and bag away differently and observed my surrounding from a different angle. I may have also stood between rows seven and eight, in the middle of the plane, and given a performance. The others could have presented things they wanted others to look at, and then we would have the conversation going. We could have had a nice time together in this narrow fuselage. Perhaps I would have made new friends for life, in this

Stretching from floor to ceiling, the text is written directly on the wall by hand with pencil, ideally by the artist. Preferably, the writing starts in the top left-hand corner.

pp. 150–1 Wilkinson Gallery, London

The text was written in a sketchbook on a flight from Helsinki to Vaasa in Finland.

'There are in our existence spots of time,
That with distinct pre-eminence retain
A renovating virtue, whence, depressed
By false opinion and contentious thought,
Or aught of heavier or more deadly weight,
In trivial occupations, and the round
Of ordinary intercourse, our minds
Are nourished and invisibly repaired;
A virtue, by which pleasure is enhanced,
That penetrates, enables us to mount,
When high, more high, and lifts us up when fallen.
This efficacious spirit chiefly lurks
Among those passages of life that give
Profoundest knowledge to what point, and how,
The mind is lord and master – outward sense
The obedient servant of her will. Such moments
Are scattered everywhere, taking their date
From our first childhood.'
William Wordsworth, *The Prelude*

()
(cont.)

stuffy situation. Unfortunately the trip is only 50 minutes, so it's not happening. We have no time to take in the small space together. But a little, a kind of community develops, we smile at each other, nod, greet and help lift things up and down if necessary.
Outside there is an enormous landscape. Lots of lakes, expansive space and long stretches of roads; endless tracts of forest.
A K Dolven, October 2011

just another puberty
2014
Oil on aluminium
250 × 125 cm

In 1999, the artist made a video work based on Edvard Munch's *Puberty*.
Puberty as a phenomenon reoccurs in the artist's painting, made fifteen years later. Here, the artist performs herself, using her bare hands as tools to apply the oil paint to the aluminium.

The work should be hung at a low level, roughly 22 cm away from floor.

Cover image Wilkinson Gallery, London

Performed and painted in artist's studio in Laburnum Street, London

A K Dolven, *puberty*, 1999. Still from video.

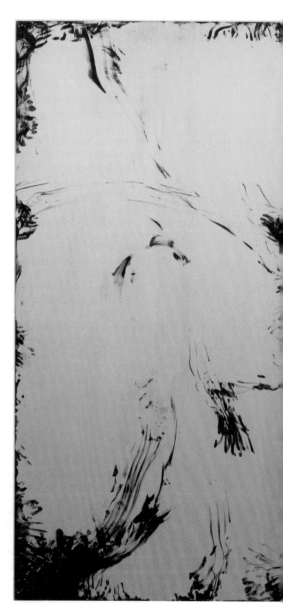

A K Dolven, *just another puberty*, 2014

a political painting

aluminium
250 cm

Using only her index finger covered in cadmium-red paint, the artist worked on a similar surface to the painting entitled *don't worry I'll lift the sky*. Starting in the top left corner, moving horizontally to the other side, the artist works until no paint is left on her finger. The subject of free movement informs this painting. Whether or not we can move freely defines who we are. The question of free movement concerns us all; and we find it here, raised within the context of a painting.

The red spot
It's all about that red spot. An abstract red spot, just beneath her open mouth, as if she wanted to say something but was stopped a long time ago. The red spot makes me think and reflect more than any words from a mouth.

The Finnish artist, Helene Schjerfbeck, was in her 80s when she painted *Self-Portrait with Red Spot* in 1944. She knew what she was doing; it's painted with such conviction. The spot is a convincing mark from a hand holding a paintbrush. Not a soft one, but a solid and steady paintbrush: a tool. This red spot is political.

Helene was talented – everyone knew that from the start. At 11, she was enrolled at the Finnish Art Society Drawing School. She went to Paris at the age of 17 with a travel grant from the Imperial Russian Senate and took part in major group shows. My compatriot Edvard Munch did the same. They were born a year apart. He died in 1944, she in 1946. Munch was supported early on by major collectors. Helene had her first solo show in her 50s, thanks to the Finnish art dealer Gösta Stenman.

This painting is also about the black eye: an eye larger than the mouth, an eye that tells about more than just seeing. Seeing is about thinking, according to John Cage. This eye has seen a lot. It's as if all her thinking is present in that black eye. The other eye is washed out. One large black eye is enough.

The red spot is the painting. It has followed me ever since I first discovered this painting in a book when I was a young woman. The shadow in Munch's *Puberty* (1894–5) made a similar impact on me at the time. It's not the look in his young girl's eyes, but the shadow, the oversized misshaped shade behind her: that is the painting – like the red spot. In 2013, I stood in front of *Self-Portrait with Red Spot* for the first time, in the Ateneum Art Museum in Helsinki. Glass covered the painting. I took a photo with my phone – my self-portrait on top of her self-portrait. The red spot hit me. An endless conversation began. Since then, I've always referred to her by her first name. Helene, a modernist painter. She was out of sync with her time: she had no children and was literally unbalanced: she fell down the stairs as a child and lived with a damaged hip for the rest of her life.

In 2014 I made a large horizontal painting full of red spots. I put red oil paint on my middle finger and pressed it repeatedly across the surface until there was no colour left and my finger was sore. The painting was in my recent solo show at Wilkinson Gallery, London. I gave it a straightforward title: *this is a political painting*. For every red spot in that painting, I thought of Helene – as well as many other women.
A K Dolven, 2014, *Frieze Masters*

The work is to be hung at eye level.
pp. 154–7 Wilkinson Gallery, London

Performed and painted in the artist's studio in Laburnum Street, London

Helene Schjerfbeck, *Self-Portrait with Red Spot*, 1944. Ateneum Art Museum, Helsinki.

Confirmed Denied

44 møn wall drawing
Wall drawing on untreated plaster surface

Made for Kunsthal 44 Møen and René Block. A drawing was made on the wall in the first room. In the centre of the drawing, we see the plan of the exhibition space. Images such as photocopies and text written in pencil (as found in the artist's sketchbooks) fill the walls. Following research in the artist's studio archive, photographs were found, such as images of her TV screen from West and East German TV channels, taken in November 1989. She lived in Berlin from 1987 to 1997, at the border: her balcony was in the East and her entrance was in the West.

A full unpainted wall, wall to wall and floor to ceiling. Images pinned and artist's handwriting with pencil directly on the wall.

pp. 158–9 44 Møen, Askeby, Møn

Work produced on site at Denmark

East (left) and West (right) German news broadcasts on TV, taken in the artist's Berlin home, November 1989

self portrait, berlin februar 1989 lofoten august 2009
2010
Two 8 mm films transferred to 2-channel video on monitor, mute
3 min
Edition 5 + AP

self portrait, berlin februar 1989 lofoten august 2009 is captured on 8 mm film, each roll 3 minutes. The camera is out of focus and turned by the artist around her body until the roll of film comes to an end. The two films are shot twenty years apart. *berlin februar 1989* is filmed from the artist's balcony overhanging Osthafen, a part of the river Spree that belonged to East Germany, while the entrance to the building was in the West. On the balcony, naked, she shot the film until the roll ended, overlooked by DDR border patrols in watchtowers and boats. In August 2009, she performed the same act, standing still while she turned the camera around her body. This time, it was on a mountain top facing north in Lofoten, late at night in the season when the sun never sets. The films were transferred to video and are shown on monitors. In 2010 the two films were put together, side by side as one work. The world is turning, and the body is still.

The monitors should be mounted with their centre 110 cm above the floor, so that they align with the centre of the onlooker's body. Ideally, the film is shown on 21-inch screens. They should be mounted at a level height, resting directly on wall brackets. There must be no gap between them.

p.163 Platform China, Hong Kong

Recorded in Berlin, German and Lofoten, Norway

Camera
A K Dolven

Edit
A K Dolven and Ulrike Mü

Performer
A K Dolven

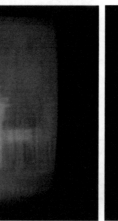

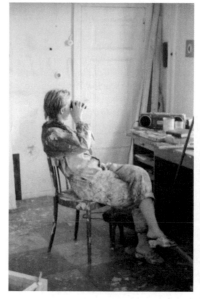

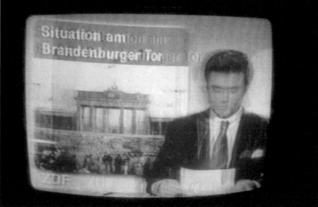

Oberbaumbrücke, Berlin, 1992. Bird borrowed from Museum für Naturkunde, East Berlin

Oberbaumbrücke, Berlin, 1988

**could hear you now
(illustrated)**

film projection, mute
57 sec
n 5 + AP

if we could hear you now is a 16 mm mute film. A young woman's face is framed in the screen. Her look is urban and contemporary, and her lips, painted red, are moving. She is trying to tell us something, but we cannot hear her in the silent film. In an increasingly fast-paced edit, the image of the woman is interweaved with footage of ice. The woman continues with her message, and a flickering after-image of her face remains visible through the many cuts in the film. After reaching an almost stroboscopic speed, the camera lingers briefly on the woman's face, and we finally look into her eyes for the first time.

The artist's grandfather, Rudolf Strandli, was a whaler in the Antarctic over a period of forty years, away for two years at a time. In 2008, together with his great-grandchild, she visited the area, filming with her 16 mm camera.

The work is preferably shown from a 16 mm film print with a looper. The image should be projected directly onto the wall, and the image size projected at 40–50 cm width. The wall should be painted red from floor to ceiling. The projection surface is white. The projector should ideally be placed on a traditional projector stand. The power cabling should be black, soft rubber, left loose and coiled on the floor.

Film shot from boat in Antarctica
Camera
A K Dolven
Edit
A K Dolven and Ulrike Münch
Actor
Thora Dolven Balke

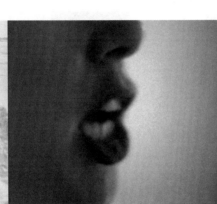

Top: Grytvigen, whale hunters' station, South Georgia, Antarctica Bottom: Rudolf Strandli (1905–79), relaxing in his room Photo: Theodor Andersson. The Whaling Museum, Sandefjord.

ty

installation with wall
ng
m film on DVD
n 5 + AP

Wall text

liberty
It is a deep sadness to leave behind the pure white beauty of Antarctica when going north and looking back. You want to return. Then, for a very long time you see nothing but ocean – enough time and space to prepare for what is coming. You know all about the continents ahead. A lot of shit and pain made by us, basically.

And there she appeared in the ocean. First as a white spire in the sea, but then it was more and more clear. It was her, the Statue of Liberty. She was floating tall and proud on top of a huge mountain. She had become pure ice and the strong sun made her brilliant and vibrant in the cold. She was enormous.

She was probably fed up with all the lies and wanted to get loose, finally.

Her age was tens of thousands of years.*

She drifted very slow and passed the ship with such elegance. Her lifetime from now on was unknown. The wound-up 16 mm camera caught her for twenty seconds.
* According to Professor Hans Amundsen, glacier expert
A K Dolven, Kvalnes, 3 August 2008

liberty is an installation with a silent 16 mm film running in a loop. This film is displayed on a monitor, which the viewer sees through a pair of

The artist's text 'liberty' should be handwritten with pencil on the wall next to the door, preferably by the artist.

The video is displayed on a small flat screen behind a closed door. The film can be experienced like Duchamp's *Étant donnés*: we watch the film through two small holes in the door. The door may be an existing door in the exhibition space. The drilled holes should remain untreated.

pp. 166–71 Peter and Paul Fortress, St Petersburg

Filmed on deck on a boat leaving Antarctica
Camera
A K Dolven
Edit
A K Dolven

liberty (cont.)

peepholes drilled through a wooden door or wall. Approaching the holes, most viewers will need to bow down to look through them. On the other side, one glimpses a moving image of an Antarctic iceberg whose shape resembles the Statue of Liberty. The iceberg floats majestically on its own with nothing else on the horizon. Bright sun illuminates both the sea and the surface of this immense mass of ice, creating a dazzling vista almost entirely in shades of white and blue. As the piece is filmed from the deck of a boat, the camera movement follows the rhythmic rocking of the waves.

madonna with man and bread

madonna with man and fruit

madonna with man and fig

madonna with man and iris

madonna with man and lily
2005
Light boxes with print on acrylic
130 × 100 × 10 cm each
Edition 5 + AP

These works revisit the image of Madonna and child, so central to the history of painting. As one of the earliest depictions of a relationship between two people, this image transcends its status as a religious icon. In this coupling, the Madonna is at once mother, whore and saint; the child is at once dependent on the Madonna, bestows gifts upon her and seduces her. The work explores the ambiguities manifest in what is essentially a relationship of power.

In this series, the Madonnas are real-life businesswomen; the 'children' are men. They are tied together in a similar Madonna and child pose, but within the settings of their individual offices. At first glance, we see the slick office interior with a clear view of its exterior landscapes and streetscapes, two from Aker Brygge in Oslo and three from Marylebone Road in London. Echoing Renaissance images of the Madonna and child, each work also features a flower, fruit or bread.

This series is comprised of five light boxes, as individual works or as a series. *Madonna with Man-Oslo and Madonna with Man-London* is a large video installation (4 min 30 sec).

Light boxes installed quite high on the wall so that the Madonna looks down on the viewer, like a church icon. The film version, *Madonna with Man-Oslo and Madonna with Man-London*, consists of two mute films projected on either side of a large-scale floating screen that hangs diagonally in the middle of a room.

pp. 172–3 Gallery 3, 14, Bergen

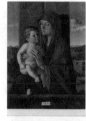

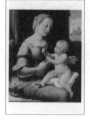

Location
Offices of AMV BBDO, Marylebone Road, London
Storebrand Insurance, Aker Brygge, Oslo

Actors
Anne Francke, Farah Ram
Golant, Tess Alps, Åse Au
Michelet, Kristin Skogen L
Kjetil Berge, Mustafa Gur,
Hooi, Knut Darre Christian

Camera for photo and vid
Vegar Moen

Edit
A K Dolven

Photo post-production
Kristian Skylstad

skrapa komager / gáidaduvvon gábmagat / scraped moccasins
Light box with print on textile
350 × 500 cm

All seems normal at first glance. We see a couple sitting on some stone steps next to their wagon. Upon closer inspection, we discover that the man's shoes appear to be scraped away. Someone has attempted to 'erase' the footwear from the image, which would have shown he is of Sami origin. This found family photo from the beginning of the 20th century is from Beiarn, Norway, a Pitesami area.

The light box is installed high up on a wall in Stormen Library in Bodø, facing large windows, which mirror the work. The mirroring in the facade makes the couple become part of Bodø city and its history as they merge into one.

pp. 178–81 Stormen Library, Bodø

Found photo from Rune Johansen's family album. We see his great-great-grandparents.

Woman: Hanna Margrete Bendik's daughter. Born 1
in Hemminghytt, Beiarn; di
1929.

Man: Kristian Albrigtsen ('Oskrestian'). Born 1846
Hallones, Os in Beiarn, in
same house where the ima
is taken; died 1931.

Work created in collabora
with Rune Johansen

Light box made by Markbr
Norway

Project manager
Magnus Jorde

Produced by
KORO

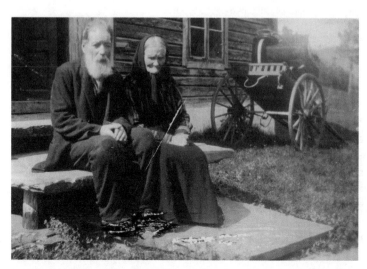

installation with bell,
columns, wire and
rope
oft Tenor, 14th-centrury
an church bell
ation size: 20 × 30 m

In 2003 the Tenor bell was lifted away from Scraptoft Church, taken down. It did not match the standard pitch that had been established as the expected sound. It was consequently set on the ground, and by that determined act it lost its voice completely. The clapper was removed as if one's tongue or vocal cords had been cut off. The sound was gone. And within a moment the bell became a mere body: a shell of metal and form.

The happiness of a birth and the mourning of a death had been transmitted through the air by this bell. It was now grounded. It's voice did not fit in with the other bells any more.

The live sound from a bell is pure. No technical support, nor gadget, no recording is needed to experience the sound. Only wind and weather affect its direction, trace and volume. No digital perfect pitch is possible. The body is very much a body on its own, high up there, somewhere. Thinking about this Tenor makes me realize that the bell sounded when Shakespeare was writing, when Machiavelli was thinking, and when Purcell was composing. The same bell's voice sounded in the New Year in 2000.

It is old. Very old. And even though I found it grounded; it is far from being scrap metal. The form is protected as it has such an age. But it lost its position among the other bells because of the specific quality of its voice – but a single voice with character is attractive. It is a personal statement. A signature. This does not imply that it is wanted by the crowd of the moment.

Thanks to the support of the people of Scraptoft Church and Leicester Diocese and their eagerness for the bell to make its voice heard, the bell is lifted again in Folkestone. Now the Tenor bell is 15–20 metres up in the air. The sky is its backdrop by the seafront, and its sound will stand on its own: it is not useless at all. In June 2011 anyone can ring the bell by pulling and help it sound. Away from the church and the others.

In 2006, I travelled 13,000 km to listen to the sound of a particular bell. It had been placed in the mountain landscape the same year in memory of a man. Getting to the bell and ringing it myself, then listening to its voice sounding far into the mountains, made me let him go.

This experience made me look for more voices by other bells. Bells of any age or tone. Coming across this analogous sound, activated by one's arm, was like listening to someone experienced. I searched for single bells and in particular for those that did not work 'in harmony' with the others.

In early 2010, I had a 1.5-ton bell raised above a square in Oslo for a few months only. *The Untuned Bell* had been removed from Oslo Town Hall (2000) with the other 48 remaining in place. In Finland, a bell I found in a London foundry, viewed as scrap metal, is now part of a permanent installation in memory of Helene Schjerfbeck (1862–1946). Both as a woman and as an artist, she was not as one expected her to be at that time. She was a brave and focused modernist painter: The Finnish Untuned Bell.

In a way, the Scraptoft Church bell sounds for all of us, as it is so old and at the same time so new. It has enormous life experience: five hundred years under extremely varying conditions. Now it sounds temporary in Folkestone, in the harbour,

Installation by the edge of the sea in Folkestone's harbour where an amusement park used to be. Here the 500-year-old bell got its sound back. It was meant to be installed for three months, but as people from Scraptoft came to listen to this sound, a sound their forefathers had listened to, an interest to keep the bell grew, from people in both Folkestone and Scraptoft. It was as if sound brought images of those they had never seen. They listened to the same sound at least – hundreds of year apart. Now the installation is for an indeterminate time, a loan agreement has been made with the Folkestone Triennial collection. Although Scraptoft Church is still the owner of the bell, the work will stay in Folkestone. Bell ringers from Scraptoft were ringing the bells in Folkestone at St Mary and St Eanswythe Church to welcome their own bell.

pp. 184–5 Folkestone

Commissioned by the Folkestone Triennial 2011, now installed in Folkestone harbour indefinitely as part of the Folkestone Triennial collection

Bell borrowed from Scraptoft Church

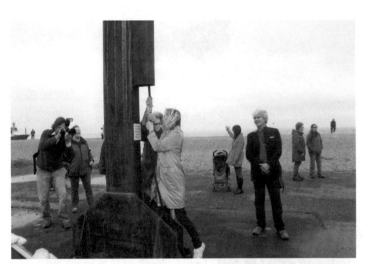

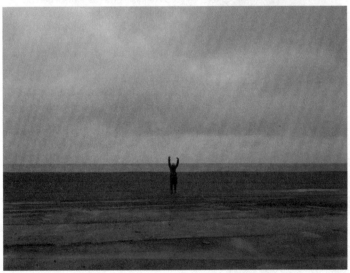

'Like pure sound or a melodic system of pure sounds in the midst of noises, so a crystan, a flower, a sea shell stand out from the common disorder of perceptible things.'
Paul Valéry, *Man and the Seashell*

out of tune (cont.)

between two ready-made H-steel pillars. The handle is specially made for there, at the sea. The bell itself, made of bronze, will never change.

Sound makes us see. The aftersound that we hear when listening carefully lasts about 50 seconds. Folkestone, with an edge to another continent, with both back and front to the rest of the world, seems to me a particularly apt place for *out of tune*.

A K Dolven, Lofoten, March 2011

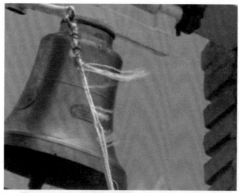

Los Tapires, close to Las Lajitas, Provincia de Salta, Argentina

untuned bell
February–June 2009
Sound installation with bronze bell, steel columns and Cry Baby pedal on concrete block
20 × 30 × 20 m

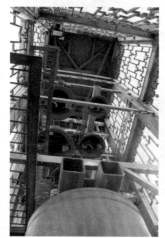

The Bell, a D sharp, 1.4 tons, was removed from the carillon in Oslo Town Hall before the turn of the last century as it was out of tune with the remaining 48 bells. The Untuned Bell then sat mute on the ground in Nauen Bell Foundry. But the artist brought it back, this time on its own, a kilometre away from the other bells in the Town Hall.

The composer Rolf Wallin made a composition that developed over a week from the bells in the town hall. It was performed by carillonneur Vegar Sandholt, as well as transmitted on national radio. To hear the sound, visit www.koro.no/filestore/UntunedBell_inauguration.mp3

'When Anne Katrine told me about the Untuned Bell returning to Oslo, my immediate thought was that all the "nice and proper" bells in the City Hall should call the outcast back. They would have to go through a process lasting a whole week, preparing themselves and the city for the return of the lost voice. And, as always with groups accepting an outcast into their circle again, only a few individuals dare to speak for it in the beginning.

Thus, one week before the inauguration, only three bells sounded in a very short melody. But five times a day the melody grew, note by note, slowly unfolding a mighty cascade of tones that filled the city's acoustical room with all of its possible pitches. As we would expect, the last bell to welcome the Untuned Bell back was the very bell that replaced it, a D sharp.

The times for playing these melodies were chosen carefully. The City Hall has a wonderful astronomical clock, showing the citizens of Oslo our place in the universe: moon phases, the sun's position in the Zodiac, eclipses and so on. But the bells don't strike at the natural time, the solar time of Oslo. Before the advent of trains, the churches and city halls struck 12 at the solar noon, when the sun was at its highest point.

On Tullinløkka, the bell was installed hanging on a wire between two 20-metre-high pillars to mark its return to the soundscape of Oslo. By pressing a pedal provided, a classic Cry Baby, the bell will make itself heard again within the city, this time as a sonic solitaire.

In this way, the Untuned Bell was experienced visually, as an object but also and most importantly, as a spatio-acoustical event. The sound was operated by the visitors themselves, thus giving them the opportunity to 'put their foot down'.

The work was removed after three months. Just before this book went to print, it was announced that the Oslo municipality had asked for the work back as an installation in a location in relationship to the Town Hall and its bell tower.

The third and only permanent work with a bell so far is *The Finnish Untuned Bell*, made in memory of modernist painter Helene Schjerfbeck – a woman who was out of tune with the expectations at her time. It stands, almost concealed, between trees in a park named after her in Ekenäs, Finland. The installation in Oslo was temporary (February–June 2010). The bell work in Folkestone was made for the Folkestone Triennial in 2011, but is still in place now and will remain so for some time to come.

pp. 186–97 Tullinløkka, Oslo

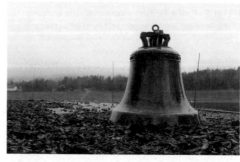

Tullinløkka, Oslo, Norway

Curator and project manag
Kristine Jærn Pilgaard

Architect
Trude Mardal

Production
KORO / URO
by Bo Krister Wallström

Co-curator
Gaby Hartel

Composer
Rolf Wallin

Entrepreneur
Ansnes AS

Construction engineering
Asle Gudim, Norconsult an
Arne Dolven

Bell foundry
Olsen Nauen Klokkestøpe

Assistant
Magnus Jorde

Poster design
Onestarpress
by Christoph Boutin

Carillonneur
Vegar Sandholt, Oslo Rådh

Sound team
Aeron Bergmann and
Andreas Hald Oxenvad

ned bell
t.)

Because of the demand for global synchroniza-tion, Oslo City's bell tower strikes noon around 31 minutes too early. Also, the citizens don't know when the sun rises and sets. So I wanted to mark the beginning and the end of the short winter days of Oslo (still only around 8 hours long in the beginning of February) with a melody. With one extra melody halfway between sunrise and noon, and another halfway between noon and sunset, there were five melodies per day.

The Norwegian Radio's *Program 2* followed the growth of the melody, reporting daily from the neighbourhood of the City Hall.

On Saturday 6 February, during the 30 minutes before the inauguration of the Untuned Bell, all the 35 melodies were played. In addition, the 11 smallest bells that had not yet been heard (simply because they cannot be reached by the computer system) were now joining the bell chorus, played manually by City Hall carillonneur Vegar Sandholt.

14:15: The Untuned Bell sounded for the first time. The D-sharp bell was the last one to sound from the bell tower of the City Hall, giving the final welcoming handshake to the untuned D-sharp of the Untuned Bell.'

Rolf Wallin

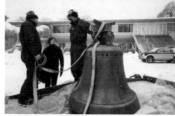
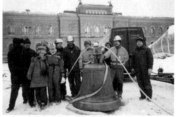

KORO
KUNST I OFFENTLIGE ROM / PUBLIC ART NORWAY

PRESS RELEASE / FOR IMMEDIATE RELEASE

UNTUNED BELL / A K DOLVEN
PRODUCED BY KORO - PUBLIC ART NORWAY

TULLINLØKKA, OSLO
INAUGURATION 6th of FEBRUARY 2 PM

Art in Public Spaces, KORO, presents A K Dolven's Untuned Bell at Tullinløkka.

s long as I can
3
LP, record player,
fier, two loudspeakers,
s
n, dimensions variable

JA, as long as I can is a dialogue, or duet, with A K Dolven and John Giorno as performers. Both utter and vary the word *ja*, the Norwegian equivalent of 'yes', for as long as their energy spans, resulting in an audio recording of 22 minutes.

There are two ways of installing this work: in a gallery setting and as a performative piece in a cinema or theatre.

Exhibited in gallery: record player, amplifier and loudspeakers placed directly on floor. Cables are loose and visible.

Performed in cinema or theatre: record player on stage, connected to existing sound system in the space. When the audience is seated, the space goes dark and the record player is illuminated by a single white spot. After a few minutes, the performer (the artist if possible) approaches the stage bringing the record. She then extracts the record from the sleeve and places it on the turntable. The performer starts the record player and returns to her seat. After 22 minutes, when the record is coming to an end, the performer removes the record from the turntable, places it back in its sleeve and returns to her seat.

Recorded at John Marshall Sound, New York, 18 October 2012

Production
Edition Block, Berlin

Curator
Gaby Hartel

Edit
A K Dolven / Deutschlandradio Kultur, Berlin

Voices
John Giorno and A K Dolven

Cover photo
A K Dolven

Cover design
Onestarpress
by Christoph Boutin

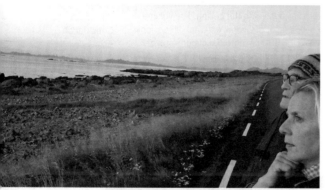
en and Giorno looking for the Green Ray, 68.2 degrees north

x dolven · john giorno

JA as long as I can

palais de tokyo · paris
le 9 mars · 2014 · 16h

john giorno · a k dolven
vinyl launch
conversation avec gaby hartel

rio cinema dalston · london
march 8 · 2014 · 30pm

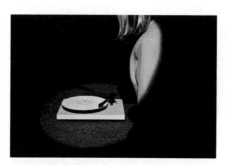

work	description	installation	info

change my way of seeing I
2011
Video installation with
ambient sound
3 min
Edition 5 + AP

The role where an artist normally looks at the world through a viewfinder is now turned around. The film is shot with a Super 8 camera held by the artist at arm's length and turned around 180 degrees. The artist is looking at the sun through the lens. Hence it is the sun 'looking' through the viewfinder at the artist's eye. This performance lasts three minutes, the length of one roll of Super 8 film. The film captures the uncomfortable blinking of a dazzled eye as the rays of the sun find their way through the optics and shine straight into the artist's pupil. The analogue film transforms this into a whiteness where pain meets beauty.

Film transferred to HD video. Large-scale back-projection on free-standing wall in the exhibition space. Sound and projection equipment is deliberately not hidden, but instead visible to the audience when entering – as if one enters 'back stage'. Preferably, the audience will enter the space and approach the screen from behind, passing the equipment along the way. Walking past the screen to its front, one enters an empty space except for two speakers.

Ambient sound is brought inside the gallery. A small microphone is placed outside the building continuously capturing everyday sounds. This is transmitted in real time to two speakers placed in the gallery space. Placement of speakers variable. Volume will be set so that outdoor sounds are carefully brought indoors.

pp. 206–9 MGM Gallery, Oslo

Recorded on the artist's balcony, at night facing nor when the sun never sets, Kvalnes, Lofoten

'Look at the light and consider its beauty. Blink your eye and look at it again: what you see now was not there at first and what was there is no more. Who is it who makes it anew if the maker dies continually?'

Leonardo da Vinci, *Notebooks*

don't do it don't do it looking into the sun
(not illustrated)
2011 (work in progress)

moving mountain
2004
35 mm film transferred to video
Projection and sound
installation in a purpose-built
room
4 min 11 sec
Edition 3 + AP

With cameraman Vegar Moen and friends, the artist travelled to the island of Vedøya in Røst, Norway, 68.2 degrees north, which is inhabited solely by seabirds. Surrounded by fog, one's only perceptive experience was the sound of birds.

At the end of the day, they erected the 35 mm camera equipment and started shooting. During four minutes, and a single roll of 35 mm film, the fog lifted.

The soundtrack, loud and distressing, is that of a cacophony of screaming birds. Two girls, facing away from the camera towards the mountain, fill the bottom corners of the image, framing the cliff that towers above them. As the fog gradually lifts, more and more birds are revealed flying in and out of the cleft of the rock face.

moving mountain is displayed as a wall projection inside a large purpose-made box. The box is constructed on site and functions as a room within a room. The interior walls are painted with a white gloss finish, allowing the video projection to reflect back onto the surfaces inside the box. The outer surface should remain untreated and unpainted. The work has a raw outside and a clean, white glossy paint inside. Four white speakers are flush with the ceiling. The volume of the sound is loud. Overall external dimensions of box: 610 × 390 cm; internal dimensions of end projection wall: 380 × 285 cm. The projection fills the wall exactly from wall to wall and from ceiling to floor. The floor is sloped up towards the image, so that the shadow of the audience's heads will fall into the projection when entering the box and visually merge with the girls' heads in the work.

pp. 210–13 Bergen Kunsthall, Bergen

Røst, Norway, 2003

Commissioned by
Bergen Kunsthall, Norway

Performers
Pernille Leggat Ramfelt
and Marie Anderson

Camera
Vegar Moen

Still photo
Chris Jacob

Post-production
Pro AV, Finland

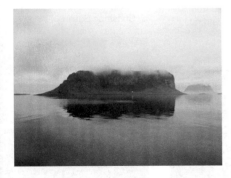

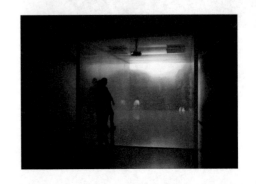

rk	description	installation	info

n voices

active sound installation.
Baby pedal, rubber cables,
speakers, digital sound file;
ernationale sung in
wegian by seven young
le, Oslo, October 2011
on 5 + AP

This sound installation is mute. The viewer activates the sound by stepping on the pedal. When stepping off the pedal, it is mute again. The sound file continues so that the viewer will enter the work at random moments in the song. We hear the world's most translated hymn, *L'Internationale* from 1871 – here sung by seven young Norwegians in their own language. The hymn belongs today to socialist movements worldwide and has been sung widely in 2011, among other places on the island of Utøya in Norway.

Two active speakers are placed on the wall about 2.2 metres above the floor. The work is intended to be mounted in a corner, with a speaker on each wall.

Thick black rubber cables run horizontally from each speaker and meet in the corner where they run jointly down to the floor. From there on, the cables run freely along the floor to a specially modified Cry Baby pedal. The sound file is built into the pedal, which can be operated by any visitor.

The work may be installed outdoors, with the cabling protected by metal conduits.

pp. 204–5 Kunsthal 44 Møen, Askeby, Møn

Recorded in Oslo, at the National Academy of Fine Art

Voices
Anders Kvammen
Arja Wiik-Hansen
Ida Gramstad
Mari Opsahl
Ragnhild Aamås
Silje Johannessen
Stine Wexelsen Goksøyr

Edit
A K Dolven

Sound
Petr Svarovsky

Fabrication
MDM Props, London

lder of tales /
ntyrsteinen
4
ite boulder, 5 tons,
sound

Under open sky and year round, one can listen to found and unknown Sami tales and one *yoik* by mother and daughter. The Sami tales were collected scientifically in the 1920s by Jus Qvigstad and bound into four large books. Within the work *boulder of tales*, two hours of stories are now reimagined in contemporary north Norwegian dialect. The two-minute *yoik* brings the original language and tone of the Sami way of singing into the stone.

The tales unveil life and relationships between people and nature as well a pagan world.

The boulder is lifted over the roof, into an atrium belonging to Stormen Library in Bodø. Throughout the year, in the shifting light conditions of this Arctic place, one can stay and listen. The floor is heated. Cables hidden under the floor. Player and amplifier inside the building. Speakers inside the stone.

pp. 214–15 Stormen Library, Bodø

Boulder donated by Gunn Helmersen from her land at the sea in Gildeskål, Norway

Voice: 1h 50 min tales read and edited by Marit Adeleide Andreassen

Recorded at I and M Studio, Oslo

Sound producer
Thora Dolven Balke

Yoik: *2 min Ii Olmmoš Galgga Riggáid Doarjut*

by Biret Elle Balto / Laila Somby Sandvik

Edit
A K Dolven and Håvard Christensen

Transport
Nordlandskrana

Project manager
Magnus Jorde

Produced by
KORO

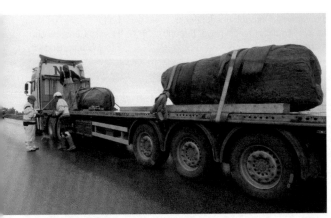

work	description	installation	info

work

bodøvoices 2014
2014
Steel and copper, 18 metre,
with light, sound and
Løddingen granite
60 × 60 × 10 cm
Cry Baby pedal

description

Bodøvoices 2014 is about listening, and memory.
The installation consists of an oversized lamppost
(18 m) – similar lampposts may be found along
any harbour or road in Norway. The lamp's
circular beam becomes a spotlight – creating an
outdoor stage for the city's population. A Cry
Baby pedal is placed in the centre where the
light hits the ground, fixed on a black square
made of granite. This square, a heated black
Løddingen stone, becomes a black square in
the white snow during winter. This type of pedal
is normally used together with an electric guitar
to create a 'wah-wah' effect. Here, instead of
guitar sounds, the pedal activates sounds heard
from 18 metres above. The audio is the voices
of people from Bodø in 2014: footballers from
local team Glimt, a great-grandmother with her
two great-grandchildren, a boy born in 2014
and a young blogger. Each sound fragment
lasts from 2 to 5 seconds.

installation

The installation is located outside Stormen
Library in Bodø, facing down to the harbour.
A cone of light shines down from the top,
especially visible in the dark times of the year.
The sculpture is silent, but when one steps on
the pedal, short recordings of voices from 2014
are heard from above. The digital files are
played from a computer inside the library. The
pedal is effectively transformed into a switch.

pp. 216–17 Stormen Library, Bodø

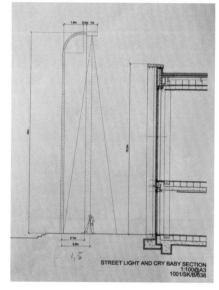

STREET LIGHT AND CRY BABY SECTION
1:100@A3
1001/SK/B/838

info

Voices

Born	Name
1920	Signe Bergithe An...
1976	Jonas Kolstad
1979	Tommy Knarvik
1980	Pavel Londak
1983	Dane Richards
1983	Thomas Jacobsen
1984	Trond Olsen
1985	Dominic Chatto
1985	Ibba Laajab
1986	Ruben Imingen
1987	Thomas Bråten
1987	Jim Johansen
1987	Vegard Bråten
1988	Lasse Staw
1989	Vioux Sane
1989	Kristian Brix
1990	Badou
1990	Anders Karlsen
1991	Daniel Edvardsen
1991	Zarek Valentin
1992	Ulrik Saltnes
1992	Ulrik Berglann
1995	Martin Pedersen
1996	Mari Høj Anvik
1996	Audun Mathisen Ar...
1996	Morten Konradsen
1996	Mathias Normann
1997	Patrik Berg
1997	Odd-André Lind Ni...
2014	Henrik Aidan Olsen

Entrepreneur
Tom Staurbakk
by Espen Christensen

Architect
Sami Rintala

Sound engineer
Håvard Christensen

Project manager
Magnus Jorde

Produced by
KORO

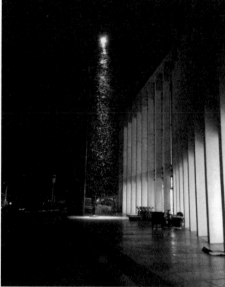

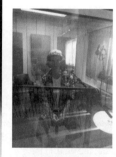

just another sound
2013
Oil on aluminium
40 × 80 cm

The artist struck the aluminium, with varying
force.
The classical oil paint on gesso is applied with
flat tools, rather than soft brushes.

The work is to be hung roughly at chest height.
pp. 218–19 Wilkinson Gallery, London

Painted and painted in the
artist's studio in Laburnum
Street, London

please return
2014
Sound installation
4 min 29 sec
Edition 3 + AP

The Norwegian word *kom* (English: come,
German: *komm*) is expressed by the artist at the
edge of a lake, facing a steep wall of mountains.
Multiple echoes are heard. These mountains are
among the oldest in the world.
By shouting towards the mountain wall, it is as
if they throw back their own voice.

The work can be installed in two ways:

Sound transmitted through loudspeakers or
surround speakers installed in a space.
Alternatively through permanently installed
sound system at venue.

Sound transmitted through headphones:
sound played by digital media player through
headphones.

In both cases, a metal sign with the text
'please return' is fastened to the wall, 150 cm
above the floor.

pp. 220–1 Ikon Gallery, Birmingham

Sound recorded by a lake i...
the mountains at Kvalnes,
Lofoten, Norway

Voice
A K Dolven

Edit
Håvard Christensen,
Store Studio, Bodø

·please return·

photocredits

thanks / takk

friends	family
neighbours	contributors
publishers	printers
curators	designers
helpers	transporters
gallerists	museums
proofreaders	boyfriends
assistants	photographers
engineers	entrepreneurs
crane companies	architects
writers	thinkers
technicians	translators
editors	repro
students	colleagues
daughter	driver